True to Life

True to Life
Why Truth Matters

Michael P. Lynch

A Bradford Book
The MIT Press
Cambridge, Massachusetts
London, England

This book was set in Stone and Stone Sans by Graphic Composition, Inc.
Printed and bound in the United States of America.

Library of Congress Cataloging-in-Publication Data

Lynch, Michael P. (Michael Patrick), 1966– .
 True to life : why truth matters / Michael P. Lynch.
 p. cm.
 "A Bradford book."
 Includes bibliographical references and index.
 ISBN 0-262-12267-7 (hc : alk. paper)
 1. Truth. I. Title.
BD171.L869 2004
121—dc22

 2003070640

10 9 8 7 6 5 4 3 2 1

to Bridget

Contents

Preface

This book is about why truth matters in our personal and political lives. The last hundred years have seen a considerable amount of writing on truth by philosophers, but much of it has been preoccupied with formal questions of definition and paradox. While this work is of considerable importance, it can leave the average person feeling rather nonplussed; it rarely addresses the concerns that cause us to worry about truth in the first place. One of the aims of this book is to correct that.

Another aim is to be clear. I like my philosophy straightforward and unclogged with academic technicalities. Even the deepest philosophical problems can be appreciated by anyone willing to roll up his or her intellectual sleeves and think hard. That is what I've tried to do in this book: grapple with the issues in a way that brings the reader with me. Consequently, I have tried to keep the technicalities to an absolute minimum.

I have been thinking about these problems for several years, and am grateful to many people for their help, although none is to blame for the results. Work on the book was made possible by a sabbatical generously granted by Connecticut College during the academic year 2002–2003 and a Bogliasco Fellowship in spring 2003 at Liguria Study Center. Versions of various parts of the book benefited from comments received during talks at The University of St. Andrews, The Moral Sciences Club at Cambridge, The University of Wales at Cardiff, The University of Genoa, The University of Turin, Florida State University, the University of California Fullerton, the University of Cincinnati, The University of Mississippi, and Tufts University. In the fall of 2002, I was fortunate to be a Visiting Fellow at the Arché center at the University of St. Andrews, where I benefited from conversations with numerous people, particularly Crispin Wright, as well as with J. C. Beall, John Haldane, and Patrick Greenough. In addition, many people suffered through early versions

of various parts of the manuscript, and helped me to avoid numerous problems. Thanks to Robert Barnard, Eddy Nahmias, Bridget Lynch, Patty Lynch, Tom Bontly, Derek Turner, Chase Wrenn, and Chris Gauker. Heather Battaly, Tom Polger, and Paul Bloomfield, old friends and sparring partners, deserve special mention for their copious and helpful commentary on various versions of the manuscript. William Alston, teacher and friend, and whose work strongly influenced (the good) ideas in this book, also provided significant comments on the manuscript at a late stage. Most important, I thank Terry Berthelot, whose relentless insistence on clarity and penetrating criticism were matched only by her unflagging support, and amazing tolerance for her husband's eccentricities. Terry's influence on this book is deep. I literally couldn't have written it without her.

Portions of chapter 7 are based on material that appears in "Minimalism and the Value of Truth," *Philosophical Quarterly* 55 © 2005, The Editors of *Philosophical Quarterly*.

Thanks too to my copy editor Judy Feldmann, and to my editor Tom Stone, for knowing what matters.

Introduction

In early 2003 President Bush claimed that Iraq was attempting to purchase the materials necessary to build nuclear weapons.[1] Although White House officials subsequently admitted they lacked adequate evidence to believe this was true, various members of the administration dismissed the issue, noting that whether or not every claim made by the president was accurate, the important thing was that the subsequent invasion of Iraq achieved stability in the region and the liberation of the country.[2]

Many U.S. citizens apparently agreed. After all, there were other reasons to depose the Hussein regime. And the belief that Iraq was an imminent nuclear threat had rallied us together and provided an easy justification to doubters of the nobility of our cause. So what if it wasn't really true? To many, it seemed naive to worry about something as abstract as the truth or falsity of these claims when we could concern ourselves with the things that really matter—such as protecting ourselves from terrorism and ensuring our access to oil. To paraphrase Nietzsche, the truth may be good, but why not sometimes take untruth if it gets you where you want to go?

These are important questions. At the end of the day, is it always better to believe and speak the truth? Does the truth itself really matter? While generalizing is always dangerous, the above responses to the Iraq affair indicate that many people would look at these questions with a jaundiced eye. We are rather cynical about the value of truth.

Politics isn't the only place that one finds this sort of skepticism. A similar attitude is commonplace among some of our most prominent public intellectuals. Indeed, under the banner of postmodernism, cynicism about truth and related notions like objectivity and knowledge has become the semiofficial philosophical stance of many academic disciplines. Roughly speaking,

the attitude is that objective truth is an illusion and "truth" is just another name for power. Consequently, if truth is valuable at all, it is valuable—as power is—merely as a means.

Stanley Fish, a prominent literary critic and Dean at the University of Illinois at Chicago, has recently cranked up the antitruth rhetoric even further.[3] Not only is objective truth an illusion, according to Fish, even worrying about the nature of truth in the first place is a waste of time. Debating over an abstract idea like truth is like debating over whether Ted Williams was a better pure hitter than Hank Aaron: amusing, but irrelevant to today's game.

Paradoxically, Fish's reasons for thinking this are a consequence of his particular theory of truth. According to Fish, philosophical discussions about truth are a waste of time because he thinks that truth has no value. Furthermore, he thinks this is what we already believe. Sure, we may *say* we want to believe the truth, but what we really desire, he says, is to believe what is useful. Good beliefs are useful beliefs, those that get us what we want, whether that is nicer suits, bigger tax cuts, or a steady source of oil for our SUVs. At the end of the day, the truth of what we believe and say is beside the point. What matters are the consequences.

Fish's rough and ready pragmatism taps into one of our deeper intellectual veins. It appeals to the United States of America's collective self-image as a square-jawed action hero. And it may partly explain why the outcry against the White House's deception over the war in Iraq was rather muted. It is not just that we believe that "united we stand," it is that deep down, many of us are prone to think that it is results, not principles, that matter. Like Fish and Bush, some of us find worrying over abstract principles like truth to be boring and irrelevant nitpicking, best left to the nerds who watch C-Span and worry about whether the death penalty is "fair."

Of course, many other intellectuals *are* eager to defend the idea that truth matters. Unfortunately, however, some defenses of the value of truth just end up undermining that value in a different way. There is a tendency for some to believe, for example, that *caring about truth means caring about the "absolutely certain" truths of old*. This has always been a familiar tune on the political right, whistled with fervor by writers from Allan Bloom to Robert Bork, but its volume has only appeared to increase since September 11. U.S. citizens have lost their "moral compass" and need to sharpen their vision with "moral clarity." Liberal inspired relativism is weakening the nation's resolve, we are told; in order to prevail (against terrorism, the "assault" on family values, and the like)

we must rediscover our God-given access to the truth. And that truth, it seems, is that we are right, and everyone else is wrong. Here is William Bennett:

In one form or another, an easy-going relativism, both moral and cultural, is our common wisdom today. But things did not used to be that way. It used to be the case that a child in this country was brought up to revere its institutions and values, to identify with its customs and traditions, to take pride in its extraordinary achievements, to venerate its national symbols. . . . The superior goodness of the American way of life, of American culture in the broad sense, was the spoken and unspoken message of this ongoing instruction in citizenship. If the message was sometimes overdone, or sometimes sugarcoated, it was a message backed by the record of history and by the evidence of even a child's senses.[4]

So in the halcyon days of old when the relativists had yet to scale the garden wall, the truth was so clear that it could be grasped by "even a child's senses." This is the sort of truth Bennett seems to think really matters. To care about objective, nonrelative truth is to care about what is simple and felt to be certain.

As a defense of the value of truth, this is self-defeating. First, an unswerving allegiance to what you believe isn't a sign that you care about truth. It is a sign of dogmatism. Caring about truth does not mean never having to admit you are wrong. On the contrary, caring about truth means that you have to be open to the possibility that your own beliefs are mistaken. Second, this dogmatic attitude, the sense of "superiority" Bennett is encouraging, confuses caring about truth with caring about what you believe is certain. As a result, it tends to undermine rather than support a concern for truth. For we are grown-ups, and our vision, unlike that of a child, is more prone to pick out shades of gray. Consequently, most of us know that it is unlikely that we will ever be absolutely sure of very much. But if we then confuse the pursuit of truth with the impossible pursuit of a feeling of certainty, then truth, too, suddenly seems out of reach. It becomes a target we'll never know we've hit, and thus a target no longer worth aiming for in the first place.

Cynicism about truth is widely shared, but it is not inevitable. We are prone to cynicism not so much because we find it so wonderful, but because we are confused about what truth is and how it can be valuable. And this in turn causes us to buy into some of the same tired assumptions about truth. Philosophers like Fish say that since faith in the absolute certainties of old is naive, truth is without value. Writers like Bennett argue that since truth has value, we had better get busy rememorizing those absolute certainties. The implicit assumption of both views is that these are the only two choices: Absolute

Certain truth with a capital "T," or no truth at all. With options like these, no wonder we are prone to throw up our hands.

This book is a philosophical exploration and defense of the idea that truth matters. I'll try to convince you that if you care about truth you better not care about dogma; that a lot, but not all, of what goes under the label "relativism" is dumb; that you nonetheless don't have to believe in one true story of the world; that staying true to yourself is hard but worth it; that being willing to stand up for what you believe is important for happiness; and that if you care about your rights, you better care about truth. We need to think our way past our confusion and shed our cynicism about the value of truth. Otherwise, we will be unable to act with integrity, to live authentically, and to speak truth to power.

Specifically, this book can be seen as a defense of four claims: that truth is objective; that it is good to believe what is true; that truth is a worthy goal of inquiry; and that truth is worth caring about for its own sake. The argument proceeds in parts. In the first part, I try to diagnose and refute the most common confusions and mistaken assumptions that lead us to be cynical about truth. Some of these confusions I've already mentioned: truth doesn't matter because it is unattainable; truth doesn't matter because it is relative; and truth doesn't matter because falsehood is often more useful. Each of these ideas is understandable; but each, I argue, is mistaken. Part II is about certain theories of truth. Cynicism about truth is not just the result of confusion and misunderstanding. It is also the result of the prevalence of certain philosophical theories about what truth is. I discuss and criticize three of the most important. The third part of the book explains *why* truth matters. My approach is from the inside out, so to speak. I begin with some deeply personal reasons for caring about truth; I argue that perhaps surprisingly, it is part of living a happy life. I next discuss why caring for truth is important in our personal relations to others. And I end by examining truth's political value, in particular the connection between a concern for truth and a concern for human rights.

Thinking through why we care about something can help us come to a better understanding of what it is. Thinking about why we should care about truth tells us two things about it: first, that truth is, in part, a deeply normative property—it is a value. And second, this is a fact that any adequate theory of truth must account for. In light of this fact, I suggest that truth, like other values, should be understood as depending on, but not reducible to, lower-level properties. Yet which properties truth depends or supervenes on

may change with the type of belief in question. This opens the door to a type of pluralism: truth in ethics may be realized differently than in physics.

The questions that matter are live ones, ones that face us everyday. "Why care about truth?" is such a question. For despite our dislike of illusion, we don't often care about truth as much as we should: we dissemble, hide behind ambiguity, refrain from speaking up, we turn away, stop asking questions, ignore reasonable objections, fudge the data, and close our minds. Not caring about the truth is a type of cowardice. And the very fact that it happens means that the question of why we should care about truth is both important and terribly personal.

It also means that our answers to it must be human ones. Consequently, the value of truth I defend in this book isn't an abstract, absolute ideal. I have no interest in putting truth on a pedestal. Truth is worthy of caring about, but it isn't worthy of worship. It is only one value among others, and it isn't even the most important value—if there even is such a thing. If truth matters, it must matter *to us,* in the confusing, conflicted lives of real human beings. If the argument that follows is sound, we may be confident that it does.

Part I Cynical Myths

1 Truisms about Truth

The Conversation-stopper

Ask someone what truth is and you are apt to be greeted by either puzzled silence or nervous laughter. Both reactions are understandable. Truth is one of those ideas—happiness is another—that we use all the time but are at a loss to define. This is why the question "What is truth?" is so often treated as rhetorical.

One of the reasons truth seems so difficult to describe is that we have conflicting beliefs about it: we sometimes think it is discovered, sometimes created, sometimes knowable, sometimes mysterious. When we use the idea in ordinary life—as we do when we agree or disagree with what someone has said—it seems a simple matter. Yet the more we stop to think about it, the more complicated it becomes.

It would be nice if we could sort out, once and for all, everything we thought about truth—to find out the whole truth and nothing but the truth about the truth, as it were. Nice, but practically impossible. The thesis of this book is much simpler. Of the many things you could believe about truth, there is at least one that you *should* believe: truth matters. Truth, I shall try to convince you, is of urgent importance in both your personal and political life.

The idea that truth matters actually sums up four claims. Together, these truisms, as I'll call them, explain what I mean by "truth" and what I mean by its "mattering." Accordingly, I begin by introducing these truisms about truth, with an aim toward convincing you that they are just what I say they are, obvious truisms. This doesn't mean that everyone agrees with them. As I already noted, some of us are confused about truth—we have contradictory beliefs about it. So we may believe these truisms but also believe something else that undermines our belief in one or all of them. Moreover, nothing is so

obvious that someone hasn't proclaimed it to be false, misguided, naive, incoherent, impossible, or corrupting for the young. And lots and lots of folks, as we'll see, continue to say as much about these four ideas.

Wittgenstein once remarked that the job of the philosopher was to "assemble reminders"—to point out to us what has been right there in front of our face all along. While this isn't all that a philosopher does, there is a lot of sense in this point. The very familiarity of something can make us forget, or even deny, its importance. When that happens, we need to be reminded of its role in our everyday life. This is what we need in the case of truth.

Truth Is Objective

If I know anything, it is that I don't know everything and neither does anyone else. There are some things we just won't ever know, and there are other things that we think we know but don't. Grant this bit of common sense, and you are committed to the first truism about truth: truth is objective.

Early on in Shakespeare's most celebrated play, Hamlet and his rather bookish friend Horatio see the ghost of Hamlet's dead father. Not surprisingly, Horatio has a hard time coming to grips with the fact that a dead Danish monarch is haunting the castle battlements. Hamlet's response to Horatio's worrying is brusque: there are more things in heaven and earth, he says, than dreamt of in Horatio's philosophy. Hamlet's point is to remind Horatio that he doesn't know it all because the universe is bigger than we are.

Not only, like Hamlet, are we sometimes ignorant; we also make mistakes. People once believed that the Earth was flat. Most of us now regard this as a rather silly idea. But imagine for a moment living in a time before advanced mathematics, before long-distance sea voyages, before airplanes, before photographs. Would you believe the Earth was flat? Of course you would. Just look at it, you would say, gesturing off toward the (flat) horizon.

Even well-supported scientific theories can be wrong. Seventeenth-century chemists, for example, noted correctly that something similar happens when metal rusts and wood burns. Undergoing both processes results in a loss of mass. According to the very best science of the day, the common cause was the release of an invisible gas, "phlogiston," into the atmosphere.[1] Since this gas took up space, had weight, and so on, its loss explained why both metal and wood got smaller after rusting and burning. It is easy to snicker at the phlogiston theory nowadays, since while there is a gas involved in both pro-

cesses, it is actually *oxygen,* which is gained, not lost, by the relevant system. Phlogiston doesn't exist. Yet the phlogiston theory was a very reasonable hypothesis at the time. It was highly confirmed by the standards of the day. The most knowledgeable scientists believed it. Yet it was mistaken.

The ever-present risks of ignorance and error underline the fact that whatever else it may turn out to be, truth is objective. Just because we believe it doesn't mean it's true, and just because it is true doesn't mean we'll believe it. Believing, as we say, doesn't make it so. The truth of Mt. Everest being the tallest mountain, for example, has nothing to do with whether I believe it or not. What matters is whether Mt. Everest really is the tallest mountain, and if it is, then presumably it would be even if no one had ever been around to see it. Of course, if there weren't any language-users around, then Mt. Everest wouldn't be *called* "Mt. Everest," since it wouldn't be called anything at all. But it would still be there, just as it would if we had called it something else, like "Mt. Zippy."

Voltaire once quipped that "let us define truth, while waiting for a better definition . . . as a statement of the facts as they are."[2] Voltaire meant this as a joke, but as working definitions go, it is pretty good. And Voltaire himself was probably thinking of a famous remark of Aristotle's that "to say of that which is, that it is, and of that which is not, that it is not, is true."[3] This is even better. When we say something true, the world is as we say it is. And when we believe truly, the world is as we believe it to be. It is the way the world is that matters for truth, not what we believe about the world.

In this sense, the objectivity of truth isn't, or shouldn't be anyway, controversial. As I've indicated, it is a consequence of accepting what everyone already does (or should) admit: we don't know everything and we can make mistakes.

The idea that truth is objective is sometimes put by saying that true beliefs correspond to reality. And that is fine, just so long as we realize that this phrase leaves room for disagreement about the nature and extent of what "correspondence" and "reality" amount to. Some hold that beliefs can't be true unless they correspond to mind-independent, physical objects like mountains, electrons, battleships, and barbers. On these theories, truth is always *radically* objective, since what makes our beliefs true on such accounts is always their relationship to real physical objects. This is obviously a matter of high philosophical theory, however, and not a truism. You don't have to believe it in order to believe that truth is objective in the minimal sense I've been describing.

We don't have to know everything about something to be able to talk about it. Take, for example, the hard drive of my computer, which (I blush to confess) I know next to nothing about. I don't know what it is made out of (little bits of metal and plastic probably), I don't know where it is exactly, and I don't know really how it gets its job done. But I do know what that job is: it acts as the main information-storage facility for my computer, where it keeps the various programs and files. For most purposes, this working description of a hard drive is good enough. It picks out what we generally mean when we talk about such things. Indeed, a lot of our ordinary concepts are like this, and it is a good thing too. This is why we can talk about something like gravity in a meaningful way before we know its real underlying nature, or even if we never learn about its real nature. We know what gravity does before we know what it is.

Our basic belief in truth's objectivity is like my basic idea of my computer's hard drive. We know the job of true beliefs, even if we don't know exactly how they get that job done. True beliefs are those that portray the world as it is and not as we may hope, fear, or wish it to be.

Truth Is Good

Nobody likes to be wrong. If anything is a truism, that is. And it reveals something else we believe about truth: that it is good. More precisely, it is good to believe what is true.

Why do we find it so obvious that it is good to believe what is true? One reason has to do with the purpose of the very concept of truth itself. Humans tend to disagree with each other: we squabble, spat, form different opinions, and construct different theories. Yet the very possibility of disagreement over opinions requires there to be a *difference* between getting it right and getting it wrong. When I assert an opinion on some question, I assert what I believe is *correct*. You do the same. And when we disagree, obviously, we disagree about whose opinion is correct. So if there is no such thing as reaching one (or none, or even more than one) correct answer to a given question, then we can't really disagree in opinion.

My point is that we distinguish truth from falsity because we need a way of separating correct from incorrect beliefs, statements, and the like. In particular, we need a way of distinguishing between beliefs for which we have some evidence, or are endorsed by the Pentagon, or denounced by the president, or make us money, or friends, or simply feel good, and those that actually end up

getting it *right*. It is not that we can't evaluate beliefs in all those other ways—
of course we can. We can, and should, criticize a belief for not being based on
good evidence, for example. But that sort of evaluation depends for its force
on a more basic sort of evaluation. We think it is good to have some evidence
for our beliefs *because* we think that beliefs that are based on evidence are
more likely to be true. We criticize people who engage in wishful thinking *be-
cause* wishful thinking leads to believing falsehoods.

So a primary point of having a concept of truth is that we need a very basic
way of appraising and evaluating our beliefs about the world. Indeed, this is
built right into our language: the very word "true" has an evaluative dimen-
sion. Part of what you are doing when you say something is true is com-
mending it as something good to believe. Just as "right" and "wrong" are the
most basic ways to evaluate actions as correct or incorrect, so "true" and
"false" are our most basic ways to evaluate beliefs as correct or incorrect.

Indeed, the connection between belief and the truth is so tight that unless
you think something is true, you don't even count as believing it. To believe
is just to take as true. If you don't care whether something is true, you don't re-
ally believe it. William James put this by saying that truth "is the good in the
way of belief."[4] Others sometimes say that truth is the aim of belief. This is not
literally so of course. Beliefs don't literally aim at anything. But both expres-
sions get at the idea that truth is a property that is good for beliefs to have.
Since propositions are the content of beliefs, and it is the content of a belief
and not the act of believing that is true, we can also say that truth is the prop-
erty that makes a proposition good to believe. In believing, we are guided by
the value of truth: *other things being equal, it is good to believe a proposition when
and only when it is true.* Since what is good comes in degrees, we can also put
this "norm" or rule by saying that other things being equal, it is better to be-
lieve something when and only when it is true. Or more loosely: it is better to
believe what is true than what is false. I don't mean that it is necessarily
morally better. Things can be better or worse, good or bad in different ways.
Clear writing is an aesthetic good; tasty food is a culinary good; and believing
true propositions, we might say, is a cognitive or intellectual good.

Truth Is a Worthy Goal of Inquiry

Values guide action. The value that, other things being equal, it is good to
keep my promises implies that I ought, other things being equal, to try to

keep my promises. The goodness of keeping one's promises gives me a reason for acting in some ways rather than others. So too with truth: it is good, other things being equal, to believe what is true, and intuitively, this gives me a reason to do certain things; most obviously, I should, other things being equal, *pursue the truth.* The goodness of believing what is true means that having true beliefs, like repaid debts or kept promises, is a goal worthy of pursuit.

That true belief is a goal worthy of pursuit does not mean that we pursue this goal directly. The pursuit of truth is in fact always indirect. This is because belief isn't something we have direct control over. We can't believe on demand. If you doubt this, command yourself to believe right now that you have a blue flower growing out of your head. Of course, you can straighten up, deepen your voice, and chant the words "I've got a blue flower growing out of my head," but that alone won't get you to believe it, for the fact is (at least I hope it is a fact) that you don't have a blue flower growing out of your head.

Nonetheless, we certainly do have *indirect* control over what we believe, and this is control enough. I can affect what I believe by putting myself in certain situations and avoiding other situations. That is, I can control how I *go about pursuing the truth,* by paying careful attention to the evidence, giving and asking for reasons, doing adequate research, remaining open-minded, and so on. In short, in saying that truth is a worthy goal, we imply that you ought (other things being equal) to adopt policies, methods, and habits of *inquiry* that are reliable, or that are likely to result in true beliefs. We ordinarily think that it is good to give and ask for reasons, good to be open-minded, good to have empirical evidence for one's scientific conclusions, because these are methods of inquiry that lead us to the truth. If we didn't value true beliefs, we wouldn't value these sorts of activities; and we value these sorts of activities because we think they will, more often than not, lead us to believing truly rather than falsely.

So we pursue true belief via engaging in inquiry. I am using the word "inquiry" here in a very general sense. I mean by it not just the methods for acquiring true beliefs I just mentioned, but all the various processes, practices, and activities we engage in when both posing and answering questions that interest us. This obviously includes both theoretical and experimental work in the various sciences, but also more mundane activities, like the sort of diagnostic tests you might run on your car to find out the source of the weird thumping noise it is making, or when one looks under the bed for a lost sock. When doing such things, we aren't happy with any old answer. Whatever else

we might want, we want the truth about the matters that interest us. So in inquiry, one of the things we are aiming at is having true beliefs, or truth, in short.

Intuitively, our second and third truisms are closely connected: since it is good to believe what is true, truth is worthy of pursuit, of being a goal of inquiry.

Truth Is Worth Caring about for Its Own Sake

Suppose I had a machine that allowed you to experience whatever you want. Once inside, floating in the tank, you live in a virtual reality of your own design—one filled with experiences of adoring friends, marvelous adventures, spectacular food, good sex, and deep conversations. None of it would be real, of course, but it would seem to be. It could even be arranged so that once inside the machine, you completely forget that you *are* inside a machine.

There is only one catch. Once inside, you can *never come out.*

Would you do it?

Most of us will probably say no. While we certainly wouldn't mind being in the machine for a few hours or even weeks, we wouldn't want to spend the rest of our life in a virtual world. Others of us, whose actual lives are filled with tragedy and poverty, might be more inclined to opt in for the long term. But even so, most would prefer having their problems truly disappear to living a life where they only *seem* to disappear. The machine produces beautiful illusions, but we want more than illusions. We want the truth, warts and all.

Scenarios like this are found throughout history and philosophy, not to mention contemporary culture. In the movie *The Matrix,* for example, the main character is given a choice between taking two pills. If he chooses one pill, he remains in a life of perfect illusion (supplied again by the ubiquitous all-powerful computer). He will not even remember that he made such a choice. Everything will go on as before. But if he chooses the other pill, he finds out the truth about his life and reality, a truth that he is warned will be unpleasant. He chooses, unsurprisingly to the audience, the truth.

Science-fiction scenarios like this are popular partly because in thinking about what we would do in such imaginary situations, we figure out what we care about. As I'll show more fully in a moment, reflecting on these sorts of situations, at least for most of us, suggests that we care about the truth for more than just the benefits it brings us. Of course, we don't necessarily need science fiction to tell us this. There are times in all of our lives when we simply want

to know for no other reason than the knowing itself. Curiosity is not always motivated by practical concerns. Consider extremely abstract mathematical conjectures. With regard to at least some such conjectures, knowing their truth would get us no closer to anything else we want. Nonetheless, if we were forced to choose between believing truly or falsely about the matter, we would prefer, at least to some tiny degree, the former. If we have to guess, we prefer to guess correctly. And of course, we sometimes care about the truth despite extremely impractical consequences. People often wish to know the truth about a spouse's infidelity even when there is an excellent chance that nothing productive will come of it. Similarly, many people wish to know when they are dying of a untreatable disease, even if they can do nothing to prevent it, and even if that knowledge has no practical value for their actual state of health.

The fact that we value truth for its own sake doesn't mean we don't also value it as a means to other ends. Indeed, the most obvious reason to pursue true beliefs is that believing the truth can get us all sorts of other things we want. Believing the truth is practically advantageous. Imagine crossing the street; looking both ways, you try to estimate the speed of approaching traffic. In making this and countless other decisions, you need to get it right. Otherwise bad things will happen, like getting run over by a bus. Believing the truth is valuable because it is a means to other ends—sturdy bridges, cures for diseases, and safety. We can sum this up by saying that truth is instrumentally good.

Many of the things we aim at in life, from money to legible handwriting, are *only* instrumentally good. We care about them not for their own sake but for what they can do for us. Most of us believe dollar bills are like this. Having dollars is good, no doubt, but only as a means to getting other things—a house, food, clothes, and the like. There is nothing valuable about the paper itself.

Something is *normative* if it is worthy of aiming at, or caring about. But something is *deeply normative,* or a value properly so-called, when it is worthy of caring about for its own sake. Love is arguably like this. Being in love with someone isn't good only as a means to other things. No doubt, it *can* lead to other goods (sex, contentment, a richer life, etc.), but that is clearly not the whole story. People value love even when it is highly impractical, or even detrimental to their pursuit of other ends. Love is worth caring about for its

own sake. Indeed, to love someone just because it gets you something you want arguably means that you don't really love him or her at all.

So one way of thinking about our fourth truism about truth is that truth is more like love than money. We—or at least most of us—care about truth, at least sometimes, for more than instrumental reasons. Truth is deeply normative; it is worth caring about for its own sake.

Of our four truisms about truth, this is perhaps the most contentious. Yet as I noted earlier, thinking about certain hypothetical situations can help you figure out whether you believe it. So let's think more carefully about the sort of imaginary situation I mentioned at the beginning of this section. In thinking about our reactions to such situations and what those reactions show, it will be helpful to proceed in steps. The first step is to see whether we have what I'll call a basic preference for the truth. By a "basic preference" I mean a preference for something that can't be explained by our preference for other things. Avoidance of pain is perhaps a basic preference; preference for money is not.

If truth was *not* a basic preference, then if I had two beliefs B1 and B2 with identical instrumental value, I should not prefer to believe B1 rather than B2. The considerations above already point to the fact that this isn't so, however. In particular, if we didn't have a basic preference for the truth, it would be hard to explain why we find the prospect of being undetectably wrong so disturbing. Think about a modification of the experience-machine scenario we began with. Some super neuroscientists give you the choice between continuing to live normally, or having your brain hooked up to a supercomputer that will make it *seem* as if you are continuing to live normally (even though you're really just floating in a vat somewhere). When in the vat, you will continue to have all the same experiences you would have in the real world. Because of this, you would believe that you are reading a book, that you are hungry, and so on. In short, your beliefs and experiences will be the same, but most of your beliefs will be false.

If we didn't really prefer true beliefs to false ones, we would be simply ambivalent about this choice. Vat, no vat; who cares? But we don't say this. We don't want to live in the vat, even though doing so would make no difference to what we experience or believe. This suggests that we have a basic preference for truth.

Some may protest that we want more than mere experiences out of life, and it is *this* fact—not any preference for truth—that makes us prefer the real

world over the vat. So consider another scenario, one dreamed up by Bertrand Russell. Suppose that, unbeknownst to us, the world began yesterday—it *seems* older, but it isn't. If I really lived in a Russell world, as I'll call it, almost all my beliefs about the past would be false. Yet my desires would be equally satisfied in both worlds.[5] This is because the future of both worlds unfolds in exactly the same way. If I believe truly in the actual world that if I open the refrigerator I'll get a beer, then I'll get a beer if I open the refrigerator. Since events in the Russell world are just the same as in the actual world once it begins ticking along, I will also get that beer in the Russell world if I open the refrigerator, even if (in the Russell world) I believe falsely that I put it there yesterday. In other words, whatever plans I accomplish now, I would also accomplish if the world had begun yesterday, despite the fact that in that case, my plans would be based on false beliefs about the past. Yet, given the choice between living in the actual world and living in a Russell world, I strongly prefer the actual world. Of course, once "inside" that world, I wouldn't see any difference between it and the real world; in both worlds, after all, events crank along in the same way. But that is beside the point. For the fact remains that thinking about the worlds only insofar as they are identical in instrumental value, *there is difference right now* between the two worlds that matters to me. Even when it has no effect on my other preferences, I—and presumably you as well—prefer true beliefs to false ones.

In preferring not to live in either the vat or the Russell world, I do not simply prefer that the world be a certain way. My preference involves my beliefs and their proper functioning, so to speak. For not only do I not want to live in a world where I am a brain in a vat, *I also don't want to live in a world where I am not so deceived, but believe that I am.* That is, if such and such is the case, I want to believe that it is, and if I believe that it is, I want it to be the case. We can put this by saying that I want my *beliefs and reality* to be a certain way—I want my beliefs to track reality, to "accord with how the world actually is"—which is to say I want them to be true.

Moreover, our preference for the truth is not just a *mere* preference—like a preference for chocolate ice cream. It goes deeper than that. That is apparent when I think about my attitudes toward my preference. Like many other people, I not only prefer the truth for its own sake, I also don't want to be the sort of person who doesn't—who would prefer the life of illusion. I want to be the sort of person, for example, who has intellectual integrity, who, other things being equal, is willing to pursue what is true even when it is dangerous

or inconvenient or expensive to do so. I not only desire the truth, I desire to desire the truth. I would no more take a pill that would make me ambivalent about living as a brain in a vat than I would choose to live as a brain in a vat. This suggests that my desire for the truth is not a mere passing fancy; it is grounded in what matters to me. I don't just prefer the truth, in other words, I *care* about it. Normally, the fact that we care about something is very good evidence that we find it worthy of caring about.[6] Accordingly, if you care about truth for its own sake, then you presumably believe our last truism, namely that truth is worthy of caring about in just that way.

This, then, is what I mean by saying we can learn about what we believe from these science-fiction stories: for many of us, our intuitive reactions to these cases suggest that we have a basic preference for the truth; that this preference matters to us; and thus that we believe that truth is worth caring about for its own sake. If you prefer not to live in the vat, or in a Russell world, then you implicitly accept that where the belief that p and the belief that not-p have identical instrumental value, it is better, just on grounds of truth alone, to have the true belief rather than the false belief.

Of course, none of this proves that everyone accepts this, or for those of us that do, that we are *right* to accept it. That is what the rest of this book is about. But it does show us where we stand.

Good Ideas and Bad

So here are our truisms about truth:

Truth is objective.

Truth is good.

Truth is a worthy goal of inquiry.

Truth is worth caring about for its own sake.

This is what I mean by saying that truth matters. I mean that beliefs that portray the world as it is are good and worth caring about, not only for their consequences but for their own sake. These truisms each remind us of something essential about truth and the role it plays in our lives. They remind us that truth, like courage or keeping a promise, is something philosophers call a thick sort of value: it has normative *and* nonnormative aspects. When we correctly describe an act as courageous, we are both describing it and evaluating it. We are commending it as something to be emulated, saying it is good and

so on, *and* describing it as an action that was done despite the danger of do-
ing it. Both are important and essential facts about courage. Similarly, when
we say that a belief is true, we are at once evaluating it—saying it is correct,
good, worthy of pursuit and so on, *and* describing it as portraying the world
as it is.[7] These are equally essential and interrelated facts about truth.

In defending the idea that truth matters, I'll be defending these truisms.
From experience, I know that reactions to them are often as wide apart as the
banks of the Mississippi River. Some of you will be saying, "well, duh" and
others will be scoffing so hard their heads hurt. But in truth, these ideas are
not really all that simple; nor are they hopelessly naive. They deserve serious
thought, and I think they are worth fighting for. Crucially, however, I *don't*
think that means that we must believe any of the following ideas, with which
our truisms are often grouped:

There is only One Truth.

Only "pure" reason can access the Truth.

Truth is mysterious.

Only some people can know the truth.

We should pursue the truth at all costs.

These are very bad ideas. As it turns out, three of the more common reasons
for rejecting our truisms—for cynicism about the value of truth, in other
words—are based on myths that confuse one or more of these bad ideas with
our truisms. Since these myths and confusions are as common as our truisms
themselves, it is important to get straight on them first. In part II, I'll discuss
some very different reasons for rejecting some of our truisms. These reasons
are less common, but more serious. They are based not on confusions, but on
bad theories of what truth is. After that, we'll be ready to tackle the really hard
question: *how* and *why* truth matters.

2 Is the Truth Unattainable?

Nightmare

The ancient Chinese philosopher Chuang Tzu once dreamed he was a butter-fly. Suddenly waking, he wondered: is he a butterfly dreaming he is a man or a man dreaming he is a butterfly?[1]

Chuang Tzu's question raises a disturbing worry. What if everything you've experienced up to now is just an illusion? What if life really is but a dream? The idea that we could be wrong about, well, everything, crops up all over the place—not only in the various religious and philosophical traditions of the world, but in literature, poems, and as I noted earlier, in lots of Hollywood movies. In the Western intellectual tradition, its most famous expression is by the sixteenth-century French mathematician and philosopher René Descartes. Descartes too wondered whether he could tell dreaming from waking life. But he one-upped the "could I be dreaming" scenario. For all I know, Descartes noted, an all-powerful but malevolent intelligence is fooling me into think-ing there is any physical world at all.[2] This is a more fearsome nightmare. Af-ter all, although dreams can be very lifelike sometimes, they tend to exhibit a characteristic lack of coherence. But an all-powerful jokester could make your experience of this book in your hands, the light in the room, your breathing, the feeling of a chair at your back, the view outside the window, and so on as coherent as you like, and you would be none the wiser.

You don't need Descartes's evil demon to generate this paranoid thought. Contemporary life in most Western countries is replete with technologies whose sole purpose is to disguise appearance as reality. Think of virtual real-ity machines, video games, holographs, Imax theaters, and the like. Our cul-ture's preoccupation with "escaping from reality" makes us all too willing and able to share Descartes's worry, and to spin off numerous variations, such

as the experience-machine we thought about at the end of the last chapter. So although the background story is different, the basic worry here remains the same as that entertained by Chuang Tzu or Descartes: how can we be *sure* that anything we believe to be true really is true?

A major root of this outlandish skeptical worry is the simple platitude that truth is objective. As I pointed out earlier, to accept the objectivity of truth is just to accept the obvious fact that we can make mistakes. Yet this innocent admission can give rise to a radical doubt: *if we can make mistakes, how do we know we aren't always making them?* And if I can never be sure, then what's the point of aiming for true beliefs in the first place? This point sums up a very common reason folks become cynical about truth and its pursuit: that it is so difficult to know what is really true that it seems worthless to even try.

It might seem that part of the problem is that our truisms about truth conflict with one another. The more objective truth is, the less it seems a goal worth striving for. As the philosopher and critic Richard Rorty says, objective truth isn't a goal, because "you cannot aim to do something, cannot work to get it, unless you can recognize it once you have got it."[3] Philosopher Donald Davidson adds, "Truths do not come with a 'mark,' like the date in the corner of some photographs, which distinguishes them from falsehoods. The best we can do is test, experiment, compare, and keep an open mind. . . . Since it is neither visible as a target, nor recognizable when achieved, there is no point in calling truth a goal."[4]

Does the fact that it is hard to recognize what is true mean that it isn't a goal worth striving for? The short answer is: of course not. The fact that the truth is hard to nail down doesn't mean that truth isn't a goal; it just means that the quest for truth isn't an easy one. But the reasoning behind this worry is worth examining, for it rests on myths and mistakes that our intellectual culture needs to put behind us.

A Map of the World

In 1507, the German cartographer Martin Waldseemüller put America on the map—literally.[5] Maps of the world were rare in those days, but even so Waldseemüller's *Cosmographie Introductio* was special, for it was the first to record that the New World was just that—a new world and not Asia, and that it consisted of two large land masses. Waldseemüller named the southernmost "island" after the explorer Amerigo Vespucci.

Waldseemüller's map is undoubtedly a major accomplishment. But it is also inaccurate. Two errors are particularly glaring: first, both landmasses of the "New World" are *extremely* narrow, far short of their real size. Second, the map erroneously shows a clear path to Asia around the top of the northern land mass—a wide-open sea separating North America and the North Pole. These errors partly reflect the limits of exploration at the time. But they also reflect something else entirely—the tendency of the human mind to color perception with preconception. At the time the map was made, European thought was gripped by the idea that there had to be a more or less direct ocean route from Europe to Asia. The discovery of landmasses in the way did not deter sixteenth-century geographers—or sixteenth-century explorers—from this view, for the simple reason that by following older Greek calculations, they had underestimated the size of the Earth. So rather than show blank spaces on the map representing a lack of information, Waldseemüller simply drew the landmasses as he—and most of his learned colleagues—assumed they had to be.

When we think about beliefs being objectively true or false, we are thinking of them as being similar to maps in certain respects. Like maps, beliefs represent the world as a certain way, and like maps, they are accurate, or true, when they represent that world as being as it is. But as the example of Waldseemüller's map shows, our beliefs, like our maps, aren't isolated from the rest of our prejudices and assumptions.

A well-studied phenomenon in the psychology of perception is that our background beliefs affect our ordinary everyday visual experiences of the physical world. Most of us have had the experience of a "gestalt switch" when looking at a famously ambiguous figure like Wittgenstein's "duck/rabbit" or the young/old woman drawing (see fig. 2.1). Given our background beliefs and dispositions, we initially see the figure on the page *as* a duck or *as* a rabbit, and we can have a very difficult time "stopping" ourselves from continuing to see it that way, even after we've had the other perspective pointed out to us. And of course, what holds for these "trivial" cases is even more obvious in other cases involving more complex concepts. When passing a young black male on the street, for example, some white people simply "see" him as dangerous, despite the fact that they have no reason to believe that that particular person is dangerous in any way. Northerners sometimes perceive a southern accent as expressing ignorance, men frequently perceive women as sex objects, and so on. In short, it seems that our experience and beliefs about the

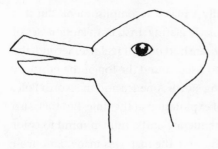

Figure 2.1
The "duck/rabbit."

world are much like Waldseemüller's map: they reflect our own preconceptions and beliefs as much as they reflect the way the world really is.

Immanuel Kant was perhaps the first philosopher to make the point that normal, full-fledged conscious experience isn't simply "given" to us by the world, but is rather partly shaped by our mind.[6] We assume that our mind more or less perceives the world as it is. Yet in actuality our habits of thought, the concepts we employ, color our perception of the world. It is as if our beliefs are a veil or curtain that we can see through—at best—rather hazily. Yet unlike Dorothy in *The Wizard of Oz,* we can't just whip aside this curtain and see reality as it is "in itself." The best we can do is experience it from our own human perspective, Kant believed. For our experience of the world is never pure and direct. It is modified by the structures and habits of our own minds.

One particular way of understanding Rorty's and Davidson's argument against the truism that truth is a goal of inquiry draws on Kant's point and applies it to beliefs. Suppose, for example, I form the belief that there is a computer in front of me. Now it is clear that I can't tell whether this belief is true by climbing out of my skin and checking whether there is a computer really out there. Any attempt to look and see whether it's there, according to our above reflections, involves some background beliefs and preconceptions on my part. So whether I like it or not, the best I can do, it seems, is rely on my other beliefs—beliefs about light in the room, the desk, my eyesight, and so on that confirm my original belief about the computer. Therefore, since I never confront the naked facts but only my other beliefs, I can't tell whether any particular belief of mine is really true or whether it just seems like it.

In sum, Rorty's and Davidson's argument seems to be this. If objective truth really is a goal of inquiry, then we should be able to recognize when we

reached that goal, that is, by recognizing when our beliefs are true. But the only way we could do that would be if we could compare our beliefs to the unvarnished facts. But we cannot do this. Hence truth can't be a goal.

The driving assumption behind this argument is that we can't recognize whether a belief is true or false unless we can compare it to the naked facts. But why should we think that? One reason would be if we were to accept an old-fashioned view of truth and representation that we might call the *looking glass view of the mind*. According to this theory, our mind is a mirror of sorts—our beliefs and ideas are true just when they "mirror" or "resemble" aspects of the world. This is an old idea, stretching back to the sixteenth-century and endorsed by various philosophers, including John Locke. Shakespeare makes the point most concisely:

Man, proud man,
Drest in a little brief authority,
Most ignorant of what he's most assured,
His glassy essence, like an angry ape,
Plays such fantastic tricks before high heaven,
As makes the angels weep.[7]

Mirrors often distort what they mirror. So if our thoughts are like little mirror images, representing things in the world by resembling or copying them, they too may play "fantastic tricks" on us, and reflect what isn't there. With real mirror images, or images like photographs, we check to see if they are accurate by comparing them to the real thing. But if all our thoughts are like this, we might think that we can only know what is true by somehow stepping around the looking glass of our minds and having some sort of "immaculate perception"—that is, somehow directly seeing that our beliefs resemble the world outside, without relying on any of our other beliefs. And of course we can't do this; unlike Alice, we can't go through the looking glass.

The looking glass view of the mind makes for good poetry, but it is not a very promising theory of truth.[8] For one thing, it isn't really clear how a mental state like an idea can resemble something out in the physical world. For another, just because something does resemble something else doesn't mean the first represents the second. The clouds outside my window may resemble Mickey Mouse, but that doesn't mean those clouds represent, or refer to, Mickey Mouse any more than they represent whatever they might look like to you. Accordingly, the mirror theory of truth shouldn't convince us that we cannot recognize when our beliefs are true or not. Indeed, quite the opposite: its problems suggest that we should instead give up on the assumption that

we can recognize whether our beliefs are true only by directly comparing them with the way the world is.

The most natural interpretation of what it means to "recognize when a belief is true" is that to recognize a belief as true or false is to either confirm that it is based on adequate grounds or note that it is not. This fits with our ordinary way of speaking: I catch an error in my thinking by catching an unsupported assumption, or by noting that I forgot to carry the one. In this sense of "recognize" I clearly *can* recognize when my beliefs are true or false—it amounts to noticing whether or not they are justified. In this sense, the truth is always pursued indirectly via pursuing beliefs that are justified—that is, by believing what is based on adequate grounds, on good reasons or evidence. To pursue the truth about who committed a particular crime, for example, involves assembling and rechecking the evidence, making sure the crime scene is not tampered with, questioning the witnesses, interviewing suspects, and keeping an open mind. Doing these things won't remove all bias, past experience, or the personal histories of the investigators. That is impossible. Unless she witnessed the crime herself, at no point can the detective simply "look and see" who is guilty and who is innocent by peering at the pure unadulterated facts—whatever that means (and of course, even "eyewitnesses" are frequently wrong). But that doesn't mean the detective can't pursue the truth about whodunit; it just means she has to do it indirectly, as do we all, by pursuing evidence that points at the truth.

There is nothing mysterious about pursuing goals indirectly. Consider investing in the stock market. When you invest, you aim at making money indirectly—by trying to make good, carefully researched investments. What makes an investment strategy wise is precisely that it is likely to lead to an increased profit. The ultimate goal of increasing one's wealth explains the more immediate goal of wise investment. Similarly, we value having beliefs based on good grounds because we think that doing so will lead us to the truth; what makes a justified belief good to have is that beliefs based on the evidence or on good reasons are likely to be true. If we didn't care about wealth, we wouldn't give a hoot about careful investing, and if we didn't care about truth, we wouldn't give a damn about justifying our beliefs.

As Davidson suggests, our beliefs don't wear dog tags identifying them as true or false. But it is simply a mistake to think that in order to recognize whether our beliefs are true—even objectively true—we need some sort of mysterious direct contact with the facts "in themselves." We recognize what

is true and false *indirectly* by recognizing, as we might put it, the *signs* of truth or falsity—that is, by recognizing what is justified and not justified.

Safety

So far, we haven't discovered any reason to think that the objectivity of truth takes it out of reach. But there is another move in the game; and this move is what lies at the heart of many people's misgivings about the value of pursuing truth.

Here is what someone might say: "You've pointed out that we pursue the truth indirectly by pursuing beliefs that are justified. But even the most highly confirmed beliefs, the ones that fit everything else we believe as tightly as we can imagine, could turn out to be false. Thus, we can never really be *absolutely sure* that any given belief of ours is really true. For all we know, we may never be hitting the truth target. So what is the point of worrying about whether our beliefs are true?"

This is the real worry, I think, behind arguments like Rorty's and Davidson's. That worry is not that we can't recognize when our beliefs are true in the innocent, indirect sense we just discussed, but that we can't ever be *certain,* via that method, that our beliefs are true. And if we can't be certain, the thought goes, then it is pointless to strive after truth.

The problem with this argument is that its operative assumption is false. The idea that the value of pursuing the truth rests on the possibility of certainty is simply a myth. To be certain of a belief is for that belief to be immune from doubt. More specifically, I am certain in my belief when I am justified in believing it and there are no grounds for doubting it. Yet certainty comes in degrees, because what constitutes a legitimate doubt depends on the situation one is in. We want the detective to be certain of her conclusions, but we don't require her to be absolutely certain, or certain beyond *all doubts whatsoever.* We require her to be certain beyond all "reasonable doubt." Thus in some cases, for example, when we are engaging in mathematics, or when we are building an aircraft engine using mathematics, our standards for certainty may be very high indeed; in others, like when trying to be certain about where we left our keys, our standards for what constitutes a reasonable doubt will be lower. But whatever standards we actually use, it is probable that they will always fall short of *absolute certainty.* Human beings are fallible. We stain the world with our sentiments, engage in wishful thinking, and forget to carry

the one. But being less than absolutely certain that something is true is typically certainty enough. We can therefore pursue what is true without trying to aim at absolute certainty.

A different way of appreciating this point is to see that in order to be absolutely certain that some belief is true, there must not only be no grounds for doubting that belief, I must moreover *know* that there are no such grounds. Thus being certain is often equated with knowing that I know.[9] But surely I can know something without having to know that I know. You can actively pursue the answer to a question without even having the wherewithal to have any sort of complicated higher-order thought about the answer you end up with. Very small children can know without knowing that they know. They can know about their immediate perceptual environment without having any particular thought about that knowledge (indeed, without even being able to spell "knowledge"). And consider the old fisherman who always knows where the fish can be found but is incapable of explaining how he knows. This needn't mean that he is just a brainless reliable indicator of the presence of fish. He doubtless has all sorts of intelligent skills and learned habits of mind that allow him to determine the best spot to drop a line. *He just may not be very philosophical.* If you asked him whether he was certain there would be fish around at that spot, he would probably say "yes" (or he might just get insulted). But that doesn't mean he is absolutely certain; nor does it mean that he is cares one whit about being absolutely certain. He is not, in all likelihood, aiming at being certain. He is aiming at finding fish. To put it plainly: I can know what is true without being certain, in the absolute, philosopher's sense, that my belief is right.

Not everyone agrees that we can know without being absolutely certain. Traditional skeptics, in particular, insist that knowledge does require certainty. But I won't wade deeper into that battle here. I am not concerned with defeating skepticism. My point is far simpler. It is that we can still treat truth as a goal of inquiry even if we can never be certain of reaching it. And *far from implying that truth is not a goal, taking skeptical doubts seriously requires that one assume that it is.* In support of the premise that I can never be certain of whether my beliefs are true, the skeptic points out that I can't rule out the possibility that they are mistaken for some reason. But this argument presupposes not only that false beliefs are bad and thus to be avoided, but that I can recognize when a belief of mine is false. If I couldn't recognize that a belief was false, I wouldn't be able to understand the skeptical possibilities that moti-

vate the skeptic's argument. And if I didn't care to avoid what's false I wouldn't give a hoot about the skeptical arguments even if I could understand them. So in order to take the thought that everything you believe could be false seriously, we assume, first, that we can recognize—at least hypothetically—the difference between true beliefs and false beliefs. Second, we assume, at the minimum, that not having true beliefs is bad. And if not having true beliefs is bad, it is so because pursuing truth is good. Bluntly put, the very fact that we do worry about pursuing the truth is what makes the skeptical worry so disarming—if it wasn't, we would not find the prospect of not knowing it so troublesome.

Skepticism is the Janus face of our concern for truth. The very fact that objective truth is a goal of our inquiries is what opens the door to skepticism, and vice versa. The possibility that we could be wrong implies that truth is independent of our beliefs; and the objectivity of truth in turn implies that we could always be wrong. Ultimately, what this shows is that to the degree we think truth is not of our making, we must also think that we could miss finding it. To paraphrase William Blake, I may never be able to throw off the mind-made manacles of culture and see how the *world* really is and encounter the naked *truth*. But from this fact alone it does not follow that it is pointless to pursue believing what is true.

While I think the above points are sufficient to dispatch the philosophical worry about truth's being a goal of inquiry, they don't, I think, get at the core motivation for why people so often collapse the value of certainty with the value of truth.

People fear uncertainty. Without some certainty, some assurance that somewhere, sometime, somehow, we believe the real truth, we fear that we will have no basis for any of our beliefs. We want certainty because we want safety. We fear that if certainty is dead, everything is permitted.

This is perfectly understandable. We want to be sure of something before counting on it. We want to test it, experiment with it, and give it a trial run. This makes good sense, but we needn't strive after absolute certainty to do this. Absolute certainty is impractical and probably impossible. But as I've argued, this doesn't have anything to do with truth. We can acknowledge the frailty of the human condition and still go on pursuing truth.

There *is* an important lesson in skepticism. Certainty is the privilege of the fanatic. The most dangerous man is he who is certain, absolutely sure, that his way is the right way. Once you feel you are absolutely positively unable to be

mistaken, you feel justified in not listening to questions, or considering the other side. You are just right, and anyone who disagrees is just wrong. This is dogmatism. Much harm could be avoided if people were less dogmatic, if they worried a bit more about whether they were right before acting. In other words, we might all be better off if we worried more, not less, about whether our beliefs were true.

We may never be absolutely certain of anything. Yet being aware of this fact can be a good thing, even though it may be a bit frightening. And it in no way shows that the pursuit of truth is meaningless. The fact that we even worry about whether we ever believe the truth actually shows that it is goal at which we aim.

3 Is Truth Relative?

Man Is the Measure

Relativism, almost more than any other philosophical topic, gets people riled up. Discussions of it pepper the Internet, fill op-ed pages, and crop up in the Pope's encyclicals. Opinions differ, to put it mildly, running from Stanley Fish's declaration that relativism "is just another name for serious thought" to the conviction of conservative critics Allan Bloom and Robert Bork that relativism threatens to end Western civilization as we know it.[1]

Relativism about truth is nonetheless an idea with a venerable history, whose original champion, at least in Western culture, is usually thought to be the Greek philosopher, Protagoras. According to Plato at least, Protagoras believed that man is the measure of *all* things—be they values or the more mundane objects of everyday life. Plato interpreted this as an endorsement of the view that truth in general is in the eye of the beholder, or is relative. Nowdays, it is more common to encounter endorsements of relativism outside of philosophy departments. Indeed, the idea, or at least what appears to be the idea, has taken root across the intellectual spectrum—in anthropology, sociology, the humanities, and religious studies. By that standard, Protagoras's idea is one of the most successful philosophical theories of all time.

The "über thought" behind relativism is that different opinions can be equally true relative to different standards. Interestingly, relativism is often motivated by some of the same things that motivate skepticism. People disagree about almost everything. And about some things, like religion, or politics, or morality, their disagreements are so wide and deep it can be difficult to find any common ground. Add to this the point we noticed earlier, that our thoughts and perceptions are likely to bear the imprint of our biases,

background assumptions, and expectations, and we arrive at the following premises:

(1) People have different beliefs about what is true.

(2) There is no way of stepping outside of our beliefs and checking to see whose are objectively true.

From these premises, *skeptics* conclude that there is some objective fact of the matter about who is right and who is wrong, but that we just can't find out what it is. Relativists draw a different conclusion: not that we can't know what is true, but that there simply isn't any objective truth to know. Truth is always truth in context; what is true for one person might not be true for another.

Despite the hostility that debates over relativism generate, many relativists and their opponents seem to agree on one thing. What they agree on is that *if* relativism really is the truth about truth, then truth doesn't matter. If truth is relative to culture, some believe, then it is culture that matters, not truth. This is seen as terrifying to some, liberating to others.

Unsurprisingly, the extremists on both sides are wrong. Relativism is not necessarily a threat to truth's value. The common temptation to think otherwise is the result of another myth: that truth matters only if it is absolute. But like the fable that truth can't be a goal unless we can be certain that we've reached it, we need to see beyond this fiction. One can grant that some truths are relative without implying that having true beliefs is not important, or a goal of thought, or worth caring about for its own sake. This is not to say that there aren't versions of relativism that do have these, and worse, implications. Some relativist views, as we'll see, *are* crazy. But not all are. When it comes to relativism, my advice is to roll up your sleeves, make the necessary distinctions, keep the good, and discard the bad.

Simple(minded) Relativism

Philosophers have been busy refuting relativism about truth ever since Plato. This is deceptively easy when the target is the idea that truth is relative to the tiniest perspectives, like a single individual. Truth, on this position, is something like "truth for me." Call this *simple relativism.*

Here's why simple relativism is so simple to refute. Suppose I am such a relativist and announce that there is no such thing as truth *per se,* there is only truth-for-me or truth-for-you. A fair question to ask would be whether the

statement I just made is true or just true-for-me. If I say that relativism is simply true, then I have apparently contradicted myself. For if relativism is true (for everyone, as it were) then it is false—it is not true that *all* truth is relative. On the other hand, if I go the other way and say that relativism is only true relative to me, I am consistent but unable to convince anyone who doesn't already agree with me. You need only remark that relativism is not true for you, and therefore false. Simple relativism, therefore, is either contradictory or terminally unconvincing.

Whether a relativist would accept this little argument, I am unsure; perhaps simple relativists don't care about convincing anyone to be relativists. But there is an even simpler problem with simple relativism. It is this. Simple relativism implies that *all* my beliefs are true. For if truth is truth-for-me, and since everything I believe is true for me (or I wouldn't, obviously, believe it), everything I believe, according to the theory, is true. I never make mistakes. How convenient!

This last point is the damning one. If there is one thing I know, it is that I don't know everything, and no theory that says otherwise can be true *or* true for me.

One reason that people sometimes favor relativism—even simple relativism—over objective theories of truth is the sense that that relativism encourages greater toleration. The thought that there is Truth out there with a capital "T" often goes together, relativists have pointed out, with the conviction that some people have privileged access to the truth and others don't. Just this sentiment was the hallmark of nineteenth-century Western colonialism, when missionaries worked with the armies and police of colonial governments to force people to believe, or at least say they believed, what the colonialists wanted them to. But if there is no such thing as objective truth, then no one occupies a privileged position on the truth. We can no longer justify forcing people to believe in our gods by saying that we know the truth and they don't. Abandoning the idea of objective truth seems to encourage a more tolerant outlook on life.

Concern for toleration is apt and important. And many people who have believed in objective truth have been intolerant. But it is a confusion to think that a belief in objective truth necessarily implies a lack of respect for other ways of life and other types of beliefs. The cause of intolerance is not objectivity but dogmatism. It stems from a sense that one can't be wrong. Many people do indeed think that they (and they alone) know the real truth, whether we

are talking about God, apple pie, or the New York Yankees. It is depressingly common for people to think they personally know what the truth is on any subject. But as I've already argued in the last chapter, one needn't believe that we know anything for *certain* to think that there is objectivity. The degree to which we believe there is objective truth about some subject is the degree to which we must admit that we can always be wrong about that subject— which is to say that we cannot be certain that our beliefs about it are correct. If truth is objective, then we must always be open to the possibility of being wrong. Thus respect for others should lead us to be careful about claiming that we know anything for certain, and that means believing that truth is more than just truth-for-me.

Simple relativism, were we able to make complete sense of it, would obviously undermine truth's value. If everything you believe is true anyway, there is not much point in saying that you ought to believe the truth. There wouldn't be much point in talking about truth at all. A basic point of even having a truth concept, as I argued earlier, is to help us evaluate some statements as right and as others as wrong. But if no one ever makes a mistake, such a concept would be pointless.

Luckily for us, simple relativism is simpleminded. Not every belief is true. Some are false, as attested by anyone foolish enough to believe simple relativism.

A closing point. Conservative critics often write as if simple relativism was the scourge of the Western world. They portray all college students, for example, as being brainwashed into this type of relativism by wild-eyed professors whose politics are somewhere to the left of Castro's. And philosophy professors, who hear what seem to be endorsements of simple relativism all the time from their students, sometimes call it "freshman relativism." In fact, simple relativism appears more popular than it actually is. It is true that in ordinary conversation, questions about morality, art, or politics are usually referred to as "matters of opinion." We might also call them "who's to say" issues, given the ubiquitous use of that phrase when such issues are brought up (as in: shrug, followed by "who's to say?"). The funny thing about such questions, of course, is that we all *do* have opinions, and passionate opinions, about them. The death penalty, gay rights, arms control—we care about these issues. Thus in asking "who's to say" we answer our own question: *we are.* Further, we all recognize that there can be better and worse opinions about any of these subject matters—some opinions are simply better informed, more

coherent, or just darn well more interesting than others. We even think that some opinions (2 plus 2 equals 4) are true and others (humans are invulnerable to bullets) are false. So why are so many of us apt to announce that they are not "matters of fact" but "matters of opinion" and assume that this means that truth is relative? Part of the reason is simple: when someone says that "this is true for me," they don't necessarily mean to be endorsing a philosophical position. The phrase "it is true for me but not for you" is most often just shorthand for: "I believe it, you don't, so let's talk about something else." Similarly, the phrase "it is a matter of opinion" is a conversation-stopper, a way of getting out of a debate one doesn't want to be in. This desire is often a very good thing, but such conversation-stoppers sometimes prevent us from having reasoned discussions about the issues that matter most. And they encourage us to think we are saying something deep ("truth is relative") when really we are doing no such thing. At best, we are either stopping the conversation, or trying to express (in perhaps a less than felicitous way) the idea that everyone is entitled to his or her own opinion. But of course, the fact that one should allow other people the opportunity to speak their minds and (to as great a degree as possible) practice what they preach doesn't entail that no one has ever been wrong about anything.

So don't assume that people are simple relativists because they attach qualifications to their opinions. This is a point that those who like to blame relativism for everything from a decline in voter participation to the popularity of *South Park* would do well to keep in mind. Simple relativism is a bogeyman; it is incoherent and believed by few if anyone. I turn now to a more serious, if still extreme, form of relativism.

Truth as Power

Nowadays, when one hears talk of "relativism," a discussion of "postmodernism" can't be far behind. This is unfortunate, for thinking that one can clarify relativism by talking about postmodernism is a bit like thinking one can clarify "democrat" by talking about "liberal." Both terms are multiply ambiguous. Nonetheless, for good or ill, PoMos (as postmodernists are sometimes called) are more associated in the public eye with relativism than any other sort of philosopher. As a result, they merit careful consideration.

Pretty much everyone admits that it is impossible to define postmodernism. This is not surprising, since the word's popularity is largely a function

of its obscurity. It was popularized by North American academics who used it as a catchall for theoretical movements ranging across art, philosophy, literary criticism, architecture, and theater. Forced to say something general about it, I often appeal to Jean-François Lyotard's rough and ready statement that postmodernism is incredulity toward metanarratives.[2] A "metanarrative" is a sort of universal truth-detecting standard, a transcendental theory or framework that can be used to judge or evaluate all other theories and frameworks. As Stanley Fish notes, most postmodernists tend to think that there is no such thing, no "standard of validity and value that is independent of any historically emergent and therefore revisable system of thought and practice."[3] There is no "God's-eye point of view" or view from nowhere because the very idea of a view from nowhere doesn't make sense. Human thought is situated in context, and it is that context that shapes our thinking.

The problem with these characterizations is that, depending on their interpretation, it can be hard to see who would disagree with them. Taken alone, for example, the idea that "human thought is situated in context" would be endorsed by many philosophers who would not describe themselves as postmodernists. Similar problems arise even when we turn to the claims of one of the intellectuals most widely associated with postmodernism, the French historian and philosopher, Michel Foucault. Foucault's work is complex and wide ranging, and I won't offer anything but the most passing summary here.[4] The key to Foucault's thought is his view that knowledge isn't the product of lone individuals working in the lab, but the result of a whole series of processes working within cultures and societies at large. In modern Western societies, Foucault argues, what comes to be labeled "knowledge" isn't so regarded simply because it has been verified by a disinterested truth-seeker. Behind the scenes, as it were, is an entire system of institutions and power relations that constrain and develop opinion. It is these power relations that shape our views more than anything else.

This is more than just a little plausible. Well into the modern period it was accepted by the scientific establishment that those of the "Negro race" were inherently intellectually inferior to white Europeans. Samuel George Morton's wildly inaccurate measurements of skull capacities led many in the nineteenth-century scientific community to believe it was "proven" that Caucasian brains were larger than the brains of blacks and thus that Caucasians were more intelligent.[5] Louis Agassiz, for example, the leading paleontologist of his day and one of the discoverers of the Ice Age, announced in

1847 that it was a *proven scientific fact* that "The brain of the Negro is that of the imperfect brain of a seven month's infant in the womb of a White."[6] Only the extremely naive would think that the acceptance of this and similar "truths" by so many was simply imposed, as Agassiz and Morton apparently believed, by the scientific data. Rather, the explanation for its acceptance can be seen, among other things, in the fact that Morton and Agassiz were racists, that all the scientists involved were white males, the enslavement of Americans of African descent, the need to justify the treatment of those slaves, the need for cheap labor, and so on. These and other social factors helped to shape the background assumptions presupposed by nineteenth-century social scientists, which engendered their beliefs about race, and which helped to establish them as "knowledge" for the mostly white culture at large.

It is no longer news that prejudice, fear—indeed one's entire worldview—affect what we believe. This, after all, was the point of our discussion of Waldseemüller's map in the previous chapter. As we saw there, the idea that our concepts and habits of thought mold our experience goes back at least to Kant. Foucault's contribution was to point out that our concepts themselves are also affected by sociological forces, "regimes" or "disciplines" of power that are always at work behind the scenes. Pick up a paper, listen to the radio, write down notes in a college course, and you are forming opinions against a background of assumptions about how information and knowledge is and should be distributed, manufactured, and protected. These assumptions shape what you and I think about what does and doesn't make sense, which standards should and shouldn't be employed to judge the truth, and what should be accepted without argument and what shouldn't. This suggests, Foucault argues, that we need to reexamine what "truth" itself means. In his view, traditional theories of truth, such as the correspondence theory, fail because they miss the most fundamental issue about truth: truth's relation to political power. In contrast, he suggests that truth "be understood as a system of ordered procedures for the production of, regulation, distribution, circulation and operation of statements."[7] This system is "linked in a circular relation with systems of power which produce and sustain it," such as the scientific community, the government, and the media.

A tantalizing view, surely; but it is difficult to know exactly what Foucault is advocating. Is he pointing to the fact that politics holds sway over what we believe is true? This is true and extremely important, but it doesn't amount to a view about the nature of truth. Thus many have taken Foucault to be pushing

a more radical thesis: that truth *just is* power. Beliefs aren't powerful because they are true; beliefs are true because they are powerful. On this interpretation, Foucault's point is that there simply are no objectively true statements in the usual sense; there are only statements that are accepted as true in a particular community at a time. Truth, as Barry Allen has put it, is what passes for truth. And what passes for truth is determined by the hegemonic systems of power.

I'll call the view just sketched *postmodern relativism*. Despite his reputation as a high priest of relativism, it is not really clear that Foucault himself endorsed the view. During an interview near the end of his life, for example, he noted, "If I had said, or wanted to say, that knowledge was power I would have said it, and having said it, I would no longer have anything to say, since in identifying them I would have had no reason to try and show their different relationships."[8] This may indicate a change of heart (the "no relativists in foxholes phenomenon"). But it may also indicate that Foucault just isn't interested in the metaphysical question of the nature of truth because he thinks that truth isn't the sort of thing that has a "nature" (a view that we'll look into later). Or it may indicate that his real interest is just historical, in what *causes* us to believe that this or that is true.

In any event, I am going to put these interpretative issues to one side. I'm more interested in whether postmodern relativism makes sense, than in whether or not Foucault is an official advocate. Let's tidy the view up a bit in order to get clear about what is being claimed. According to postmodern relativism, a belief is true just when it passes for true or when it is *justified relative to the standards accepted within the culture or community—the systems that account for how statements are created, distributed, and regulated.* But which standards of evidence, reasoning, testimony, and so on are accepted depends on the beliefs of the people within that community. More precisely: it depends on the beliefs of certain groups within that community—those that control the "regimes" or systems of power at work in that community. In effect, we (if "we" are lucky enough to be the ones in power, that is) decide what counts as proper justification, and so, indirectly, we decide on whether the belief, say, that Oswald shot J.F.K., is properly justified. If it is justified by those standards, it is automatically true.

This is a *slightly* less subjective view of truth than simple relativism. On the view in question, truth is relative not to individuals, but to standards of evidence created by the institutions and systems of power operative within a

culture. As a result, the view avoids some of the weirder consequences of its simpler cousin. Individuals can be mistaken about what is true or false, because they can be mistaken about what is accepted by the systems or regimes that govern them. If the standards of justification within my community decree that Oswald acted alone, then I'm wrong if I believe otherwise. Similarly, everyone's opinions won't be true, and it is possible for individuals within the system, so to speak, to disagree about what is true or false.

Nonetheless, postmodern relativism is no more tenable than simple relativism. First, there is the pedestrian point that the view misrepresents what we mean by the word "true." Ordinarily, we think that what is once true is always true. But consider: if truth can be nothing more than what passes for truth, and what passes for truth is constituted by systems of power, then as those systems change, so does the truth. It follows that in the American South of the 1960s and '70s, African Americans really were morally and intellectually inferior to whites because that was the view of the white political power structure at the time. But this is unintuitive: surely such racist views were false then *and* now.

Perhaps the postmodern relativist will reject squabbles over what we ordinarily mean by the word "true" as irrelevant. But that doesn't matter; for the real problem with postmodern relativism is not that it misdescribes our concept of truth. The real problem is that it pulls the rug out from under the feet of any attempt to rationally criticize the political systems of power in one's own culture. This is ironic, for many postmodernists see themselves as engaged precisely in such criticism.

If truth is what passes for truth in one's culture or system of power that regulates that culture, then a critic's statements can be true only if they pass for truth in that system. Now either (a) these statements pass for truth in the system they attempt to criticize, or (b) they don't, because they are part of another, radically different system. Neither alternative seems to allow for meaningful social criticism.

Start with option (a). If Martin Luther King's criticisms of American views on race already passed for truth among the systems of power that regulated his culture, then he wouldn't have needed to make them. At worst, whites would have presumably been ignoring truths relative to standards already in front of their face. They would be convicted of inconsistency. This is something; catching Americans or anyone else in inconsistencies is important and

good sport to boot. But inconsistency hunting does not exhaust meaningful social criticism. Sometimes the point is to change people's minds by getting them to see *new* possibilities and *new* truths.

Now consider option (b): that social criticism must always be from the standpoint of another system. What is widely acknowledged in African American culture (e.g., that the police don't as a rule treat people of different races equally) may not pass for truth in white American culture. But if truth is what passes for truth in my culture, then presumably both cultures are right about this issue. Cops both do and do not treat people fairly by race depending on whose culture you speak from, and there is nothing else to say. If so, then how are we to understand an attempt by a member of one culture to convince a member of the other culture? After all, views inconsistent with our own will automatically pass for false in our culture. This is the problem behind option (b). If social criticism emanates from a different cultural perspective than my own, then we are back to where we were with simple relativism: everyone is right, no one is wrong. But this is not an attitude likely to engender social change. For if we push on and try nonetheless to change the minds of those in the other culture, what is it that we are doing, according to the postmodernist? Apparently nothing more than simply opposing one system of dominance with another. This threatens to collapse any distinction between rational persuasion and ruthless manipulation.

The only way to get around this uncomfortable consequence is by admitting that communities, cultures, and so on can share certain truths. Perhaps there are some beliefs that pass for truth in every culture, and these beliefs can be used as bridges to build consensus across communities. This is promising, but it is not clear that postmodernists would accept it. For to accept that some beliefs pass for truth everywhere seems to run against the anti-universalist flavor of postmodernist thought. More important, the gambit would not save postmodern relativism even if it were accepted. For on the view in question, a belief passes for true, roughly, when those in power in the culture believe it. But as the Martin Luther King example suggests, this leaves no room for criticism from the disenfranchised within a particular culture. If you have a belief that is contrary to the beliefs of the powerful, you are simply wrong, and that is that.

Now, if there are two things I know, it is that I don't know everything, and neither do those in power—at least those in power in *my* community. Any view that says otherwise should be rejected—and not just because it violates

the truism that truth is objective, but because it undermines the point of even having a concept of truth. Having a concept of truth allows us to make sense of the thought that a claim, no matter how entrenched in one's culture, no matter how deeply defended by the powers that be, may still be wrong. As I'll argue in greater detail later, the distinction between truth and what passes for truth is necessary in order to make sense of speaking truth to power. And this is something, surely, that we need to do.

Relativism without Nihilism

So far, relativism seems like bad news. The versions we've discussed make truth depend on what people believe and undermine the value of having true beliefs. But there is still something right about relativism too. Relativism emphasizes the importance of context; and context does matter. Further, relativism also leaves room for a sort of pluralism. And pluralism is appealing. Sometimes at least, there can be more than one true description of reality. And yet we don't want to say that every story of the world is equally true. We want to say that in the game of truth, there are ties for first place, but there are also losers. We want, in other words, some aspects of relativism without sliding into nihilism.

This is not as hard as it sounds. Think back to the discussion of maps from the previous chapter. Maps, we saw, are products of the context—of our interests and assumptions—as much as they are products of the landscape they are about. One way in which our interests and concerns shape our maps is by determining what it is our maps map. The most obvious example of this concerns a map's specificity. A crudely drawn sketch in the sand would be good enough to tell you the layout of my neighborhood in order to give you directions from a nearby highway, but it won't do for purposes of surveying legal property boundaries. Both maps are equally good relative to the interests that motivated their making. But our contributions don't stop with the determination of a map's scale and relative precision. When making maps, we must bring to the table a host of conceptual choices. We have to decide what counts as a mountain, and what a hill, where the valley ends and the mountains begin, and the difference between a bay and a gulf. And obviously, different people can make different decisions about these matters, between which there is no clear objective way of choosing. Nonetheless, once a decision is made about what counts as a mountain, or hill, or bay, or whatever, there will

be objective truths about where the mountains and hills are located. Yet it also remains the case that our choices shape the map. There is more than one true map we can make of the world, for the world does not simply map itself; and it tolerates more than one way of mapping it.[9]

So one way that context affects mapmaking is that our choices determine what a map maps. But context comes into play in another, deeper sense as well. Even when our conceptual choices are already made, the context can determine the way in which the map is accurate. This is because there are different types of maps. A nautical chart of a coastline is one thing; a map showing average population densities of various U.S. states is another. The chart showing the coastline is accurate insofar as it corresponds to the actual physical shape of the coastline. Sailors depend on this being the case. But the map of population densities doesn't "correspond" to any particular physical objects in this way, partly because it does not represent that sort of thing. What it represents is a certain mathematical ratio—average population densities over broad, legally defined areas. Both maps may be accurate, but the manner in which they are accurate is quite different. In this way too, there can be more than one true map of the world, because there is more than one way for a map to be true.

Both of these lessons apply not just to maps, but to our representations of the world in general, including our beliefs. The contents of our beliefs, like the contents of our maps, are determined, at least in part, by the concepts we have at our disposal.[10] How we sort the world, how we categorize it into groups and categories, depends on our conceptual choices. Imagine I asked you to count *all* the objects in my living room. If you take the task seriously, you would first have to ask me what counts as an object. Are the desk and the books on it counted as one object or many? What about the stereo system and its components? The motes of dust under the shelf? The atoms that make up everything else? Given what I mean by "object" these are all perfectly good examples of objects, and thus could be included in your total.

Significantly, which concepts I have is not just a matter of personal whim— my interests, gender, race, culture, form of life, my entire worldview, in short, all affect how I think about the world. This the postmodernists get exactly right. But as we saw in the case of the conceptual choices that affect our maps, *this point alone doesn't have anything to do with truth or accuracy.* Given a particular conceptual scheme, it isn't up to us how many objects there are in the room, or in the universe. This is because at root, our conceptual choice determines what we believe, not whether our beliefs are true.

Yet, as with maps, there is another, deeper sense in which context can affect our beliefs about the world. Just as there are different types of maps, there are different types of belief. Think of all the things I can believe: that there is a very tall spruce in my front yard, that two and two is four, that stealing is wrong and also illegal, that pointing with the middle finger is rude, that Napoleon lost the battle of Waterloo, that Microsoft is a powerful corporation, that a gun can kill a person. All these beliefs are true, but intuitively, how we understand their truth differs. Take my belief about the spruce in my front yard. While we humans can decide whether we are going to call that thing a spruce, or even a "thing," we don't just create spruce trees by naming them. If my belief that there is a spruce in my yard is true, then it is because there is a spruce actually in my yard. The existence of the spruce is what makes that belief true. Similarly, we can't seriously maintain that we can just make ourselves invulnerable to bullets, or that diseases won't hurt us, or that the ozone layer will just fix itself. When it comes to beliefs about the physical world, in other words, it is difficult to deny the thought that what makes our belief true that x is F is whether that belief is responsive to x's actually being F.

Yet when it comes to the human-made world, the world of stock markets, corporate mergers, politics, and perhaps even morality, it is more difficult to find, or even conceive of, mind-independent objects to fit our thoughts. Here it seems we can't just look and see what is true or false, and our desires and conceptual prejudices more clearly affect the very nature of what it is we are thinking about. Yet talk about these sorts of things is as susceptible to truth and falsity as talk about mountains and mongooses. We can make mistakes, and big ones, about economic, political, and moral matters. And as I emphasized earlier, to admit that we can make mistakes about a subject is tantamount to accepting that our thoughts about that subject can be objectively true or false. Thus, in some areas, our beliefs can be true or false, but their truth and falsity seems to have little to do with the behavior of various mind-independent objects. In such cases, we are more prone to think that we have much more latitude in our conceptual choices, and that the world more willingly tolerates different descriptions. We think that context matters more.

These reflections encourage us not to overlook the simple thought that perhaps *truth doesn't always come in the same form*. The views we've been discussing in this chapter ignore this possibility. Ironically, they are not just relativist, they are absolutely relativist. They say that all truth—even the truth about truth—is relative. As we've seen, that is a bad idea. It not only runs into conflict with the truism that truth is objective; it underwrites a

nihilistic attitude toward the value of truth. But perhaps we can reject these views while still keeping what is right about relativism. Some truths may be more dependent on the vagaries of context than others.

Here's a quick example: propositions of law. These are the various claims made about what the law requires or allows, including both general claims, such as the proposition that segregation is illegal or that the law protects flag burning, and specific propositions, say, that Exxon must compensate Alaska for an oil spill. Propositions like this are surely capable of being true. When we hire lawyers, we expect them to say *true* things about the law, both to us and in court. And yet propositions of law clearly aren't true in the way that propositions about spruce trees are: they don't correspond to something concrete and mind-independent called "The Law." It seems more likely that propositions of law are true because they fit or cohere with a particular *system* of like propositions—*the body of law*—and false when they don't fit with that system. If something more like this is right, then it would make sense of the fact that laws are social constructs par excellence. We make laws, and different communities make different laws depending on their citizens' interests, background, and attitudes. Whether it is legal to buy alcohol, or carry a handgun, depends on where you are. As a result, while legal truth is objective in that we can make mistakes about what does or doesn't fit with the body of law, it is also relative—whether an action is legal or not depends on the system of law in question. In this sense, the pluralist intuition behind relativism I noted earlier seems apt with regard to the law: there can be more than one true description of "legal reality"—of what actions are legal and what are not.

Just what account of truth would be right for legal propositions is, of course, a complicated matter; but it is clear that neither simple relativism nor a strongly objective theory of truth would be quite right. As I've suggested, some form of what Brian Leiter has called a "moderately objective" view of the law seems more appropriate.[11] Whatever the right theory turns out to be, however, my point is that in rejecting relativism, we should not throw the baby out with the bath water. As I put it earlier, when a belief is true it has a certain job to play in our mental life. An important part of that job is to portray the world as it is. So to care about truth, roughly, is to care about having beliefs that do that job. This shouldn't diminish when the way the world is, and therefore how it is correctly portrayed, reflects our own activities and interests—as, I've suggested, may be the case with the law. There too we will care about believing what is true—it is just that how the job of true believing gets done may vary. In some contexts, truth may be more contextual.

4 The Truth Hurts

Dangerous Knowledge

On July 16, 1945, the mushroom cloud of the first atomic bomb stained the desert sky outside Los Alamos, New Mexico. The director of the Manhattan Project, J. Robert Oppenheimer, later recalled that he had been struck at the time by the words of Krishna from the Bhagavad Gita, "I am become death: the destroyer of worlds."[1]

Knowledge is power, and if power corrupts, then as Oppenheimer's soulful lament suggests, absolute knowledge may just corrupt absolutely. The truth can hurt. Nuclear weapons research is a classic case of the perils of its pursuit, but there are other examples. Currently, human cloning and genetic research are hotly contested on the grounds not only that they may lead to knowledge that could ultimately be more harmful than beneficial, but that they may lead to knowledge that is, in some sense, intrinsically bad or not fit for humans. Similar questions are raised about research on human embryos, genetically altered foods, and even space exploration. And we don't need to appeal to science to see the point either. Pursuing the truth at all costs can be perilous in everyday life. People often seek the truth about things of which, in some cases at least, they might be better off ignorant: spousal fidelity, the identity of one's biological as opposed to adopting parents, even, in some cases, their health.

The pursuit of truth can be harmful even when the information that is pursued isn't. During World War II, Nazi scientists performed horrible scientific experiments on Jews enslaved in concentration camps.[2] Among the awful experiments conducted were some meant to measure how long a human being could survive in cold water before freezing to death. The Nazi scientists conducted these experiments by immersing helpless prisoners in waters of different temperatures and then observing them until they died. The Nazi scientists

supposedly believed this was a means to discovering the truth about human capabilities for survival. But it was also, obviously, horrendously wrong. There are other examples. Beginning in 1932, in Tuskagee, Alabama, 399 African American men with untreated syphilis were studied without their consent in order to chart the progress and impact of the disease on the human body. Despite the discovery in the 1940s that penicillin was an effective treatment for syphilis, treatment was withheld from the men without their knowledge for forty years. The scientists involved in this research, for the Public Health Service's Division of Venereal Diseases, did not see this as a bad thing; like some of the Nazi scientists, many of the researchers involved thought of themselves as simply working for the glory of knowledge. They were pursuing truth.[3]

Knowing how a disease progresses and damages the body is an important piece of information, just as knowing how long a person can survive in cold water is an important piece of information. These things would be good to know, presumably, but not at all costs. Knowledge is not that glorious.

I've claimed that truth is a goal worth pursuing. But examples like the above suggest that neither the truth nor its pursuit may be as good as they are cracked up to be. Indeed, the one thing people never tire of reminding me of whenever I claim that truth and its pursuit are good is that there are many times when they aren't. The truth can hurt and falsity can have its own rewards. But these exceptions hardly show that true belief isn't good and therefore not worth striving for. They are the exceptions that prove the rule.

Exceptions That Prove the Rule

The simplest reason truth is worth pursuing is because believing the truth is good. There are two ways something can be good. First, it can be absolutely, indefeasibly good, or good *all things considered,* or good no matter what the context. Not too much, if anything, is *that* good. Second, it can be *prima facie good,* or always good considered by itself, or defeasibly good, or good other things being equal. Most everything that is good is *prima facie* good. Keeping your promises is like this. There are times when you shouldn't keep a promise. If it turns out that you can't keep your promise to meet your friend for dinner if you stop to help the drowning child, you should obviously break the date.

It's important to note that keeping your date with your friend is still good because it honors your promise. The value of keeping your promise doesn't go away. But it is not good enough to warrant ignoring the child's pleas for help.

More precisely, we might say that keeping your promise, while always good, is always *prima facie* good, but not always good all things considered.

Cognitive goods like true belief are no different. I earlier endorsed what we might call the truth-norm or rule: that other things being equal, it is good to believe what is true and only what is true. The point of the "other things being equal" clause is to signal that truth is not an absolute good. *A belief's being true is prima facie cognitively good, good considered by itself, or good other things being equal.* A belief's being true is a good-making property of that belief. But since beliefs have all sorts of properties, some of which can make a belief bad to have, a belief's being true is not always good absolutely, or all things considered. Sometimes other values should take precedence over the value of truth.[4]

Some propositions can be true, for example, but not good to believe. That's the relevance of the Oppenheimer example: he worried that our knowledge of nuclear weaponry was dangerous. And some true propositions would not be good to believe for more mundane reasons: some are too complicated for any human to believe, while others may be too trivial to be worth the effort. Phonebooks and encyclopedias contain lots of information; but all things considered, spending your time memorizing their contents isn't a fruitful way to fill your time. So while being true always makes a proposition *prima facie* good to believe, it may be better, all things considered, not to believe it.[5]

Conversely, a false proposition may still be good to believe all things considered. Self-deception, for example, can be good all things considered. An athlete that deceives herself into thinking she is better than she is may actually perform a bit better at certain times than she would have had she a more realistic sense of her abilities. Positive thinking, in other words, can be helpful, even when it is "unrealistic."

Sometimes other cognitive values require false belief. One of these values is that we should believe what is justified by the evidence. In following this rule, we sometimes end up going astray. This is because even the best evidence can mislead. At one point all the evidence available to some community may have indicated that the Earth was flat. Intuitively, someone in that community would have been justified, based on the available evidence, in believing that the Earth was flat; but he would have been mistaken nonetheless. Yet the fact that, in particular situations, we have a false but justified belief doesn't mean that believing the truth isn't *prima facie* good. Once again, the key point is that the value of believing what is justified is parasitic on the value of believing what is true. Having justified beliefs is good because justified beliefs

are likely to be true. Indeed, an essential part of what makes a belief justified is precisely that it is based on grounds that make it likely to be true. If a belief's being true *wasn't prima facie* good, it wouldn't make much sense to gather evidence, check and recheck calculations, or worry about whether you have good reasons for believing what you do. But while having good evidence, reliable belief-forming processes, and so on are solid means to truth, they are imperfect means. Thus, following the justification rule, although generally wise, is not a guarantee.

So truth is a *prima facie* good, and therefore, there can be exceptions to the general rule that it is good to believe what is true and only what is true. We shouldn't overstate the importance of these exceptions however. For example, systematic distortion and false belief can, in some cases, be adaptive for an organism. An organism that systematically overestimates the probability that a movement in the bushes is caused by a predator may be more likely to survive than one that estimates accurately. With animals and humans alike, quick and dirty habits of belief-formation are often better than precise, labor-intensive ones. It would be absurd, however, to conclude from *this fact alone* that the pursuit of true beliefs, let alone the possession of the beliefs themselves, has no value. The fact that believing falsely, or adapting strategies that often result in false belief, can be evolutionarily adaptive in *some* cases hardly means that it is adaptive in all cases. To see this, imagine what would happen if I were to *constantly* form false beliefs in the real world. Walking out my door, I would fall down, since I would underestimate the depth of the step. I might put my car in drive when I meant for it to reverse; I could think the coast clear when cars are in fact hurtling down the road at me; or think that safe food was poisonous and poisonous food safe, and so on. In the *vast majority of cases,* in other words, the less accurate I am in my beliefs about just my immediate environment, the less likely I am to succeed in my goals—including my goal of surviving.

A similar lesson applies to value of true belief about your own psychology. The psychologists Shelley Taylor and Jonathan Brown's experimental work in the 1980s indicated that many healthy people systematically overrate themselves and their loved ones with respect to certain abilities and traits.[6] Healthy folks are more likely to rate themselves and their loved ones as more successful at certain tasks than they actually are. On the other hand, depressed people are often much more accurate in their perceptions of themselves or others. More recently, advocates of the "positive psychology" movement, such as the

psychologist Martin Seligman, have emphasized that people who are less realistic but more optimistic about their own chances at certain tasks, like the athlete I mentioned earlier, frequently do better at those tasks. And people who as a rule take criticism less seriously, and who self-criticize less, are often happier than those who carefully and accurately assess their own faults.[7]

Once again, it is important not to overestimate the importance of the results. Again, they point to an important fact—that believing truly isn't an absolute good. But they don't show that believing truly isn't always *prima facie* good. The fact that healthy people often believe falsely about themselves along some dimensions does not entail that they are *incapable* of facing up to the facts about themselves while still being happy and successful. And while Taylor and Brown's experiments indicate that people who are depressed are often more accurate in their self-assessments, this doesn't show that there are no healthy people who are just as accurate, nor that there may be some severely unstable people who are very inaccurate. Most important, none of these studies supports the idea (nor do the researchers claim that they do) that someone who *always* engages in optimistic self-deception is going to be more successful or happy. Someone who always self-deceives is apt to get hurt fairly quickly and in fairly obvious ways.

I noted earlier that true beliefs are best described as cognitively, as opposed to morally, good. Typically, it is persons, desires, characters, and actions that are most often called morally good or bad. This is because such things are the subject or object of responsibility; that is, they are fit for praise or blame. Beliefs, on the other hand, are not strictly speaking within our control. When you open your eyes in the morning, you just start forming beliefs about your environment. You can't help it, and therefore your belief's being true wouldn't typically be called morally good. In this sense, we think of beliefs like feelings. Consider the feelings of pleasure or pain, for example. Experiencing pleasure is *prima facie* good, but like a belief's being true, it is not *morally* good. You don't have control over the pleasurable feeling itself, just as you don't have control over the belief itself. Nonetheless, you do have control over how you pursue or avoid pleasure. And the same goes with belief. You have control over how you pursue forming beliefs. And in *that* sense, you are responsible for what you believe. Consequently, just as true belief is a *prima facie* cognitive good, so *pursuing* true beliefs is a *prima facie* cognitive good in its own right. But because we have control over the ways in which we pursue truth and avoid error, the *pursuit* of truth can be both cognitively and morally good.

It can also be bad. Sometimes pursuing the truth about some question would be morally worse than not pursuing it. This may be because, as in the case of nuclear weapons research, the answer itself may prove dangerous or harmful. But it may also be because the manner of pursuing that truth is dangerous or harmful, or simply morally wrong independently of its consequences. Consider again the Nazi or Tuskagee experiments: it is not the information pursued that is morally bad here, but *the manner in which that information is pursued.* And we need not resort to such dramatic cases. The National Institutes of Health and the National Science Foundation heavily monitor contemporary scientific research that involves any sort of experiment involving human subjects. In cases where the only way in which we can obtain certain scientific information is harmful to other people, we generally feel—rightly—that the information is not worth pursuing, all things considered. So in deciding whether to pursue a particular line of inquiry, we must first determine whether pursuing that line might conflict with our other values, moral or otherwise.

There is also an important difference here between the goodness of pursuing truth and the goodness of believing a true proposition. A belief's *being true* is always *prima facie* cognitively good. And as I'll argue later, when I discuss the importance of intellectual integrity, it is both morally and cognitively good to pursue true beliefs *as such.* But this doesn't entail that it is morally good to pursue every *particular* truth. It is not morally good to pursue the truth about how best to torture a human being, for example. Nonetheless, as I'll try to show later, it is still good to pursue truth *in general* or *as such* because of the role that true beliefs and their pursuit have in a flourishing, happy life.

All of this just reminds us of the obvious fact that while truth is a value, it is not the only value. A lot of ink has been spilled over trying to find some formula or principle that will allow one to decide, *in any situation whatsoever,* which of two or more competing *prima facie* goods should win out. I am skeptical that any such principle can be found. Any plausible candidate (such as the golden rule, for example) is always too vague to be of much help in many real-life conflicts. "Do unto others as you would have them do unto you" does help me decide to rescue the drowning child rather than attend the meeting; but it is less helpful in deciding whether to support the building of a factory that will increase employment in a poor area but also increase pollution in the same neighborhood. It is apparent to most people that making value

judgments is not a precise enterprise. Life decisions aren't like mathematics. We cannot decide in advance what we should do, because what we should do depends in large part on the particular details of the situation in question. This shouldn't be surprising. Human experience varies, and experience always brings with it new dilemmas, new conflicts. Just when we think that life can't get any more complicated, it often does. So it is silly to think that we can decide in advance how to adjudicate *every* conflict of value. In practice, we adopt rough guidelines to help us out. But these guidelines admit of exceptions, and we must often use our judgment to decide which is the best thing to do at the moment. This general point applies to the goal of believing truly as well. It is good to believe what is true and to avoid believing what isn't, other things being equal; but conflicts can arise, and we can't expect a formula to tell us when other concerns trump pursuing truth and when pursuing truth trumps those other concerns. Life is not that accommodating.

Knowledge is often dangerous. Accordingly, pursuing the truth and only the truth at all costs no matter what the consequences is rarely a good thing. That is no surprise. Always pursuing anything, no matter what the consequences, is frequently a recipe for disaster. That is the human condition; and it applies no less to truth than to any other value.

Context and Significance

One way of putting the point of the previous section is that inquiry as a whole, or all things considered, is always a juggling act of balancing potentially competing goals against one another. To engage in inquiry is to ask questions: to ask how, what, where, and why. To ask questions is, in part, to pursue true belief. But this pursuit is not simply independent from other pursuits. We want to know, but we also want to be safe from harm, to appreciate beauty, to further our personal projects, to love and be loved. And it is a mistake to think that these other ends are totally separate from inquiry considered as a whole, as if they were things we did only on our days off from the pure pursuit of knowledge.

Consequently, some philosophers, including Susan Haack and Philip Kitcher, have argued that inquiry, including scientific inquiry, is really aimed not at the truth as such, but at what we might call *significant truth.*[8] In a sense, this is completely right. Not all truths are worthy of belief all things considered, and some true beliefs would be bad to have. This doesn't imply that

believing truly isn't always *prima facie* good. But it does imply that some true beliefs are more important than others. Some truths are significant; others are not. If we wish, we could sum this up by saying that one of the aims of inquiry in general, or all things considered, is significant truth. But we must be careful. To say that all things considered, we aim at significant truth, isn't to say that there is a separate goal, *significance,* that we aim at in addition to aiming at truth. Rather, it is a way of reminding us that some truths are more important to us than others, whether our concern is finding out why the car is making noise or searching for the grand unification theory in physics. So in saying that in inquiry we are aimed at significant truth, we remind ourselves that while truth is a value, it is not our only value.

Inquiry is properly guided by our other goals and values as well as by the truth. Thus, the sorts of truths we find to be significant enough to pursue will depend not only on the good of believing the truth, but on whether we think grasping these particular truths will help us to reach our other goals. And this is exactly the way it should be. The reason we don't think it obligatory to read the phone book, despite the veritable fountain of truths it contains, is that pursuing those truths is just not going to get us where we want to go (in most cases, anyway). And the reason we think the infamous Tuskagee and Nazi experiments are barbaric is that they tortured and killed people. And the value of the truth gained does not outweigh those deaths. Again, this point in no way undermines the value of any particular true belief *qua* true belief. But it does imply that that our moral and cognitive values are not as separate as some might think. As we clumsily grope for truths that are significant and important, we balance both our moral concerns, concerns about autonomy and the sacredness of human life, the costs of investigation, and so on, against the value of believing what is true.

Whether a belief is significant depends on the context. This is true even when we are talking about which beliefs we find scientifically significant. There is nothing spooky about this point. As philosopher William James observed: "we plunge forward into the field of fresh experience with the beliefs our ancestors and we have made already and these determine what we notice; what we notice determines what we do; what we do again determines what we experience; so from one thing to another."[9] We might put this by saying that our worldview influences what is significant for us. And our worldview is a complex whole composed of many things, each of which can change over time. Most obviously, experience is always in flux and differs from person to

person, time to time. What stands out as a surprising and interesting experience, or new scientific result, depends, among other things, on what we think is normal to experience. And this depends on the type of experience we've had in the past.

And then there are the very concepts and cognitive capacities we employ. Concepts, even very basic concepts, can be extended and enriched in various ways. Thus our very concepts of identity, substance, personhood, and so on will color the sorts of judgments we can make about the world. And the beliefs we form as a result will in turn affect our theories, and our theories will in turn guide our experience and our sense of significance. Philosopher of science Thomas Kuhn and others have argued that as a result, experience is always "theory-laden."[10] But even if what Kuhn and others have claimed on behalf of this phrase is not always right, it is surely true that whether scientists take the result of an experiment as significant depends on the background scientific theories they accept.

Finally, the fact that we have different concepts and experience both determines and is determined by our different interests. We want different things at different times. And what we are interested in, naturally, affects what in our environment is salient to us. Consider the matter of which diseases receive the most attention in terms of research and research support. How much effort is expended depends, among other things, on how many people are affected by the disease, whether we have any good theories about what causes the disease, and sadly, various political interests. Early on after the discovery of AIDS, for example, research into the causes of the syndrome was hampered by an incorrect homophobic perception that it was a problem only for those who were gay. Significance—either of a belief or question—is hence as much the slave of prejudice as it is a servant of reason.

So while being true is what makes a belief good to have, inquiry is guided by more than just the value of truth. Loosely speaking, we can sum this up by saying that inquiry aims at significant truth. Note that this doesn't mean that it might not also sometimes aim at other things. We sometimes want not just truth, but what we might call understanding. We sometimes ask questions, for example, because we want to know *how* to do something: how to tile a wall, or lay a foundation, or win friends and influence people. And we also wish to understand things: a piece of music, the character of a friend, the complexities of one's feelings for another, the significance of a memory. In these situations, we understand not necessarily by grasping some fact, but by

grasping relationships—how aspects of reality fit together. Of course, in order to understand, we often must have certain true and justified beliefs as well. But intuitively, our understanding of them, our grasp of how they are, is not limited to the sum total of true beliefs about them. Thus, in saying that significant truth is an aim of inquiry, we don't imply that it is the only aim. We want truth, we want significance, we want know-how, and we want to understand.[11]

Questions and Answers

In thinking about the value of truth as I've been describing it, certain questions naturally arise. I'll finish off this chapter by answering some of the most common.

Q: Suppose an elderly man has available to him some inconclusive evidence that he is in poor health but does not seek out medical confirmation of this fact. He does not go to the doctor and so on, and tries successfully to just put his health out of his mind. In fact, he is in poor health—he has only six months to live. Suppose he has no friends or family depending on him, and all his financial affairs and so on are in order. According to your view, is he still making some sort of mistake by not seeking out the truth about his health?[12]

To this sort of question, I answer in the typical philosophers' way: that depends. Believing what is true is good, and hence one should (see below), *other things being equal,* pursue having true beliefs. So it depends on the details of the case. It may well be that his avoiding the truth is not hurting anyone else. But it is an open question as to whether it is harming himself. Depending on his psychology, he may well benefit from knowing that he has only a short time to live. He may use his time more wisely, pouring his energies into worthwhile projects that he might not have otherwise pursued, than if he did not know the truth about his medical condition. Indeed, I will claim in part III that other things being equal, believing the truth about certain aspects of your own psychology is an essential part of living a flourishing life. Thus, if other things really are equal, then it is very possible that the elderly man is harming himself by avoiding the truth about his own life.

On the other hand, he might be the sort of person who would enjoy life more by not knowing for sure whether he will live or not. Finding out the truth may depress him so much that he will be unable to accomplish worthwhile projects he might have otherwise been able to complete. Either situa-

tion is possible, and thus it depends on the individual case. It may turn out, in other words, that some other values rule out the benefit of believing this particular truth, or it may turn out that the benefits of believing this particular truth may win out.

The fact that it might go either way depending on the case should not surprise us. That is the way it is in life. The devil is in the details.

Q: Come on, what about really trivial beliefs? Surely there are all sorts of true beliefs I could have that are not even prima facie good?

Without a doubt, there are all sorts of true beliefs (say, beliefs about how many threads there are in my carpet) that are not worth having, all things considered. But the fact that I should not bother with those sorts of beliefs doesn't mean that it isn't still *prima facie* good to believe even the most trivial truth.

Think of it this way. There are all sorts of trivial but still morally good actions you could be doing right this very instant. You could, for example, go out and take some weeds out of your neighbor's garden, or help an old lady across a road. These types of deeds are *prima facie* good things to do, and they remain so, whether or not you, or anyone else, in fact do them. But these *prima facie* good deeds aren't necessarily worth doing for you right this instant. The time alone it would probably take you to actually find a suitable old lady to help cross the road is prohibitive; there are all sorts of things you could be doing closer to home, as it were (such as washing the dishes after supper) that are just as good. Nonetheless, this doesn't mean that helping old ladies to cross the street isn't always *prima facie* good. Of course it is. It just may not be the best thing for you to do all things considered.

Q: But hypothetically, doesn't your view imply that omniscience is the ultimate cognitive goal?

To be omniscient is to know everything. But knowledge involves, in most cases, anyway, more than just true belief. Thus God—if he or she exists—has more than true beliefs; God also has reasons for what God believes. So in that sense, my view doesn't necessarily imply anything about omniscience. Yet if we use "knowledge" to stand for true beliefs, my view does imply that it is always *prima facie* better to have more true beliefs than false ones. But it doesn't imply that it is better all things considered.

There is an underlying issue here that is actually rather deep. As I noted earlier at the beginning of this chapter, knowledge is power, and power corrupts;

so absolute knowledge may just corrupt absolutely. As a formal syllogism, this is invalid, but the point remains: human beings are imperfect creatures. We lie, and steal, and seek power for power's sake. We are frequently poorly equipped to handle the power that can come with the truth—as Oppenheimer realized, too late, that fateful day in 1944. Thus, given the way humans actually are, it is always relevant to ask whether any particular line of inquiry should be pursued. It may be good to believe what is true, but that doesn't mean that every belief is equally worth pursuing all things considered. Maybe there are some things that wouldn't, in the end, be good for humans to know. It seems to me an open question.

Q: So what is prima facie, "other things being equal" good on your view—having true beliefs, a true proposition's being believed, or the pursuit of truth?

All three: in fact, on one natural interpretation, they all come together in a package deal. What philosophers call the content of a belief is a proposition, and when we say that a belief is true, we mean not that the believing itself is somehow true, but that *what* is believed is true. And what is believed is a particular proposition. (Belief is a special type of attitude—doubt, hope, and fear are others—that one can have toward a proposition.) Now propositions, considered by themselves, are not good nor bad just by themselves; they are good or bad to believe. This is similar to saying that types of actions aren't themselves good or bad, what is good or bad is performing those actions. So, on my view, the property of truth is normative of belief in the following sense: being true is what makes a proposition good to believe. We can put this equally well by saying that what makes a belief good to have (other things being equal, of course) is that it is true. So, other things being equal, it is better to have more true beliefs than false ones.

Furthermore, something's being good is action-guiding. Sometimes this is put by saying that something's being good underwrites our having an obligation to pursue it. But we must be careful. By "obligation" here, I don't necessarily mean "duty," but something more like "reason." Thus the fact that it is good to give to charity is a reason to give to charity. Its being good is what makes it good to engage in charitable acts. Similarly, the fact that it is good to believe what is true is a reason to pursue the truth—that is, to engage in policies and practices that are likely to result in true beliefs.[13]

Here I should pause to emphasize something that will loom larger later on. Although part of what makes the pursuit of truth a *prima facie* good is the good-

ness of what is being pursued, it is *entirely possible that the pursuit of truth is good all on its own*—independently of the good of the end pursued. This is not un-heard of. Physical health is good, and pursuing it (by working out, eating right, etc.) is good mainly because the goal being pursued—health—is good. But the pursuit of health—say, through working out—may itself be intrinsically valuable for some people. For some, the means may become an end in itself.

Q: Your view, however, makes the value of truth contingent on the exis-tence of believers. It implies that it is true beliefs that are valuable; so if there were no believers, truth wouldn't be valuable.

Truth is normative. Just as what makes certain actions good to perform is that those actions are courageous, so a proposition's being true makes that propo-sition *prima facie* good to believe. But this doesn't make the value of truth con-tingent in a deep sense. Because even when there were no believers, it would still be the case that: if there were any believers, then it would be *prima facie* good to believe that *p* if and only if *p* is true.

Q: You've said that pursuing the truth is not always worth it, all things con-sidered. It often depends on the consequences. This makes it sound as if the value of true belief consists in its consequences alone. But I thought you said there was more to it than that.

There is. The fact that the consequences of believing matters doesn't mean that it is all that matters. The question is what makes truth, other things be-ing equal, worth caring about for its own sake. This is the subject of part III.

As I've already argued, many of us already think that truth is worth caring about for its own sake, that there is more to the value of truth than getting what you want. Not everyone agrees, however, as we'll see.

Part II False Theories

5 Truth as a Means to an End

Round and Round We Go

In November 1906, only four years before his death, the psychologist and philosopher William James delivered a historic series of lectures at the Lowell Institute in Boston. James began the second of these lectures with this story. During an extended camping trip one summer his traveling companions became immersed in a quarrel over a man who had circled a tree, trying in vain to catch a squirrel. Clinging to the trunk, the squirrel managed to always keep the tree between itself and the man. The question in dispute was whether in circling the tree, the man had gone round the squirrel. James reported he solved the problem by noting that it depends on what you practically mean by "going round": if you mean moving successively to the north, east, south, and west of the squirrel's position, then the man did go round him; but if you mean, being first to the right of the squirrel, then in back of the squirrel, then to his left, and so on, then the man clearly did not go round the squirrel. There is no such thing as simply just "going round" full stop. And once one has seen that, one sees there is really nothing for the disputants to argue about.[1]

Besides demonstrating that the silliest issues can seem entertaining when one is out in the woods for a few days, this story illustrates what we might call the pragmatic attitude: cut the bull, get down to brass tacks, and focus on what practically matters. There is no sense, James is pointing out, in trying to solve a problem independently of considering how various answers might relate to practical experience. Ignore practical experience, and, like the man chasing the squirrel, one just ends up going round in circles.

Following his friend Charles Peirce, James used the word "pragmatism" to describe the position he presented during his lectures that November. The

term has subsequently been used to name a bewildering variety of views, but despite (or perhaps because of) this variety, pragmatism remains the most distinctively American contribution to philosophy. Pragmatist viewpoints have seeped deep into our cultural bones, and, through the works of the most influential pragmatists, it has affected everything from psychology (William James created the first experimental psychology laboratory in the United States at Harvard in 1875) to education (via the reforms of John Dewey) to the law (through the jurisprudence and legal decisions of Oliver Wendell Holmes, Jr.). Yet like any theory, pragmatism is also a reflection of the culture that created it. For good or ill, the pragmatic hero is part of our cultural myth: the square-jawed man of action, the social worker laboring in the welfare trenches, the entrepreneur who just "gets things done." Pragmatism is the philosophy of real politic, of results; it embodies a respect for the success and fallibility of science, impatience with metaphysics, and a fondness for the concrete case.

While we'll have several occasions to discuss such pragmatic attitudes throughout the book, in this chapter, I'm interested in the sort of pragmatism James made popular. In the eye of what I'll call the classical pragmatist, Plato's and Descartes's obsession with discovering the secret "nature" of the True and the Good has led Western philosophy down the primrose path into metaphysical quagmire. We can no more "discover" truth, according to James, than we can "discover" whether the man went round the squirrel or not. Truth, as he liked to say, is made, not found. To think otherwise misconstrues humanity's place in the world—most fundamentally, by misunderstanding how our ideas relate to reality.

For classical pragmatists, beliefs don't represent mind-independent *objects* or *facts*. Beliefs are tools, like cars or computers, hammers and nails. Humans make them for specific reasons, to accomplish specific goals. This belief about beliefs is at the heart of pragmatism, for it leads immediately to a new and radically different way of thinking about truth. What makes something a good saw isn't that it copies anything. Something is a good saw when it cuts wood well. Analogously, on the pragmatist's view, a belief isn't good—that is, true—because it copies reality. Good beliefs, like good tools, do good work.

Using good tools matters because they help you get what you want—from an addition to the house or a successful heart transplant. So if beliefs are tools, and true beliefs are beliefs that work well, then true beliefs matter for the same reason good tools matter. They help us get other things we want.

Almost everyone will agree that true beliefs are definitely good to have for plain instrumental reasons. The interesting thing about the pragmatists is that they make this a matter of definition: true beliefs just are those beliefs that are successful at getting us what we want out of life. Thus, for the pragmatist, truth is valuable *only* as a means, not as an end. Accordingly, classical pragmatism rejects our fourth truism about truth. It thus merits close attention.

The Right Tool for the Job

The locus classicus of pragmatism is an article entitled "How to Make Our Ideas Clear," published in *Popular Science Monthly* in 1890 by a quirky mathematical logician with a bad habit for losing his temper.[2] The author was C. S. Peirce, and his view of the meaning of ideas is a key to understanding pragmatism.

The title of Peirce's article is not just a joking reference to the ubiquitous "how to build a better mousetrap" sort of article; it is an ironic nod to Descartes. Descartes believed that in the face of skepticism, only "clear and distinct ideas" are certain. Clarity and distinctness are signs that an idea corresponds to reality, or is true. To Peirce, this was a completely wrong-headed strategy. For one thing, it is too subjective (clear to whom? Distinct from what?). For another, it invokes the wrong picture of how our ideas relate to reality—what I called earlier the looking glass view of the mind.

If you want to get clear about your ideas, Peirce wrote, you don't hold them up to the mind's eye and try to see if they clearly mirror reality. You "consider what effects, that might conceivably have practical bearings, which we conceive the object of our conception to have. Then, our conception of these effects is the whole of our conception of the object."[3] To have an idea of something, in other words, is to understand its possible practical effects on your experience. Think of how you explain a corkscrew to someone who doesn't know what one is. You wouldn't begin by an exhaustive list of some particular corkscrew's physical and chemical properties, for example, its shape, weight, size, and so on. You would simply tell them that a corkscrew is a tool for getting corks out of wine bottles. You get the idea of a corkscrew from learning how a corkscrew works—what it does. Similarly, Peirce argued, getting a clear idea of anything is a matter of getting clear on its practical effects. To have an idea of a lemon, for example, is to have an idea of something that is sour when tasted, yellow when looked at, that can be divided by a knife, from which juice can be used to make lemonade, and so on. Our idea of lemons consists

solely in the impact lemons have on our sensory experience. Therefore, the beliefs our ideas compose aren't mirrors of a mind-independent reality; they are shorthand for actual and possible human experience.

Peirce's pragmatic view of ideas and beliefs has some clear practical consequences itself. It implies *that there can be no difference that doesn't make a difference.* That is, the only distinctions between ideas and beliefs that matter are those that make a practical difference to our experience. This means, among other things, that two beliefs that have the same practical consequences don't really differ, and beliefs that have no practical consequences have no real meaning at all.

James agreed with Peirce that there are no differences that don't make a difference. And like Peirce, James thought they implied a particular view of truth. In his famous lectures mentioned at the start of this chapter, James does not deny the correspondence intuition that true ideas agree with reality. As he says, this much any dictionary will tell you about truth. The pragmatist, James insists, merely wishes to know what this "agreement" and what this "reality" consist in. And characteristically, he wants to know their pragmatic definition—that is, he wants to know what they practically mean.

James's answer, roughly, is that the truth of a belief consists in the practical use it has in your life. For James, truth is made, and beliefs "become true just in so far as they help us get into satisfactory relation with other parts of our experience."[4] Truth is "only the expedient in the way of thinking, just as 'the right' is the expedient in the way of behaving."[5] The rough idea is that a belief is true when and only when it leads us to interact with reality in a beneficial way; when, as he says, "it helps us to deal, either practically or intellectually"[6] with reality. In short, truth is utility for James: a true belief is one that gets us something else we want.

Putting it this quickly makes the view sound cruder and less plausible than it actually is. James did not mean to imply the simple minded idea that all and only beliefs that are immediately useful are true. He realized that there are some true beliefs that are not immediately useful to anyone, and that others are false but extremely useful. And he was aware that in any event, the notion of "usefulness" as it stands is too vague to be of much use.

To understand the pragmatic theory of truth, one needs to understand the idea lurking just behind James's formulations. That idea links truth to justification. Most nonpragmatists explain justification in terms of truth: a belief is justified just when it is likely to be true, we might say. But the pragmatist re-

verses this order and adds a pragmatist twist: truth is explained in terms of justification—but *practical* justification. A belief is *practically justified* when it helps us, *durably and over the long run, achieve our goals*. Thus, for the Jamesean pragmatist, a belief is true just when it is practically justified, when it works to get us what we want over the long haul.

Tools are good or bad insofar as they work or don't work. But whether a tool works well depends on what sort of tool it is, what goal it is meant to help us accomplish. And we might have many different goals. Accordingly, different sorts of beliefs are practically justified in different sorts of ways. Many beliefs about the physical world around us, James argues, are useful insofar as they are verifiable or verified by sense experience. An idea that is verified is useful because, among other things, it acts as a basis for further action and prediction. Other propositions, such as abstract thoughts about mathematics, James suggests, are useful in a different way. Here true propositions lead us into "useful verbal and conceptual quarters as well as directly up to useful sensible termini" by leading us to "consistency, stability and flowing human intercourse."[7] Abstract propositions such as those of mathematics are useful insofar as they are coherent and lead us to systematize our experience.

In sum, truth for James is practical justification *in some form or other* over the long haul. The true belief in any situation is the belief that is the right tool for the job at hand.[8]

James himself believed that truth was valuable. Indeed, one of the many ways he had of putting his view explicitly defines truth as a species of the good: "the good in the way of belief," James said, was truth.[9] In other words, just as in acting we aim to do good, so in believing we aim to believe what is true and avoid the false. But James and the other pragmatists didn't believe that anything was good in and of itself. For the pragmatists, all value is extrinsic and instrumental. Something is valuable just when it gets us something else we want. The value of truth is no different.

To see why the pragmatist is committed to this view, it helps to compare James's views on truth with a particular view about what makes an action right or wrong: utilitarianism. Interestingly, James dedicated his lectures in their published form to the most famous utilitarian of all—John Stuart Mill, who James imagined would have been the leader of the pragmatist movement (Mill died in 1873, when James was 31). According to utilitarianism, the right action in any situation is always the one that has the highest expected utility— which is to say, that it leads to us getting what we want (which Mill believed

was the greatest amount of happiness possible). No action, on this view, is ever absolutely right or wrong—rather, any action, even murder or rape, could be right given an extreme enough situation (e.g., if otherwise millions would die). And Mill, unlike some of his predecessors, was careful to emphasize that "happiness" isn't simply a uniform simple matter of brute physical plea- sure.[10] Pleasure comes in different forms, and so many things are responsible for happiness. Similarly, James wished to say that a belief is true just when it is useful to believe, that is, that it acts as an instrument for getting us some- thing else of value. But, as Mill believed that the way in which an action could lead to happiness, and the type of happiness it could lead to, could vary, so too James thought that the way a belief can be useful, and the type of useful- ness it can have, can vary.

Like Mill, whose view implies that it is the consequences of your actions that make them right or wrong, what makes a belief true for James is its prac- tical consequences on your life. Accordingly, the value of truth is entirely in- strumental: "Our obligation to seek the truth is part of our general obligation to do what pays," James noted; "The payments true ideas bring are the sole why of our duty to follow them."[11] Again, James acknowledges that not all true beliefs need pay in every situation; it is therefore convenient to have a "general stock of *extra* truths" that will pay in the long run. Nonetheless: "The possession of truth, so far from being here an end in itself, is only a prelimi- nary means toward other vital satisfactions."[12]

For the classical pragmatist, truths are good because—and only because— they have cash value. They get us what we want.

Why (Classical) Pragmatism Doesn't Work

What makes a hammer useful for hammering nails but not for driving screws? The shape of the hammer, for one thing; the shape of screws, for another. Ac- cording to pragmatists, beliefs are like hammers. But now: what makes one belief more useful than others? Are there hard and fast facts about what makes one belief pragmatically justified and another not?

This question puts the pragmatist in an uncomfortable dilemma between falling into relativism or admitting that not all truth consists in pragmatic utility. On the one hand, it seemed obvious to many of James's contempo- raries that his answer here must be rather subjective or relativist. For what makes it useful for someone to believe in angels may be entirely a subjective

matter of how it makes them feel. But even if it makes me feel better over the long haul to believe that there is an angel protecting me, that does not make it true that there is such an angel. In short, unless James can come up with some independent standard of what makes one belief pragmatically justified and another not, his pragmatist theory seems in danger of collapsing into the most radical of relativist views discussed in the last chapter. On such views, there really is no difference between what we believe and what is true. And as such, there seems little point in calling them theories of "truth" at all.

Against allegations of this sort, James frequently insisted that it was not just up to us to decide whether some belief was pragmatically justified or not.[13] It was partly dependent on the way reality is. This sounds sensible. After all, what makes a hammer useful depends partly on what we try to do with the hammer and partly on certain physical facts about the hammer and the rest of the world. Similarly, it seems obvious that there are hard, objective facts about whether some beliefs are pragmatically justified. Consider my belief that the brakes in my pickup are in good operating order. This is a useful belief for me to have. Its usefulness consists in the fact that by believing that the brakes are working, I can make various small predictions in order to guide my future action (if I press the brake pedal, the truck will stop). But obviously it is useful for me to believe that my pickup's brakes are working only if they *are* working—if it is *true* that they are working, in other words. Yet this is not something that the pragmatist can say: we just invoked truth to explain usefulness, rather than the other way around.

In short, then, the classical pragmatist is stuck in the dilemma mentioned earlier. What makes a belief useful? If it is just our beliefs, we slide into an unhealthy form of relativism. But if it is the way the world is, we must give up our pragmatist theory of truth.

A second important problem for pragmatism is that it can't account for the truth or falsity of some types of propositions at all. The best example is truths of the past. As Hilary Putnam has pointed out (citing Josiah Royce, one of James's colleagues), James's version of pragmatism in particular implies that the truth of beliefs about the past depends on what happens in the future. Here's why: according to James, a belief is true just when it is pragmatically justified in the long run. But whether a particular belief of mine, say, that Caesar crossed the Rubicon on horseback, is pragmatically justified in the long run depends on what will happen in the long run. But presumably either Caesar crossed the Rubicon on horseback or he crossed some other way, or he

never crossed at all. And surely whether he did or didn't is not going to be determined by what happens in the future.[14]

You might think that James could reply to this by saying that whatever the truth or falsity of the *thought* that Caesar crossed the Rubicon on horseback, the actual *reality* of the situation still remains independent of us. It is just that in this case, reality is not yet forcing any useful evidence on us so that we can decide the matter. Not so fast, however. Recall our truism that truth is objective. A simple way of putting this point is to note that we are inclined to accept that for every proposition p, it is true that p if and only if p. Thus it is true that Caesar crossed the Rubicon on horseback when and only when he really did cross on horseback. And vice versa, obviously. This means that there is a logical connection about what we say about what's *real* (the actual event of Caesar's crossing, let's say) and what we must say is *true* (the proposition that he did cross on horseback). This illustrates not only that Jamesean pragmatism has a problem with past truths depending on the future, but that the past itself would end up depending on the future. And that is absurd.

My two criticisms are not just random darts thrown at the board. They are connected by an underlying problem that lies behind both the dilemma and the problem about the past. While James believed that beliefs could be useful in different ways, he still thought that utility, or pragmatic justification in the long run, was the sole nature of truth. Both of the above objections show that this can't be right: some truths, such as truths about what makes something useful or not, and truths about the past, must consist in something other than usefulness.

A More Coherent Suggestion?

So far, I've been aiming at what I've been calling classical pragmatism, or the idea that truth consists in practical justification in the long run. Like any philosophical position, this one can be tweaked in various ways. Some philosophers have suggested that reworking the idea that truth consists in justification might save pragmatism.

Descartes thought that justifying our beliefs was like building a house. You begin with a foundation of sensory evidence, gathered through direct contact with the world. On that you construct a superstructure of beliefs—your theories. But there is another way to look at it. Perhaps, as Otto Neurath suggested, inquiry is more like rebuilding the hull of your boat while at sea. There

is no foundation stone for the hull—all the planks of the boat (this was before fiberglass) are equally important. Similarly, we don't test our beliefs in isolation against reality; we see them as part of a system. So while new evidence forces us to rebuild our theoretical ship, we must of course rely on other parts of our existing belief system while doing so. As such, our aim when justifying our beliefs is not to try and found all knowledge on just a few foundational stones, but to try to have the most stable, and coherent, belief system possible.

Some philosophers have taken this picture of justification to be a good picture of truth as well. According to the coherence theory of truth, it isn't believing that makes it so; it is coherent believing that makes it so. That is, a proposition is true not simply because it is believed, but if and only if a belief in that proposition would be a member of some coherent system of beliefs. A belief system is coherent, roughly, to the degree that its members are (a) consistent with each other, and (b) display mutual relations of support. On this picture, in other words, beliefs don't fit the facts; they fit with other beliefs.[15]

Like the more traditional pragmatist view, the coherence theory does not see truth as a matter of mirroring reality with the mind. Further, whether our beliefs cohere or not seems to be a sensible question, one we ask each other quite frequently; in that sense, it is practical. Further, on the surface, the coherence theory might seem better than classical pragmatism; it may seem to avoid simple relativism.

But as a general definition of truth, coherentism still has three glaring problems. First, it defines truth as coherent belief, but it is hard to understand "coherence" except by reference to truth. After all, a necessary condition for two beliefs being coherent is that they are consistent, and beliefs are consistent just when they can both be *true*. Second, if truth just is coherence, then it follows that coherent systems of beliefs have members all of which are true. But that is implausible. Surely some of our beliefs, no matter how well they might hang together with what else we know, can still be wrong. Finally, coherence theories are too permissive. Consider the following little belief system:

God exists.

God wrote the Bible.

God is never wrong.

The Bible says that God exists and that He is never wrong.

This is a highly coherent little system, and a popular one to boot. It all hangs together (why believe God exists? It says so in the Bible. Why believe what is

says in the Bible? Because God wrote it.) But just because it hangs together doesn't mean it is true. It may be true, but its coherence doesn't make it so.

The original coherence theorists were neither pragmatists nor relativists. They believed that there was one and only one maximally coherent system. Consequently, they tried to get around this problem by requiring that belief systems not only be coherent, they had to be comprehensive. That is, to be true, a belief not only had to cohere with other beliefs in the system, it had to do so no matter what further information was received. But this gambit also fails. For no matter how coherent we make the system of beliefs, we can always ask the following question: *What makes it true that any system is or is not coherent?* If we say that it is just an objective mind-independent truth that the system is coherent, we are relying on another theory of truth besides the coherence theory. On the other hand, if we say that what makes it true that the system is coherent is that the belief that the system is coherent is itself coherent with the system, then it seems that *too many* systems will be coherent. Truth will be too easy to come by. Consequently, the coherence theorist must say that what makes a given belief system coherent can't be that we believe that it is coherent and that belief in turn is believed to be coherent with our other beliefs. Unless there is something independent of coherence that plays a part in making beliefs true, belief systems, no matter how coherent, become untethered to reality.[16]

You might think: "so much for the coherence theory." That would be too hasty a conclusion to draw. The real lesson is that coherence can't be what makes *every* sort of belief true. It remains open whether it is a good explanation of what makes *some* beliefs true.

Differences That Make a Difference

There are other ways to tweak the pragmatist theory of truth, and we'll look at one of those ways later, when we think about Peirce's own "verificationist" take on truth. But instead of getting farther into the details of different pragmatist theories of truth, let's back up and look at what is arguably the central pragmatist idea: that the only differences that matter are those that make a difference.

Richard Rorty, the most influential pragmatist currently writing, believes this principle tells against not only the idea that truth is worth caring about for its own sake, but also against our second truism: that truth is a goal worth striving for. As he says, "Pragmatists think that if something makes no differ-

ence to practice, it should make no difference to philosophy. This conviction makes them suspicious of the distinction between justification and truth, for that difference makes no difference to my decisions about what to do." In defense of this last point, Rorty makes an empirical claim, namely that obeying our duty to seek the truth "will produce no behavior not produced by the need to offer justification."[17]

Imagine, Rorty might say, a detective trying to solve a murder. She will engage in all sorts of behavior: she examines the murder weapon for prints, interviews witnesses, checks with the lab, and so on. Suppose after a full investigation she comes to believe that the butler did it in the library with a candlestick. On the basis of what she does, the actions she performs and so on, we could just as well say that she believes this because it is what she takes to be true, or we could say that she believes it because it is what she takes to be supported by the evidence. That is, nothing in the detective's practice indicates whether she is, during her inquiry, aiming at truth or aiming at what Davidson elsewhere calls "honest justification."[18]

So Rorty's argument turns out to be this. There is no difference in the *behavior* of someone who is aiming to believe what is justified and someone who is aiming to believe what is true. So there is no practical difference between seeking true beliefs and seeking justified beliefs. And since the only differences that matter are practical differences, there is no difference that matters between taking truth as a goal and taking justification as a goal.

As Rorty himself notes, you can take this sort of argument one of two ways. One way is to interpret it as a defense of classical pragmatism—or the idea that at rock bottom, truth just *is* justification of some sort. On this sort of view, we are right to think truth is a goal, but wrong in thinking that it is objective—that is, a goal separate from justification. On the other hand, we might conclude that we are simply wrong in naively thinking that truth is a goal. We may *think* we are aiming at truth when forming beliefs, but we are not. We are actually aiming at having beliefs that are justified. This is Rorty's conclusion.

What are we to make of these claims? Without a doubt "no difference without practical difference" is a powerful slogan. It sounds like plain old common sense. But let's be careful. There is a fine line between plain old common sense and first-rate spin.

Unsurprisingly, the key point is what is meant by "practical difference." If by "practical difference" we mean, like Rorty, "observable difference in behavior," then it is hard to see why we should take the pragmatist slogan seriously.

After all, if you are a very good actor, there may be no *behavioral difference* between your loving someone and just pretending to. That doesn't mean there isn't a difference that matters!

Nonetheless, Rorty is of course right that practical effects are effects on our action, on our "practices." That is what makes them practical. But something can affect our actions without affecting them directly.

Imagine that the only way you had of making money was by investing what you already had (this is in fact precisely the situation many retirees in the United States are actually in). We might then say that you have both the goal of making money (or increasing your wealth) and investing your money wisely. What makes an investment wise is precisely that it seems likely, based on the available evidence, to lead to a profit and thus increased wealth. As a result, whenever you invest, we might describe you as aiming at a wise investment, or aiming at wealth. But this fact hardly means that there isn't a difference between aiming at wise investments and aiming at wealth. Indeed, that there is a difference is implied by two important facts about the practice of investing. Lesson number one about investing is that although wise, carefully researched investments *usually* result in profit and vice versa, this needn't be the case. Not all wise investments are profitable and not all investments that are profitable may be wise. And yet, second, aiming at the one goal is what explains aiming at the other. Were an investor not interested in wealth, she would not give a hoot about investing. And that means that there is a practical difference between aiming at wealth and investing wisely after all. That practical difference does not consist in any behavioral difference between someone aiming at wealth and someone aiming at investing wisely. After all, it couldn't—in the simple scenario I've envisaged, you can only aim at the one via the other. The practical difference, rather, consists in a simple fact about the practice of investing: that there would be no such thing as investing if no one had the goal of being wealthy.

We can apply these lessons to truth and justification.[19] Just because there is no direct behavioral difference between aiming at justified beliefs and aiming at true beliefs does not entail that the independence of these goals makes no difference whatsoever on our practice. As we saw earlier, we all appreciate that there is more under heaven and Earth than dreamt of in our philosophy. The existence of ignorance and error, even global, pervasive, and undetected ignorance and error is one of the hard realities of life. More precisely, there are propositions about the distant past and about the far side of the universe that

will never be justifiably or unjustifiably believed by anyone. Nonetheless, they may still be true. And there may be beliefs that we are justified in believing now (that is, the evidence available to us indicates they are true), but which nonetheless may be false. In other words, lesson number one about justification is that not every justified belief will be true and not every true belief is justified. This is because truth, like the goal of becoming wealthy in our example, is an indirect norm. A belief is justified to the extent to which it "tracks" or "indicates" the truth. We value justified beliefs partly *because* justified beliefs tend to be true. Thus, while a belief's being justified might have independent value all its own, it is also valuable because having such beliefs are a means to believing what is true. And again, similar to our example about wealth and investment, it follows that unless we had the goal of believing what is true, we would not care about whether our beliefs were justified or based on adequate grounds. The point of our practice of justifying beliefs rests, at least in part, on the fact that we value believing what is true.

In short, the conclusion of Rorty's argument doesn't follow from the premises. Even if there is no direct practical difference between aiming at truth and aiming at justification, it doesn't follow from this fact alone that there is no difference at all. Having truth as a goal of inquiry is what explains why we bother to justify our beliefs in the first place.

Rorty might well reply that this response rests on a view of justification that he does not accept. For Rorty, "justification" always means "justification for us"; justification *is* relative to an audience.[20] And of course what determines whether we can justify something to an audience has nothing to do with truth. What beliefs are justified is determined by standards of evidence that we happen to accept. And since these standards might differ widely across communities, what will be justified to one audience may not be justified to others. This is the explanation, as Rorty sees it, of what he calls the "cautionary use" of the word "true," when we say, for example, that something may be justified but not true.[21] When we say such things, Rorty believes, we aren't actually embracing a separate goal, "truth," distinct from justification. We are simply reminding each other that what may be justified for one audience may not be justified for another.

I have already argued in this book that by saying something is true, we are not merely claiming that it is justified to an audience. Truth, I've claimed, is minimally objective. Insofar as Rorty wishes to deny this, I reject it. Nonetheless, I certainly don't deny that Rorty is right that context does affect the path

of inquiry. I agree with Rorty that inquiry "has many different goals . . . getting what we want, the improvement of man's estate, convincing as many audiences as possible, solving as many problems as possible."[22] Quite so. As I argued above, when asking questions, when engaging in inquiry, we are guided by many values. But it is a serious mistake to think that on this basis, we should no longer say that one of the goals of inquiry is also having true beliefs.

And crucially, it is a mistake with definite pragmatic consequences. As Barry Allen notes, for philosophers like himself or Rorty, "what the 'love of truth' comes to in practice is the demand that claims made with the authority of knowledge withstand refutation."[23] I do hope my claims withstand refutation, certainly, but that is not my only hope. I also want them to be right.

To think otherwise is to confuse the love of truth with the love of winning.

6 Truth and the Scientific Image

Naturalism and Human Values

Imagine I have a book that records within its pages every physical fact about you. By every "physical fact" I mean every fact about your biological and chemical makeup right down to the level of the molecules composing your body. This would be an impractically big book, of course, for it would include not only many general facts about digestion and molecular bonding but specific facts about how your particular brain works. Since this is an imaginary and not a real book, let us also suppose that it contains all the relevant facts about your past and present physical environment as well. In short, my book will contain all the facts that could be known about your nature and your nurture.

Now suppose I read this book: would I then know everything there is to know about you?

Many of us, myself included, will say no; there are some things to know about a person, such as facts about his consciousness, or his moral worth, that won't be recorded in a catalog of the *physical* facts about him. But others will respond more like this: "Well, there is no way you could read such a book in your lifetime, of course, but if such a book really were to exist, and you were really able to read it, then of course you would know everything about me. You said that the book contains the whole truth about my brain and its environment. What else is there to know?"

These two responses illustrate the conflict between what Wilfrid Sellars called the "manifest image"—or our pretheoretical, ordinary conception of the world, and the "scientific image" or the world as science tells us it is. Over the last century, the scientific image has both sharpened and broadened its scope. Science is rapidly proving that much of what we once thought immune from scientific discovery is not so. The explosion of work in molecular

biology, the completion of the human genome project, and the constant evo-
lution of neuroscience show that we will soon know much that was once
hidden. Culturally speaking, science—particularly natural science—is our
paradigm of knowledge. We trust it to build bridges, cure diseases, fight wars,
and to explain our bodies and brains to ourselves.

The theoretical face behind the scientific image is *naturalism*. "Naturalism"
is a sticky word. The views that go under the title come in many shapes and
sizes. In its original sense, it is simply the opposite of supernaturalism. It is the
view that we can explain the *hows* and *whys* of the world without invoking
supernatural deities or mysterious arcane forces. I count myself as a natural-
ist of this sort. But many calling themselves naturalists today supplement this
attitude toward explanation with a metaphysical thesis, namely that ulti-
mate reality is thoroughly physical in nature. On this view, there is nothing
over and above the physical objects and properties of the world. Call this
reductive naturalism.[1]

Although I feel its pull, I am extremely dubious of reductive naturalism, in
part because I am not sure what is meant to be included under the label "phys-
ical." In saying this, I don't just mean that I find it hard to figure out how
certain properties, like psychological properties and logical properties, for
example, could be physical or determined by the physical. I mean that I am
unsure of what a physical thing is in the first place. Are the fields and dimen-
sions of contemporary physics physical? If so, what properties do they share
with teacups and trees? Sometimes a "physical object" is defined as "what-
ever sort of object physics studies." But this is painfully circular, since physics
is just the study of physical objects.

Reductive naturalists don't share my worries. When confronted with my
hypothetical storybook, many will think that my book either contains the
entire truth about you, or that we could quickly deduce the entire truth from
what it does contain. Of course, even the most radical naturalist won't claim
we *now* know every fact about human beings and their environment, or even
that we might some day come to know all those facts. Instead, the point is
that whatever truth there is to know about the world, in principle, can be
discovered by scientific investigation of the general sort that our scientists
engage in today. In its most radical form, reductive naturalism ends up advo-
cating what biologist E. O. Wilson has called "consilience"—the idea that
knowledge is unified, but in a particularly radical way: the one true story of
the world is written in the language of natural science.[2]

Reductive naturalists like Wilson see themselves as stout defenders of truth, justice, and the scientific way, as manning the gates of civilization against the postmodernist barbarian hordes. Perhaps in some sense they are. But there is also something deeply ironic about this self-image. For like it or not, the consistent reductive naturalist is no more a friend of the idea that truth matters than the most rabid postmodern relativist. This is because reductive naturalists must apply their theory to truth itself. If you want to say that the one true story of the world is written in the language of science, then part of that story had better be the story of truth. And that means that if reductive naturalism is true, and truth is a real honest to goodness property of our beliefs, then it must be reducible to some physical property. But even if truth does turn out to be nothing over and above some natural physical property of beliefs (something that, as you'll see, I seriously doubt is the case), it is unclear how possession of any physical characteristic could be something that it is good for beliefs to have—something that we therefore ought to pursue. In my view, reductive naturalists, like pragmatists, must deny that truth is a value.

Given its centrality in the contemporary intellectual milieu, reductive naturalism turns out to be a serious threat to truth's value. But discussions of it can get complicated quickly. So here's a quick roadmap of the rest of this chapter. To say anything interesting about reductive naturalism applied to truth, we first need some examples of what such a theory would look like. To that end, the first two sections briefly introduce and criticize two attempts to reduce truth to some specific physical property of our beliefs. I next show why no such theory will ever be able to work if truth is deeply normative, and I refute various responses that could be made by the naturalist. I close by pointing out that far from making truth mysterious, the fact that truth is not a physical phenomenon actually opens the door to an interesting form of pluralism about truth.

The Greek physician and philosopher Hippocrates claimed that there are two things, science and opinion; "the former begets knowledge," he said, and "the latter ignorance." Maybe so; but although it is likely that science will tell us much or even most of the truth about the world, it won't tell us the truth about truth.

Truth as What Science Tells Us

In 1922, the same year a former patent clerk was awarded the Nobel Prize for physics, a group of scientists and philosophers began assembling in Vienna to

discuss the nature of truth and meaning. Their aim was nothing less than intellectual revolution. They aimed at unifying the sciences, dispensing with metaphysics, and solving all philosophical problems. While it was never destined to be a household name, "logical positivism," as their movement came to be called, would eventually include some of the most influential thinkers of the day, including Moritz Schlick, Otto Neurath, Rudolf Carnap, and even Kurt Gödel, one of the greatest mathematicians of the twentieth century. They disbanded when the Nazis came to power in the mid-1930s, and Schlick was shot to death by a former student. But their movement would have long-lasting effects on both individual intellectuals and our conception of human reason. At its heart was an idea called verificationism, or the view that anything true can be scientifically verified.[3]

Actually, this idea can be traced back even further than logical positivism. The founder of pragmatism, C. S. Peirce, entertained a view that was strikingly similar to verificationism. Indeed, pragmatism and verificationism have always been intertwined in both spirit and practice. Recall that Peirce's maxim, picked up by James, was that to understand an idea, one looked to its practical effects. Thus, when Peirce looked to understand truth, he applied his pragmatist method to the idea of truth itself—to look to the practical effects of truth on our experience. Peirce took these practical effects to concern the settling of disputes and the relief of doubt: "the ideas of truth and falsehood, in their full development, appertain exclusively to the scientific method of settling opinion."[4] The practical upshot of a belief's being true is that we can or should agree on it; reaching the truth settles the matter, and allows us to move on to new mysteries, new problems. Hence we find Peirce offering the following general definition: "*The opinion which is fated to be ultimately agreed to by all who investigate, is what we mean by truth, and the object represented in this opinion is the real.*"[5]

By investigation, Peirce meant scientific investigation, *verifying* our hypotheses against our sense experience. A proposition is verified when we accept it on the basis of the relevant sensory evidence, where that includes the direct testimony of our senses as well as the read-outs of various machines and so on. Tweaking it just a bit, we can put Peirce's basic idea like this: true beliefs are simply those we would, in fact, come to believe at the end of science, were the exhaustive process of collecting evidence and testing hypotheses ever completed. Put more simply: truth is ideal verifiability.

It was the logical positivists, however, that ended up advocating the most radical form of Peirce's idea. The positivists dismissed *any* unverifiable claim

about the world as nonsense. In their view, each meaningful statement could be sorted into one of two boxes. Either, like "most crows are black," it is an informative claim about the world, in which case it will be verifiable or falsifiable by the scientific method; or else, like "bachelors are unmarried adult males," it is verifiable by default, since it is simply true by definition. Any statement that doesn't fit into these boxes was empty; it could neither be true nor false. Accordingly, some of these philosophers thought the property of truth is identical to verifiability.[6] (Still others believed that it wasn't a property at all—a viewpoint I'll get to in the next chapter.)

These sorts of views have important implications for the nature of value. Take the opinion that the death penalty is unjust. You may think otherwise. If you do, then it *looks* as if we are disagreeing over the truth of whether the death penalty is unjust. But the positivists did not see it that way. For them, the only meaningful debates were scientific ones. They would agree that scientific evidence could help us decide some things about the death penalty, such as whether it is an effective deterrent to crime. But, they claimed, it is hard to see how it could help us if our disagreement comes down to whether it is just to kill a prisoner for the sake of revenge. How does one test for whether some action is just or unjust? Justice doesn't seem to be that sort of animal: moral propositions can neither be verified nor falsified empirically. So, contrary to appearances, the positivists claimed, neither side of the debate could be speaking the truth; and neither side is saying something false either. For according to verificationism, for my claim to be false, its negation (the death penalty is *not* morally wrong) would have to be verifiable. Yet, the positivists claimed, it seems that neither view can be.

In the positivists' eyes, then, although it *looks* as if I am trying to say something true when I claim that the death penalty is unjust, in reality, I am only expressing an emotion or attitude toward the idea (like saying, "Boo death penalty!"). Ethical claims on this view are simply not in the game of being true or false. Similar claims, of course, can be made about art and religion. Few think that debates about art, religion, or ethics can be resolved scientifically, and accordingly, the positivists believed, we shouldn't think that such activities are even capable of leading us to the truth.[7]

Verificationism, and logical positivism in particular, came under heavy attack in the latter part of the twentieth century. As a result, it is fashionable to dismiss verificationism as dead. That's not quite true. Like many supposedly "dead" philosophical views, it has just gone underground. Consider how frequently we dismiss debates that seem to have no immediate practical effect on

our lives as "matters of opinion"—sharply distinguishing them from "matters of fact," which can be settled by straightforward scientific investigation. And many people simply use the word "fact" as a *synonym* for "something that is proven"—where by "proof" is meant "scientific or mathematical proof." So perhaps it is not surprising that many people regard the arts and humanities as second-class citizens of the academic state. Not everyone, for example, believes that college students should be required to take courses in the humanities. As one student once memorably put it to me, these courses are "interesting" but they don't really "teach anyone any new facts." If one's conception of a fact or truth is verificationist, then this is certainly the case. Poetry does not lend itself to the sort of inquiry that can be funded by a grant from the National Institutes of Health, and what paintings can show us isn't measurable in the lab.

Luckily for poets (and philosophers!) verificationism, at least about truth, is wrong, and it is instructive to see why. As I've noted, the positivists' view on truth, insofar as they had one, flowed from their views about meaningfulness. A verificationist view of truth itself would be like the view we drew out from Peirce earlier: a proposition is true if and only if it would be verified under ideal scientific conditions, or (alternatively) accepted at the end of scientific inquiry. Truth, as I put it, is ideal verifiability. Such views are reductive: they reduce truth to something else—being ideally verifiable. But if a reductive theory is going to be successful, it needs to specify some property that is necessary and sufficient for a belief's being true. And they must do this without begging the question—that is, their candidate property can't itself be something that we need truth to explain. It is pretty easy to see that verificationism can do neither. First, some beliefs could be true but not ideally verifiable. Consider, for example, the following propositions:

It rained on this spot 15,000 years ago today.

There is an even number of stars in the universe right now.

Both of these claims are straightforward descriptions about the natural world. Presumably they are either true or false. Yet what are the chances that either would be either verified or falsified no matter how "ideal" the circumstances? Unless we can solve the apparently intractable paradoxes of time travel, the extremely distant past lies outside of not just present verification, but all possible human verification. The same problem affects the claim about the number of stars. No matter how good our telescopes are, what we see with them is light from the stars. Depending on how far away a star is, its light can take so

long to get here that the star itself may have burned out by the time we see its light. Thus the number of stars that exist *now* is not the number of stars we can now see from Earth. So counting the stars we see now, or even the ones we could see if we traveled farther out to space, will not help. The upshot is that verifiability is not necessary for truth in general.[8]

A verificationist could, of course, stick to his guns and simply declare beliefs in such propositions empty or not "real" beliefs at all. Good luck. The past was once the present. So if there are facts about what events happen now, surely there are facts about what events happened in the past, whether or not we can discover or verify those facts. It is crazy to think that beliefs about the distant past lack content. Far better to deny that only verifiable beliefs are true.

Just as some propositions could be true but not ideally verifiable, so others might be ideally verifiable but not true. The belief that I have not recently been turned into a brain in a vat is presumably as verifiable by scientific evidence as any proposition can be. But it might not be true. It is possible, just possible that I might right now be floating in a vat of liquid, experiencing an elaborate illusion generated by a supercomputer. Unlikely, yes, but possible. Consequently, verifiability is not sufficient for truth either.

Finally, the very idea of verification presupposes the idea of truth, anyway. To verify a hypothesis is to justify it, to supply evidence for it. What sort of evidence? Evidence that shows that it is likely to be true, of course. Truth can't be reduced to verification because verification must be explained in terms of truth. Similarly with "accepted at the end of science" or the like: for presumably what would be accepted in such conditions is just what is justified by the evidence—what is likely to be true. The only way to avoid this problem is to "go pragmatist" about verification—to say that you verify a hypothesis when you show that it works to get you what you want. But as we saw in the last chapter, that idea is not very promising.

Verificationism also has a problem explaining the value of truth. We think that just as it is good to do what is right, it is good to believe what is true. Yet the claim that, other things being equal, it is good to believe what is true is no more or less verifiable than the claim that, other things being equal, it is good to repay our debts. And neither does it help to replace "truth" here with "ideally verifiable": the claim that one ought to believe what is ideally verifiable is not presumably ideally verifiable. In sum: if truth is a value, truth can't be verifiability, for truth's value is not verifiable. The verificationist's own view entails *that the claim that it is good to believe the truth is cognitively meaningless.*

Indeed, verificationists have problems even explaining the instrumental value of truth. For on the verificationists' view, to say that truth is instrumentally valuable is just to say that a belief's being verifiable is instrumentally valuable. And of course, it is useful to have one's beliefs verified. Verification isn't good in itself; it is just a means to an end. What end? Truth, of course! The reason that it is good for your beliefs to be verified by the evidence is that beliefs that are verified tend to be true.

To identify truth with what science will or would tell us at "the end of inquiry" gets things backwards. Science is good, in part, because it helps us to get things that we want: warmer houses, faster computers, cures for diseases, and so on. But the best explanation of why science succeeds at helping us get these things is because it gets at the truth about how things are: the nature of warmth, the structure of information, the underlying causes of the disease.

Of course, scientists are human like the rest of us, and so the truths they arrive at, even when things are going as well as possible, are usually incomplete and partial. And even when they reach the whole truth about some matter, the truth reached may, depending on the subject matter, be context dependent or "relative" in one of the two coherent senses of that word discussed earlier in this book. Neither of these points, while sound, should obscure the fact that one of the ways we judge the success of science is how close it gets to the truth, because only by doing that can we explain why science is able to explain the things it does explain. For this reason, it makes sense to say that science aims at the truth (even if it often fails to reach that aim, and even if it has other aims as well). The goal of truth is needed in this way to help explain the value of our scientific practices, and for this reason, if no other, those practices cannot explain the value of truth.

I noted above that it seems as if many people implicitly do accept a verificationist attitude toward values. But there is another side to this story. There is a severe disconnect between the verificationist standpoint people often espouse and what they actually do. If we really did believe that verificationism were the truth about truth, it would be utterly mysterious why we are so passionate about the very topics we are most passionate about. The issues that really provoke people, that cause them to stand on picket lines, to engage in politics, and to throw bombs, are precisely the sorts of issues that are never going to be decided by science. And yet these are the matters on which we are most inclined to have strong opinions, and to defend what we believe as the truth.

One may reply that this simply demonstrates the inherent irrationality of the human condition. You might think that we would be much better off if we

just went whole hog in the verificationist direction and gave up on the idea that there really are any truths about ethics or religion. Perhaps there would be less bomb-throwing. But do you really think it would be better if we just agreed that "slavery is a violation of a fundamental human right and should therefore be stopped" is merely one emotional reaction among others to the practice of slavery? I don't think so. In my view, the resistance artistic and philosophical claims have to verification should not teach us to that all talk about poetry, philosophy, art, and literature is mere amusement, suitable only for cocktail party conversation, but that there is something deeply wrong with a verificationist view of truth that implies otherwise.

Mind as Map

Many philosophers tend to stand up and salute whenever criticisms of the sort I just raised against verificationism are trotted out. Stripped of its fancy scientistic garb, verificationism is just another form of pragmatism. And like that theory, it seems to get things backward, at least with regard to science: propositions aren't true because science tells us to believe them, science tells us to believe them because they are true.

Many contemporary philosophers, however, are as keen as any verificationist to reduce truth in a physically respectable way. But they attempt to do so by way of a particular version of the correspondence theory of truth.

One way of getting a handle on the correspondence theory is by thinking about maps. Anyone who has ever been lost in Brooklyn or attempted to navigate the London Underground knows the value of a map. Maps are representations that help us find our way. Maps—whether it is your hiking map or Rand McNally's—do not *copy* what it is that they represent. Maps represent by reproducing, on a much smaller scale, the structural relationships that exist between elements of the landscape. The lines of a map are structurally related to one another in a way that represents the relationships between the parts of the landscape itself. In both cases, the *structure* of the representation matches the *structure* of what it represents. We can put this by saying that the two are "structurally isomorphic."

Our ordinary surroundings are littered with representational devices that work this way. In the misty days of yore, LPs represented certain sound structures because of a series of grooves in a vinyl disc. These grooves corresponded to the sounds we heard when the music was played. CDs encode the same information digitally—but that digital information, again, remains structurally

isomorphic to the sounds that we end up hearing. Computer programs, such as the one I am using as I write this sentence, represent information in a similar way—as a series of 1s and 0s, in a programming language.

Early correspondence theorists like Bertrand Russell and Wittgenstein held that beliefs are structured too.[9] My belief that there is a cat on the mat is similar in *structure* to my belief that the cat is on the teapot, or the cat is on the credenza. Each is of the form: *x is F.* Russell and Wittgenstein suggested that we understand how very complex beliefs represent by first explaining how these very basic sorts of beliefs represent, and then explaining how basic beliefs compose more complex beliefs. On their view, basic beliefs themselves, like the belief that the cat is on the mat, are in turn composed of individual concepts that represent various objects and properties in certain configurations—what they called facts. A basic belief is true when it corresponds to a basic fact, and a belief corresponds to a fact when the terms of the belief are in the same configuration as the objects that compose the fact that belief is about. Finally, a complex belief is true when it is entailed by the truth of the basic beliefs.

The most recent version of the correspondence theory is thoroughly naturalist in character. Call it *causal realism.* Like Russell and Wittgenstein, the causal realists hold that beliefs are built up out of concepts in the way sentences are built out of words. But unlike their forebearers, they don't think that, strictly speaking, beliefs as a whole refer to "facts." When I believe that a cat is on the mat I refer not to something called "the fact that the cat is on the mat," but to (what else?) *a cat.* Thus the belief is true because there is an object that the concept *cat* represents that is among the class of objects that the concept *is on a mat* applies to. Generalizing, you believe truly when you represent objects as having the properties they actually do have. This account has some real advantages over earlier attempts to explain correspondence. It replaces talk of "facts" with more straightforward talk about the ordinary objects and properties in the world around us. It even replaces talk of "correspondence" itself with talk of the reference or representation of our concepts to objects and properties. Yet we still clearly retain the basic thought behind earlier correspondence theories: beliefs are true or false as a result of (a) the structure of their parts; (b) the reference of those parts to reality; and (c) the way that reality actually is.[10]

So far I've described only half of causal realism. The view has two parts: first, an identification of truth with accurate representation; and second, an

account of what representation or reference *is*. That account explains representation as a matter of causation.

Here's the idea. The link between a real map and the landscape it represents is not mysterious or "metaphysical." It is, at least in part, a matter of cause and effect. The map wouldn't be the way it is if the landscape wasn't the way it is. The features of the landscape *cause* us to draw the map a certain way. Similarly with records, CDs, or computer programs. The causal chain is just longer. The digital information encapsulated on the latest Bob Dylan CD is the way it is, ultimately, because Dylan made certain sounds in the recording studio. If he had made different sounds, different information would have been encoded. Perhaps something similar is going on with beliefs. At the very least, it seems that my belief that there is an apple on the table is true (if it is) *because* there is an apple on the table. The apple's being on the table causes my belief to be true. Accordingly, the rough idea behind the causal theory of representation is simple: my particular thoughts represent what causes them.[11]

The causal realist theory of representation has received a lot of attention from researchers over the last thirty years. It comes in a variety of forms and is far more complicated than the rough idea that gives rise to the view might indicate. But the same basic problems face most versions, and we can get a sense of what these might be by looking at how they arise for the rough idea that beliefs represent what causes them.[12]

One problem concerns error and misrepresentation. Suppose my thought about a cat refers to *whatever* causes that particular thought. The problem is that cats are not the only things that cause my cat-thoughts; they are also caused by books about cats, television images of cats, cat statues, and little dogs that look like cats from a distance. In short, the defender of the causal theory of representation must explain how it is that my cat-thoughts represent only some of the things that cause those thoughts—namely cats—and not other things. Otherwise, they'd have to say that if my belief "that there is cat" is caused by a small dog seen in the distance, then that is what it is about, and therefore it is true: the smallish dog really is a cat. And that is crazy.

Another problem has to do with indeterminacy. As I noted in chapter 3, one problem with the idea of mapping is that, independent of context, it is indeterminate what maps represent. A branching squiggly line, for example, could represent any number of forks in the road. And the problem isn't just one of scale or improper mapmaking. Any map, no matter how detailed, is going to be structurally similar to an indefinitely large number of different systems of

objects. The same problem would hold for our beliefs given the causal theory. Every time we could say that an actual cat causes the thought "cat" in me, we could also say, with equal justification, that an undetached cat part caused that thought. This is because wherever there are cats there are undetached cat parts, and wherever there are undetached cat parts there are cats. But if so, then no matter how we solve the problems above, it seems we have no reason, on the causal theory, to say that my thought "cat" refers to cats and not undetached cat parts. As a result, it is simply indeterminate whether my belief "that there is a cat" is true, given that it is indeterminate what that belief is a belief about.

Causal realists have attempted various ways of getting around these problems. One suggestion is that my cat-thoughts represent only what *normally* causes those thoughts.[13] Since cats normally cause cat-thoughts, they refer to cats. And therefore, a belief "that cats are furry" is true just when the object that is the normal cause of my cat-thoughts has the property that is the normal cause of my furry-thoughts.

Okay, but what the heck does "normal" mean? If it means "statistically normal" then it clearly doesn't help with the problem of error. Humans are prone to all sorts of perceptual illusions, bouts of wishful thinking, and so on. It may be statistically likely, for example, for small dogs seen in the distance to cause humans to believe that "there is a fuzzy cat." That doesn't make the belief true. So, the fact that whatever normally causes my "x-thoughts" has whatever property normally causes my "F-thoughts" doesn't mean that my belief that x is F is automatically true.

Neither does it help to claim, as some have suggested, that my cat-thoughts represent what causes them in ideal epistemic conditions: that is, conditions where I know the cat is nearby, the lighting is good, my glasses are clean, and so on.[14] Whatever other merits this suggestion may have, it won't do for purposes of reducing truth to a purely natural property. For the ideal epistemic conditions *are* ideal precisely because they are a situation in which I already believe certain relevant truths: namely, that the thing I see is not a little dog, my glasses are clean, and so on. The very property being defined—truth—ends up being invoked to explain the properties it allegedly reduces to.[15]

Finally, any form of causal realism faces a third and very simple problem. It implies that I can have beliefs only about things with which I causally interact. Causation is a paradigmatically physical phenomenon. Thus the "causal" part of causal realism means that various things whose antics make our be-

liefs true must be physical—things with which we can causally interact. The "realist" part of the view means that they must be mind-independent objects as well—like the traditional correspondence theorists, causal realists have no truck with relativism or contextualist views.

Here's the rub: we have beliefs about all sorts of things, and some of our beliefs are not about physical, mind-independent objects. I believe that two and two are four, that murder is wrong, that the economy is on a downturn (as of this writing), that flag-burning is constitutionally protected, and that Shakespeare was a better poet than yours truly. All these beliefs are true (especially the last one). But not a one of them seems to fit the causal theory's analysis. Take two and two being four. Whatever else numbers might be, they aren't physical objects like tables and chairs. And they aren't likely to be the marks we make on pages (those are "numerals"). Nor are numbers ideas in our heads, since two and two made four, presumably, before there were any numerals *or* ideas. The laws of physics couldn't be true if mathematical claims weren't true; so if there was anything around before humans, there were numbers. Numbers, then, are weird. If, as seems plausible, no number is ever in causal contact with our thought, then my belief that two and two make four can't be true in virtue of a causal relationship between it and numbers.[16]

Or consider my beliefs about the law and the economy. Far from being mind-independent, laws and economies are paradigmatically conventional items. Humans make them, and they don't seem easily understood as physical either. Even the Constitution of the United States isn't physical, as the following point shows: if every copy of the U.S. Constitution were somehow destroyed one day, that wouldn't mean that the United States suddenly had no Constitution. It would mean only that there weren't any copies around to consult.

Like the verificationist theory, causal realism can't explain the truth or falsity of all sorts of beliefs that we have in daily life. In my view, the sensible thing to conclude from this observation is that even if causal realism can explain how some of our beliefs are true (such as beliefs about the middle-sized dry goods of our immediate physical surroundings), it can't be the whole story. It isn't a successful reductive definition of truth.

Unsurprisingly, this is not how causal realists see it. Indeed, their reaction to this issue is remarkably the same as the verificationists: Hold the theory and damn the consequences. As a result, "Locate or eliminate" has become

the dominating mantra of much of contemporary philosophy. For any given subject matter that doesn't appear to be getting with the program, whether it be mathematics or ethics, the mission is to either find a way for it to really be about the natural world or give up on it as being a source of truth altogether. So for example, one famous philosopher, partly on the basis of causal realism, has ingeniously argued (I'm not making this up) that we can't have true beliefs about numbers. There is nothing that would count as a number that could be in causal contact with our brains. So, strictly speaking, it just isn't true that two and two are four. And many philosophers continue to believe, for similar reasons, that our beliefs about values can't be true either. They either hold that they are simply all false (because beliefs like murder is wrong just don't causally interact with anything objective) or they hold that ethical claims don't even get that far. They can't even be false, because they just aren't in that game of truth or falsity. They are disguised expressions of emotion, or efforts at manipulation, and that's all. This was just the theory we saw the verificationists adopt.

A striking fact about the contemporary philosophical scene, then, is how little distance there is between causal realism and verificationism when it comes right down to it. There are differences of course, but in the end the sorts of global worldviews encouraged by each view seem remarkably similar. The underlying thread binding them together is a puritanical form of naturalism, one that requires a naturalized theory of truth itself.

Moore's Problem

So far, we've discussed two ways in which one might try to reduce truth. There are other ways, of course, and I am not going to pretend that the above discussion is anything like exhaustive. In my view, the real problem with reductive naturalism about truth isn't that it can't locate some property or other that is necessary and sufficient for a belief's being true. The real problem is how to account for the value of truth.

In 1903, the philosopher G. E. Moore began a treatise on the nature of moral goodness with a quote from Bishop Butler: "everything is what it is and not some other thing."[17] Or in other words: things is as they is and ain't as they ain't. Either way, the sentiment is apt; for Moore didn't think that moral goodness could be reduced to an underlying physical property.

No attempt to define the concept of goodness, Moore thought, could succeed. The simplest way Moore had of making his point was via what has come

to be called the "open-question" argument. Suppose, for example, that we tried to define "x is good" as "x is pleasurable." No such definition could ever be right, Moore said, because it will always make sense to ask, "x is pleasurable, but is it good?" Substitute whatever allegedly physical property you like: survival value, utility, and so on, and it will always be an open question whether that property is good in every situation. And the very intelligibility of the question, he argued, indicates that our concept of goodness can't be the concept of any single physical property.

Moore's own view was that our concept *good* is simply unanalyzable. It just isn't the type of concept you can explain with an illuminating, reductive definition, the type of definition where one specifies a single property had by all and only the things to which the concept applies. Like the concept *yellow*, it can't be defined in terms of simpler concepts. Yet, like *yellow*, it is a concept that has real application in the world. Consequently, Moore concluded, goodness itself is a simple "nonnatural" property.

Moore's view was a smash hit at first, but later it fell out of fashion. This was owing in part to the fact that "nonnatural" properties seemed metaphysically spooky—a bit too much like "supernatural." And second, if "good" can't be defined in terms of something that we can get our hands on, so to speak, than how do we know about it at all? Even if we grant that *yellow* also can't be defined, at least we can see it. That's how we know what it is. So Moore's view seems to imply that we must somehow be able to "sense" goodness. The upshot is that Moore's view seems to make moral goodness into something of a mystery; you just have to know it when you "see" it with your built-in moral radar.

Notwithstanding the problems with his positive position, I think that there is a lot of sense in Moore's basic critical point. We've already seen reasons for doubting that either verificationism or causal realism can identify a property that is necessary and sufficient for a belief's being true. On that score alone, it is not surprising that both fail a parallel version of Moore's open-question test. "The belief that x is F is ideally verifiable, but is it true?" and "The object that normally causes my x-thoughts has whatever property normally causes my F thoughts, but is my belief that x is F true?" are both open questions. If either proposal was a good definition of "true," asking these questions would seem more like asking: "the man is a bachelor, but is he an unmarried adult male?" That question truly is unintelligible, but the above questions are not. Again, given the various objections we've seen above, this is not surprising. The above objections show that naturalist theories have a real problem identifying some underlying property N that all and only true beliefs share. And if

you already know, on independent grounds, that not all xs are ys, you know that no definition of x in terms of y will work.

Critics sometimes protest that Moore's open-question argument shows only that it is difficult to rigorously define vague and open-textured words like "good"—which is hardly surprising. But Moore's point actually goes much deeper than mere lexicography. His open-question argument is a way of illustrating an entirely general problem that faces any attempt to reduce a normative property to a purely natural property. Applied to truth, that problem is this. Suppose that a belief's being true consists in standing in some natural relation N to the world. What about a belief's being N makes it good to believe, or correct? On the face of it, no amount of information about what physical properties my beliefs actually have logically entails anything at all about what sort of properties they ought to have, or it is good for them to have. If I am given only physical information, it seems entirely open as to what the normative status of my beliefs might be. Consequently, the normative properties of my beliefs are distinct from those natural properties. This is simply a particular version of a very general problem first pointed out by Hume: that it is impossible to simply deduce how the world ought to be from how it is. From the fact that being whacked with a candlestick hurts, it doesn't follow that Colonel Mustard shouldn't whack you with one, unless one adds the additional normative assumption that one shouldn't hurt other people. The norm "don't whack" follows only from premises that are themselves partly normative. This point is sometimes put by saying that you can't deduce an "ought" from an "is." And that is okay, as long as one realizes that the important point isn't just about how we use words. The important point is that our moral claims pick out properties that appear to be conceptually distinct in kind from physical properties.

It is important to be clear about the point here. I am not concerned here with instrumental norms, like "good handwriting" or "being rich." Your handwriting is "good," let's say, just when it is legible or easily read by others. Thus, "your handwriting is very legible" really does entail that your handwriting is good, because those two phrases mean the same thing. But legible handwriting, while good, is only instrumentally good. It isn't worth caring about for its own sake—we care about it because we care about communication. Instrumental norms are about cause and effect relationships: they are of the form "if you want x, then do y." Unsurprisingly, then, they aren't the sort of thing to trouble a naturalist.

What is troubling for the reductive naturalist are what I called earlier deeply normative properties, or values. Deep norms are more than instrumentally

good. And as I argued right from the get-go most of us believe that truth is deeply normative. If it is, then any form of reductive naturalism about truth faces a big problem. For according to reductive naturalism, if truth is a substantive property, then it must be nothing over and above some physical property. But as I've just argued, deeply normative properties are over and above any physical property. Therefore, if truth is deeply normative, it too must be something over and above any physical property. If truth matters, reductive naturalism is false.[18]

Naturalism as Nihilism

A favorite joke of philosophers is that one person's *modus ponens* is another's *modus tollens*. From the claim that if *p* then *q*, one can either add *p* and deduce *q*, or add not-*q* and get not-*p*. (This kills them at the American Philosophical Association, which just goes to show that humor is relative. Or maybe it shows that philosophers aren't very funny.) In any event, the saying can be aptly applied to the most radical way of responding to our argument. From the premise that if truth matters, then reductive naturalism is false, one can always conclude that since reductive naturalism is correct, truth mustn't matter after all. So there.

In fact, this sort of in-your-face response has been made by at least one eminent philosopher, Stephen Stich. According to Stich, truth not only isn't worth caring about for its own sake, it isn't worth caring about at all. In Stich's view, having true beliefs isn't even good as a means to other ends.[19]

Stich is a hard-charging reductive naturalist if there ever was one. As he sees it, mental states like beliefs are really states of the brain. Accordingly, if these states of the brain are going to be true or false, they better bear some sort of natural, physical relation to the world. Thus Stich assumes that if there is any truth, it must be a sort of mapping of the world by our brain. In short, truth is what causal realists say truth is. Causal realists, recall, hold that beliefs are true or false as a result of (a) the structure of their parts; (b) the reference of those parts to objects and their properties; and (c) the way those objects and properties really are. Beliefs map the world in virtue of their being causally related to it in the right sort of way.

Stich has two ingenious, if ultimately unpersuasive, arguments for his conclusion that truth is not good. His first begins by pointing out—as I did earlier—that all by themselves, maps don't represent anything because they potentially represent too much. The same bunch of squiggly lines on a page

could be interpreted, in other words, as a map of any number of things. Similarly, for a brain state (what Stich takes a belief to be) to represent anything, it must be assigned a particular interpretation—one, roughly, that takes it to be about these objects rather than those objects. Yet it seems that there are indefinitely many ways to do this—just as there are indefinitely many things we could take any map to map—including electrical systems, or blades of grass, or anthills, or street systems or whatever. Stich then alleges that each of these different ways of assigning content to our beliefs results in a different "truthlike" relation, between which we have really no sound reason to choose. Put differently, my beliefs can map the world in all sorts of ways. Thus, on an interpretation where "gold" refers to the stuff with atomic number 79, my belief that there is gold in the safe will be true when and only when there is stuff with atomic number 79 in the safe. But on an interpretation where "gold" refers to any malleable yellow metal, then my belief will be true even if there is only fool's gold in the safe. So one and the same belief might not be true but still be, as Stich says, "true*." And there is an indefinite number of ways to interpret the reference of my thoughts and hence an indefinite number of ways my beliefs can map onto the world—some will be true*, others true**, and so on. And it is here, Stich argues, that we see that reductive naturalism leads us to the conclusion that truth has no value. Why should we think that believing truly is on the whole any better than believing truly*? For all we know, the instrumental and intrinsic value of believing truly* is just as good as believing truly or truly**. Absent any reason for thinking otherwise, we really can't say that truth is more valuable in any way than truth*.

I've already argued against causal realism, and I confess I am tempted to simply refer back to that previous discussion, adding only that if Stich is right, then we have just one more reason to reject that view. But even putting that aside, as both William Alston and Alvin Goldman have remarked, Stich's argument misses the mark anyway.[20] His argument implies that there are different ways to interpret a given brain state. What our beliefs/brain states are about is simply indeterminate from the standpoint of the physical evidence. But so what? The fact that there are different ways of interpreting a given map simply doesn't imply, *all by itself,* that there are different ways for any of those interpretations to be true. Similarly, just because there are different ways to interpret what our brain states are about doesn't mean that these states are true in different ways. Interpretation is one thing; truth is another. Thus Stich fails in demonstrating that there are any different "truthlike" relations in the first place, and his argument collapses.

Stich has another, more direct argument for the conclusion that truth lacks any instrumental value. He asks us to consider poor Harry, who, believing truly that his flight leaves at 8 P.M., gets on his plane only to have it crash and kill him. As Stich points out, had Harry believed falsely that the flight left at 9 P.M., he would have lived. Stich's point is that had Harry had one less true belief, and one more false belief, and everything else stayed the same, then Harry would have been better off. Thus, Stich concludes, having more true beliefs is not always instrumentally better than having more false beliefs. To this Stich adds that "it would be no easy matter to show that believing the truth is generally (or even occasionally) instrumentally optimal."[21]

I am not persuaded. There is no doubt that in some cases, having true beliefs can lead to bad consequences, as I've noted myself from the start. And sometimes even having more true beliefs than false beliefs will not be the best thing in a particular situation all things considered. This is the point of reminding us, that like most values, the value of having true beliefs is defeasible. But again: so what? True beliefs are *also* generally extremely useful. As Goldman has pointed out, take any claim of the form that "if I do *x*, then I will avoid harm"—for example, "If I look both ways before I cross the street, I won't get hit by a bus." It is extremely helpful, to put it mildly, for such beliefs to be true. Were more of them false than not, life would be nasty, brutish, and short. Finally, the following point about Stich's example is worth keeping in mind. It is certainly correct that if Harry had one more false belief and one less true one, and everything else stayed the same, he would have lived. But it is also the case that if Harry had one more *true* belief and one less *false* belief and everything else stayed the same, things would have worked out better for him. If he had not believed that he would be able to fly safely on that particular plane, but instead believed that his plane was going to crash, then Harry would still be collecting frequent flyer miles today.

The Motivational Tractor-beam

Another possible naturalist response concerns value and its link to motivation. It is an incontrovertible fact that some of the people much of the time, and perhaps most of the people some of the time, are not very motivated, perhaps not even motivated at all, to pursue the truth. People frequently mislead themselves deliberately; we ignore evidence, fail to listen, arrange things so we hear only those who agree with us, and so on. Of course, many times we are not motivated to pursue the truth because we believe that other values

should be given more weight than truth. Thus the scientific researcher might stop a certain line of inquiry if she determines that the only way to pursue it involves harming human subjects. But this isn't the only sort of case possible. Some people, we might say, aren't motivated to pursue the truth at all when it isn't in their benefit to do so. They see the instrumental value of having true beliefs, but they feel absolutely no desire to pursue knowledge when it is not beneficial or when it has no practical consequences whatsoever.

The fact that we are sometimes motivated to pursue the truth in this way may lead some to doubt that truth is a value in the sense I've described it. The reason is that some ethicists believe that real, deep values or norms must be like the tractor-beams favored by science-fiction writers: they reach out and suck you in. Specifically, they believe that if X is good and I judge that X is good, then, necessarily, I must be motivated to pursue X. To see something as good is to be motivated to pursue it. Good things, as it is sometimes put, have "to-be-pursuedness" built right into them. So if you can judge that something is good without being motivated to pursue it, it isn't really good after all.[22]

Put these thoughts together and you have an argument against the idea that truth is deeply normative, or more than instrumentally good: if truth were deeply normative, then it would be inherently motivating, a motivational tractor-beam. But truth isn't like this: we are not, even other things being equal, always motivated to pursue the truth. Therefore, truth isn't deeply normative.

What are we to make of this argument? Not much, I think. For starters, and as I've already noted, the fact that we might not want to pursue the truth about some matter or other may be a result of a whole host of factors. I might worry that pursuing the truth in that case is not best all things considered, for example. But even if we put that complication aside, the fact is that truth, like many other things, can be good without being inherently motivating.

Perhaps some things that are good are such that if we believe they are, we automatically desire them. But this isn't always the case. I can recognize that something is good without wanting it, and even more obviously, I can want something while seeing very clearly that it is bad.[23] At least with some things, motivation is not necessarily connected to something's being judged to be good. To use an example of philosopher Paul Bloomfield's, consider health.[24] Physical healthiness is good. A robust state of health is clearly instrumentally good; but a minimum amount of health (the amount necessary for one to still be alive) is arguably both instrumentally and intrinsically good. But not all of

us are motivated to pursue what we believe is healthy. In fact, many of us are frequently motivated to do what we *know* is unhealthy. But this hardly shows that health is not good. Neither does it show that I somehow don't really believe that, for example, not smoking or exercising every day is healthy. I do believe these things, and I further believe that I therefore ought not to smoke and ought to exercise every day, because what is healthy is good. But alas, that doesn't mean I *want* to do either. The gap from *should* and *want* can be very wide indeed.

Similarly, one can find oneself not motivated to pursue the truth, but this doesn't show that believing what is true is not good. What it shows is that we are only contingently motivated to pursue the truth. Knowing that one ought to pursue the truth does not *entail* that one is motivated to do it. That is a sad fact about the human condition. Truth, as A. E. Houseman once said, is the faintest of human passions.

Of course, none of this proves that truth *is* deeply normative. But it does derail the thought that truth isn't deeply normative just because it isn't inherently motivating. And it also derails another line of thought. Some naturalists have claimed that normative properties are "odd" or "queer" sorts of properties precisely because they (according to these philosophers, anyway) have this "to-be-pursuedness" aspect built into them. The thought is that properties like this would be so strange that they just couldn't be the sort of properties that could be found "out in the world." Hence one might think that even if truth *were* inherently motivating this would just end up showing that truth was some sort of ontologically odd property.[25]

Maybe so, but truth isn't inherently motivating; and so we can put this argument safely aside.

The Possibility of Pluralism

So, to believe that truth is good, you don't have to believe it is some sort of weird motivational tractor-beam. Still, reductive naturalists may protest that the position I've been defending makes truth odd in another way. I've claimed that truth's being good makes the property of being true something over and above any physical properties a belief may have. Truth does not "reduce" in this sense. But then one might wonder if we aren't just left with something like Moore's position applied to truth. Critics attacked Moore, recall, because they thought he made goodness a mystery—a simple property

we can't say anything about. This is partly because Moore's problem isn't just with natural or physical properties. *Any reductive theory of truth,* any attempt to say that truth is nothing over and above some other property (whether it be coherence, pragmatic justification, or what have you), faces the same problem if any does. Moore's problem is entirely general in this sense: it isn't just physical properties; *no purely "descriptive" property can ever suffice to capture a deeply normative property.* If Moore is right, then the normative will always be something over and above the nonnormative. And that, one might worry, really does make truth a mysterious sort of property, unrelated to, and unanalyzable in terms of, any other sort of property. And it causes an epistemological worry too: if truth is really like this, we would have to have a special sort of "intuition" to be aware of it, just as Moore believed we needed some sort of special moral sense to be aware of goodness.

In short, the naturalist argument I'm imagining is this: if truth were really deeply normative, then it would be a Moorean mystery—a simple *sui generis* property. But it is extremely dubious that there are any properties like this. Hence, we should conclude that truth is not deeply normative.

In response, one could always grit one's teeth, bite the bullet, and just maintain that truth is mysterious and that is it. Truth is queer but here, so to speak. One could say this, but we don't have to. We can believe that truth is always something over and above descriptive properties without having to think that truth is mysterious. To claim that truth is reducible to purely descriptive or naturalistic properties is one thing; to think that we may still be able to give descriptive or naturalistic criteria for a belief's being true is another. You can reject the former without rejecting the latter. Indeed, this was just G. E. Moore's position. As he said, "I never should have thought of suggesting that goodness was 'non-natural' unless I had supposed that it was 'derivative' in the sense that, whenever a thing is good (in the sense in question) its goodness . . . depends on the presence of certain non-ethical characteristics."[26] In short, Moore believed that moral properties like goodness were dependent on natural properties without being identical to such properties. The dependency in question Moore thought, was this: if two actions are alike in every physical aspect (caused by the same event and having the same consequences, for example) then they must be alike morally. If the one is good, then so must be the other. As it is sometimes put, moral properties *supervene* on natural or physical properties. Since moral properties can't be defined in terms of physical properties, they are something over and above the physical

properties. Nonetheless, they depend on them in the sense that there can't be a change in moral properties of an action unless there is a change in its natural or physical properties.

This sort of dependency relationship is not just confined to the realm of the moral. In fact, all sorts of things that we believe exist are dependent on other things in precisely this way. Imagine that you and I begin making two sculptures of Groucho Marx. Amazingly, we end up with statues that are completely indistinguishable. If we judge the one statue to be a good likeness (it captures his famous grin), then we must judge the other as a good likeness as well. Intuitively, the aesthetic property of being a good likeness is not identical to any particular physical property the statues may have, but it does depend on their physical properties. A slightly more controversial example concerns the mind. Many researchers believe that mental or psychological properties supervene on physical properties, such as the neurobiological properties of one's brain. Anyone physically identical to you, in other words, will also be mentally identical. Yet again, we might think mental properties, such as the property of being in pain, are still over and above the physical properties on which they depend. Or consider economic properties. Being worth a dollar is not identical to any lower-level physical property of a particular piece of green paper, or any other collection of physical properties. Nonetheless, whether something is or isn't worth a dollar is certainly dependent on noneconomic properties in a particularly obvious way: if you have two identical objects (coffee cups, say) made out of the same stuff with the same origin and history (that is, one wasn't previously owned by someone famous, for example), then if, at a particular time, the first is worth a dollar, so must the other be worth a dollar. Like mental and aesthetic properties, it seems clear that economic properties are dependent on other sorts of properties—not just physical properties in this case, but social and historical properties of objects.

The exact nature of the dependency relationship in each of these cases is a matter of debate among philosophers. Some will point out, for instance, that if the dependency between two classes of properties is strong enough, we may end up giving up on the idea that they are really distinct classes after all. While I admit it is controversial, in my view this is not plausible for the cases just mentioned. In these cases, the properties in question can be said to depend on the physical without reducing to the physical. Broadly speaking, there are two reasons for this. First, in these sorts of cases, we don't think that

there is some sort of conceptual link between the physical properties and the moral, mental, or economic properties. We don't think, in other words, that you can simply *define* "*x* is good" or "*x* is in pain" in purely physical terms. Second, dependency is not identity. It goes only "one way." Take mental or psychological properties, for example. Plausibly, if two persons are exactly alike in terms of their physical properties, they can't differ in terms of their psychological properties. No mental difference without physical difference, as it is sometimes put. *Yet the reverse doesn't hold: whatever is alike in all psychological respects needn't also be alike in all physical respects.* Dogs, for example, can experience pain, and so can humans. But there is no reason to think that when a dog and a human experience pain their brains must be in the same state. And we can imagine that extraterrestrials physically different from us with whom we share similar psychologies. Or take economic properties again. No two objects can be economically different but identical with regard to their natural or historical properties, but two things could be naturally or historically different but still worth the same amount of money.

This may seem like a small point, but in fact it is rather explosive. For what it implies is that *X*-properties can depend on *Y*-properties without particular *X*-properties depending on *the same* particular *Y*-properties. The particular underlying *Y*-properties that *X*-properties depend on can vary. And in the cases just discussed, it seems highly likely that this will be the case. Philosophers typically put this by saying that, in these sorts of cases, the "higher-level" property (e.g., the moral or mental property) can be *multiply realized*—the exact lower-level property it depends on may vary with context.[27]

Here's the pay-off: it seems clear that truth could be understood in a similar way. Like moral properties, we don't think there is a logical, conceptual entailment between the natural properties of a belief and its truth. This is because, like moral properties, truth is a normative property. Nonetheless, the property of truth remains strongly dependent on other properties that a belief may have. More precisely, given a belief of a particular kind, if that belief is true, then it has some property *P* such that necessarily, if a belief of that kind has *P* then it is true, and if it doesn't have *P* it is not. Just like moral and mental properties, the property of truth can be seen as something over and above the properties on which it depends, but it depends on them just the same.

If this suggestion is right, then we can think of truth itself as what philosophers call a *functional* property. As I've noted previously, true propositions can be seen as having a certain job—or function—to perform in our mental life.

True propositions are those that are good to believe, and that correctly portray the world as it is. This is truth's job description, as it were. Beliefs or propositions are true when they do that job. Thus the lower-level property of a given belief on which its truth depends can be thought of as what accomplishes the job of *being true* for that type of belief. It *does* the truth-job for that sort of belief, but it is not the property of being true itself. Being true is having a particular job, the job of correctly portraying things as they are.[28]

The advantage of this approach is twofold. First, it allows us to avoid saying that truth is a mystery. At the very least, truth is no more or less mysterious than many other properties we find in our daily life. Second, and more important, it opens the door to a pluralism about the sorts of properties of beliefs on which truth depends, or which get the truth-job done. I've noted that what plausibly explains one sort of proposition's truth does not explain the truth or falsity of another sort. My car and my house cause most of my beliefs about my car and house, and presumably this fact has a lot to do with why my beliefs about them are true when they are. On the other hand, as I argued earlier, it is not at all clear that this account can help explain the truth of other sorts of beliefs, such as beliefs about what is legal or illegal. Intuitively, what we want to say is this: beliefs can be true in different ways. And this point dovetails nicely with the current suggestion that truth is a higher-level functional property. For as we all know, a given job, like being a teacher or a cashier, can be done in different ways by different people in different contexts. There is *one* job but *more than one person that can do it.* There are many realizers of that job. So too with truth. A belief is true when, among other things, it gets things right. But what property of that belief does the job of "getting things right" (or "correctly portraying the world as it is") may differ depending on the type of belief in question. Thus, when it comes to beliefs about the physical world around us, like my belief about that big spruce in my yard, it is likely that the truth of that belief is realized by its being causally responsive to some bit of the concrete world—in this case, the spruce. My belief's being causally responsive to the presence of the tree is how it gets the job of being true done. But even so, this doesn't mean that this job always gets done in the same way. For other sorts of beliefs, truth may come in a different form in that the job of being true gets realized differently. Of course, since truth is normative, it must be good to believe a proposition that has a property that realizes truth's job or function. But this is not because of any intrinsic facts about the lower-level property itself. What makes it good to believe a

proposition with the relevant lower-level property is precisely that it is doing the *truth*-job—and part of doing that job is being a property that is good for beliefs to have. Thus it is good to believe what has the realizing property just because in doing so, one believes what is true.

I've argued in this chapter that if truth is a deeply normative property—one that is more than instrumentally good for our beliefs to have—then it isn't reducible to a purely physical property of our beliefs. Yet the idea that truth is irreducible does not mean that truth is a mystery. It instead opens the door to a new possibility: that truth, much like courage, kindness, or love, is one thing that comes in many forms.

7 Truth as Fiction

Analogies

Philosophical problems and answers tend to repeat themselves. Ask "What is X?"—where "X" could be the beauty, or truth, or God—and the philosophical opinions will sort themselves into familiar groups. Some will say that being an X is nothing over and above being a Y. This is reductionism—the idea that, for example, truth is just correspondence, or coherence, or whatever. Others will insist that X is an irreducible mystery—an important but indefinable feature of the world. Others might attempt to say that X supervenes on different properties in different contexts. But still others will simply dismiss X as a fiction. This last group will claim that "What is X?" is a misguided question. Like the witch, the unicorn or the liberal U.S. politician, X is a myth. It doesn't exist.

The idea that truth is a type of fiction sounds at once radical, interesting, and a bit screwy. After all, how can one say it is true that there is no truth without contradiction? But in point of fact, the position can be made consistent, and more than one philosopher has flirted with it. That doesn't mean it is right, however. Consistency is one thing—plausibility is another. As a result, strictly speaking, it is not very popular among philosophers to deny that truth exists. But like a lot of radical ideas, the idea that truth is a fiction does have more moderate and reasonable cousins. On these views, truth can be said to exist; it simply has no nature that needs explaining. The question "What is truth?" is therefore still misguided; it is not a deep philosophical issue.

This latter sort of view *is* popular among professional philosophers. Interestingly, many who hold it agree with me that truth matters. To that extent, I have no quarrel with them—at least in this book. In my own view, however, the idea that truth has no nature is not easily combined with the idea that

truth is good in the way I've been claiming it is. If truth is not a substantive feature of the world, it is hard to see how it could matter very much.

Nietzchean Lessons?

Few philosophers have written more forcefully and influentially on the value of truth than Nietzsche. And arguably, no other philosopher has campaigned so aggressively for the idea that truth has no value. I say "arguably" because everything about what Nietzsche says is disputable, especially when it comes to his claims on truth. What *is* clear is that Nietzsche didn't think it was just self-evident that we should care about truth—whether or not we do care about it. Thus he asks: "Granted we want truth, why not rather untruth?"[1]

Even if he thought truth had some value, at one point, Nietzsche rejects the idea that it was what I've been calling deeply normative or good. That idea— that truth is worth caring about for its own sake—he called "the prejudice of the philosophers."[2] He didn't expect his rejection of this to sound intuitive (to philosophers anyway): "The falseness of a judgment is for us not necessarily an objection to the judgment; in this respect our language may sound strangest."[3] Nonetheless, he finds the "prejudice" rather ridiculous, "as if there were an actual drive for knowledge that without regard to questions of usefulness and harm, went blindly for the truth."[4]

Nietzsche here makes two mistakes, both of which I've already argued against. He first assumes that if you believe that truth is worthy of caring about for its own sake, then you must also believe that the pursuit of truth should be blind to any other values or concerns. This, as I've argued from the beginning, is just wrong. No matter what we are talking about, we must always balance the pursuit of one good against the pursuit of others. One can believe that truth's value is more than instrumental without buying into the idea that there is only one *supreme* good. His second mistake is in thinking that believing truth is more than instrumentally good means that we all must have some inner "drive for truth." This is the idea that if things are good, they must be motivational tractor-beams. As I argued earlier, this is a bad idea. We should pursue the truth, but we don't always do what we think we should do.

There is a tendency in Nietzsche, like many philosophers before and after him, to lump the thesis that truth is a real and independent end of inquiry together with Platonic myths that truth is *one* and certain. Readers who make

these same assumptions therefore often hail him as something of a prepost-modernist, as advocating a new theory about the nature of truth, one that links truth to power. And remarks linking truth to power are not difficult to find in his writings. He says, for example, that "the criterion of truth resides in the enhancement of the feeling of power."[5] Elsewhere he adds: "the will to truth would then have to be investigated psychologically: it is not a moral force, but a form of the will to power."[6] And "will to truth is a making firm. . . . 'Truth' is therefore not something out there, that might be found or discovered—but something that must be created and that gives a name to a process."[7] On the basis of these and similar remarks, many commentators think he advocated a form of relativism. Others have argued that he believed in a type of pragmatism about truth.[8]

While both of these interpretations have some plausibility, I am more interested here in another possibility, recently pointed out by Alessandra Tanesini.[9] This other possibility is that Nietzsche is not interested in telling us what the hidden nature of truth is. As Tanesini reads him, Nietzsche's vision of philosophy is essentially revisionary in character. He had no interest in simply *describing* the property of truth because he doesn't think there is such a property of being true, or truth. As Nietzsche once caustically remarked, sweeping as usual many things together in one steamroller of a sentence, "there exists neither 'spirit'; nor reason, nor thinking . . . nor truth." All of them, he proclaimed "are fictions without use."[10]

Accordingly, Tanesini thinks, Nietzsche wasn't so much interested in giving us a theory of truth, but in getting us to see that truth wasn't the sort of thing that we could meaningfully theorize about. What we can theorize about is our psychology—why we value truth and why we bother to utilize a word like "true" to commend and endorse statements. As Nietzsche says at one point: "What is needed is that something must be held to be true—not that something is true."[11] It is the holding true, the fact that something passes as true in one's culture, that intrigues Nietzsche, not the being true. *Being true* is a fiction; holding true is what is important.

If this interpretation is right (and I think it is at least a contender) then perhaps Nietzsche is not identifying truth with power, but telling us to give up on the idea of truth in favor of the idea of power. On this view, the central Nietzschean lesson is that it is power that is valuable, not truth.

I say "perhaps" here, because as I've already noted, understanding Nietzsche's intentions is a difficult business. Bernard Williams, in his own recent

book on truthfulness, argues that Nietzsche was in fact very serious about truth in a certain sense and thought it highly important.[12] And Williams's view is not entirely implausible. Sometimes Nietzsche writes as if what he wants us to see is the real truth about ourselves—stripped bare of the obscuring myths we constantly enclose ourselves within. Perhaps the best we can say, as Kristin Pfefferkorn has noted to me, is that Nietzsche himself just didn't have a single, stable view of truth across his entire career.

Nonetheless, the idea that we should replace, not identify, truth with power is there for the taking in Nietzsche's texts. Unsurprisingly, the contemporary philosopher who has most absorbed this lesson—whether or not it was actually Nietzsche's—is Richard Rorty. Rorty, as we've seen in previous chapters, is not fond of the idea that truth is valuable. Like Nietzsche, Rorty is often interpreted as holding some sort of relativist pragmatism. But Rorty's considered view, perhaps like Nietzsche's, is subtler than his critics tend to admit. The reason for the confusion is that as Rorty has candidly noted, philosophers like himself tend to go back and forth between wanting to reduce truth and wanting to eliminate it.[13] In reductionist moods, Rorty was tempted to reduce truth, for example, to justification. That is, like other pragmatists, he was prone to define "x is true" as "x is useful" or "x is justified relative to the standards acceptable in my community," or some such. Since what your community accepts, and what is believed to be useful, is very much a matter of who has the power, this could be glossed as the claim that truth reduces to power. But Rorty's considered view is more radical, and if Tanesini's interpretation of Nietzsche is correct, more Nietzschean. As Rorty puts his view: "truth is not the sort of thing we should expect to have a philosophically interesting theory about."[14] It is not that the secret nature of truth just is justification or power or whatever. There is no such thing as the nature of truth. Consequently, rather than trying to reduce truth, we should just stop worrying about it entirely.

Rorty thinks that this is more authentically pragmatist, in part because, as we've seen, attempts to reduce truth to something else (like "utility") always end up impaled on counterexamples. Further, the reductive route just doesn't go far enough in throwing off the Platonic yoke. It just recapitulates the old project of "metaphysical activism" that tries to lead us from the cave and into the light. The nature of the light has been changed, of course—from "correspondence" to "utility"—but the metaphor is still the same. Better simply to

give up the idea that there is such a thing out there as "the nature of truth" and get on with the down and dirty business of politics.

But how can we make sense of this view? How can we make sense of the idea that there really isn't anything to truth? As I noted earlier, it isn't as hard as it sounds. Views like Rorty's are usually called "deflationary" in that they deflate the pretensions of the more standard views like pragmatism and the correspondence theory to bare the inner nature of truth. The case for any sort of deflationism generally starts by calling attention to the so-called transparency of truth. When we consider that it is true that roses are red, it seems that we can "look right through" its truth and simply consider that roses are red. In other words, we can infer that roses are red from the proposition that it is true that roses are red, and vice versa. The deflationist calls our attention to the fact that in general we accept that the belief (utterance, proposition, etc.) that p is true if and only if p. The basic idea is that this schematic principle (more or less, depending on the variety of deflationism involved) explains all there is to explain about truth.

The earliest and perhaps the most radical form of deflationism is sometimes called the "redundancy" theory of truth.[15] On this account, "it is true that p" is literally a long-winded way of saying "p." To say that it is true that roses are red, for example, is really just to say in different words that roses are red. Thus we only *appear* to ascribe a property to a sentence or proposition when we say that it is true; we are in reality ascribing nothing, and saying nothing more than if we had simply stated the proposition itself. Of course, it admits that there is a *word* "true" that we all understand and employ. And that word may have a practical function—it may help us signal our agreement with what others have said, or it may have a "cautionary use" as Rorty believes—warning us that what we may justify to one audience we may not be able to justify to another. What the redundancy theorist denies is that this word picks out any property—be it relative, objective, or whatever—that some beliefs have and the rest do not.

The view is a bit like moral skepticism. When someone says that there is no such thing as an immoral action, they don't mean that there are no actions that are *labeled* "bad," "evil" "immoral" or the like. They can admit that a society may find it practically useful to label actions in this way. They mean that it is a mistake to think that there is anything *behind* the language of morality, something that makes one action right and another wrong. It is not that

moral properties like "good" are relative to a culture or whatnot; there just aren't any such things. In the same way, the radical deflationist about truth thinks there is nothing behind our usage of "true." In particular, there is nothing that *makes* our beliefs true, relatively, absolutely or otherwise. It is best simply to give up on the idea that truth is a property of our propositions or beliefs at all.

The redundancy theory, then, makes sense of the idea that strictly speaking, there is no such thing as truth—in the sense that there is no property of truth. And if one adopts this radical form of deflationism, then it is clear that you'll also have to deny that truth is a value. If, strictly speaking, there is no such thing as truth (no such property) then there is literally nothing *to be* valuable. It might be practically useful to call some beliefs "true" and others not, but it can't be worth caring about truth for its own sake. For again, there is no property of truth that some beliefs have and others lack to care about.[16]

The redundancy theory is very implausible, however. The key to the view, remember, is that *it is true that p* simply means the same thing as *p*, where "*p*" is a variable for any proposition whatsoever. The thought is that ascriptions of truth are simply superfluous; they add nothing to the content of what has already been said. But a moment's consideration reveals some clear counterexamples to this claim. Consider, to take just one example, the claim that

Everything the Maximum Leader said is true.

Clearly, the claim that *Everything the Maximum Leader said is true* is not equivalent to everything the Maximum Leader said. When we generalize over claims like this, we are not just repeating what is said because we may not even know what was said (such generalizations are therefore sometimes called "blind"). And obviously, there is not just one example. There are lots of times we wish to generalize over a huge amount of claims in this way, like when we say that every proposition is either true or false. Accordingly, all ascriptions of truth are not redundant as the theory demands.

The redundancy theory, then, although simple, is not workable. Nonetheless, many philosophers remain tempted by its basic insight: that anything we can say with the word "true" we can say without it.[17] But even if this were true (which it isn't) it wouldn't show that truth really isn't a property. Just because one can dispense with *a word* doesn't itself show anything about what does or doesn't exist in the world.[18] If you want to be a deflationist it isn't sufficient to point out that in some theoretical sense, we can do without the *word*

"true." If you want to say that truth isn't a real property you need to provide some independent metaphysical arguments. You might, for example, take the Rortian/Nietzschean route: reject the idea that truth is objective, also find problems with the idea that truth is coherence, or pragmatic justification, and so on, and then conclude that there just isn't any property of truth. On the other hand, one might be impressed by naturalism. As you'll recall, reductive naturalists must believe that if truth is a property of our beliefs, then truth must reduce to a physical property. But as we've seen, it is very unlikely that truth will so reduce. In my view, this just means that we should reject reductive naturalism. But some will draw quite a different conclusion. Instead, they reject the assumption that truth is a property. If truth isn't really a property, then naturalism is off the hook. There is no embarrassment in not explaining something when there isn't anything really there to be explained. It is this aspect of deflationism that explains its current widespread appeal among many analytic philosophers: it saves the day for reductive naturalism. It offers to explain away our language's seeming commitment to a putatively nonphysical property.

As I've already noted, there are various forms of deflationism, some more plausible than others.[19] And many deflationists don't see themselves, as Rorty does, as giving up on the value of truth. In their own eyes, they are friends of truth, as pious as the rest of us. In terms of a religious analogy, they would say that God exists, but not in the way the traditionalists have always believed. Nonetheless, they would insist that the concept and the associated ideas of piety, worship, and so on, are still extremely valuable, perhaps even in some sense indispensable, and whose function in thought can be explained without recourse to anything spooky or metaphysical.

Minimalism

According to philosopher Paul Horwich, there is no harm in thinking that truth is a property; it is simply not the sort of property we can say much about, metaphysically speaking: it is not a property with a nature. Horwich calls his view minimalism. This is an apt name; like a minimalist painting, a minimalist theory of truth eschews the baroque. What matters are simplicity, clean lines, and pure form.

Unlike Rorty, Horwich thinks truth is valuable. And without a doubt, Horwich's view has many advantages. But in my own view, Horwich still can't

believe that truth matters in the sense I've been defending in this book. Consequently, I think minimalists like Horwich must either abandon their minimalism or join ranks with revisionary skeptics like Rorty, declare truth without value and storm the temple gates.

Horwich has developed minimalism in significant detail, and I won't try to summarize everything one might say about it.[20] But here is a rough sketch. Like any deflationary view of truth, minimalism has a metaphysical part and a semantic or conceptual part. Metaphysically, minimalism, as I just noted, allows that truth can be a property of sorts. That is, if you think that any normal predicate expresses a property, then truth is a property. It is just not a *substantive* property. Substantive properties, according to Horwich, are properties that admit of a constitution theory. That is, they are properties that can be reductively defined or identified with some more basic property.[21] These properties, on this view, are those sorts of properties that have an explanatory role in our theorizing about the world—we appeal to them in explaining other things of interest. They are properties that have underlying natures that need explaining. Truth, according to the minimalist, has no such role, and no such nature.[22]

Conceptually, the key idea behind minimalism is that our grasp of the concept of truth consists entirely in our disposition to accept instances of the propositional version of the T-schema:

(T) The proposition p is true if and only if p.

The function of the truth predicate, on this account, is that it serves as a device of generalization. Purely in virtue of (T), it allows us to summarize open-ended strings of claims. Thus, when we say, "Something Alice said was true" we usefully summarize an open-ended disjunction of conjuncts: for example, "Either Alice said that roses are red and roses are red, or Alice said that snow is white and snow is white," and so on. The basis for our use and understanding of the truth predicate, and the thin property it expresses, is hence simply our acceptance of the instances of the T-schema, and that is what we need in order to explain both the concept of truth and *all the facts that involve truth*.[23] No robust metaphysical account, and in particular, no account of a substantive truth property, is needed.

My misgivings about this theory are these. We believe that truth is good; that is, we believe what I earlier called the truth-norm:

(TN) Other things being equal, it is good to believe that p if and only if it is true that p.

But (TN) can't be derived from the purely nonnormative (T). Therefore, *contra* minimalism, that schema cannot fully capture everything we believe is true of truth. It can't capture all the facts about truth.[24]

Horwich, of course, disagrees. According to Horwich, (T) may not entail (TN) directly, but it does do so given the assumption of certain other obvious facts *not* involving truth. On this basis, one might claim that whatever else (TN) might be, it is not a substantive fact about *truth as such.*

According to Horwich, claims about the value of truth are simply more cases of using the word "true" to generalize a more complicated thought. (TN), in other words, is simply shorthand for our disposition to accept every instance of:

(B) Other things being equal, it is good to believe that *p* if and only if *p*.

Note that (B) doesn't mention truth at all. In other words, to say that it is good to believe the truth is simply shorthand for saying we are disposed to accept an open-ended stream of little belief norms, namely:

It is good to believe that the dog has fleas if and only if the dog has fleas, and it is good to believe that roses are red if and only if roses are red, and it is good to believe that . . . and so on.

The result is that we explain the value of truth in terms that don't explicitly mention truth. The concept of truth is needed only to help us express that infinite collection of commitments. As a result, the value of truth is either not deeply normative in character after all; or it is deeply normative, but this is derivable from the nonnormative T-schema, and hence no threat to minimalism.

This reply does not succeed. If we are to use (B) to help us derive (TN) from (T) then we must be rationally justified in accepting its instances. But if we are willing, *a priori,* to endorse an infinite list of *normative* propositions all of which fit a particular pattern, it is highly likely that there is a general, principled reason that we do so. And in my view, the reason we accept (B)'s instances is that we accept (TN); therefore, (B) can't be used to deduce (TN) itself from (T). Accordingly, (TN) is a fact about truth that minimalism can't explain. Or so I will now argue.

What is the reason we think that it is good to believe that Socrates was a philosopher if and only if he was, and so on? What, in other words, justifies or rationally explains our acceptance of all the instances of (B)? To see the force of this demand, let's first look at why one sort of explanation is *not* going to work. It is not the sort of reply that Horwich himself would make, but

it will help us see the difference between the present call for explanation and a similar one in the case of (T). Suppose we ask why we are inclined, *a priori,* to endorse every (nonparadoxical) instance of (T). Here, a more traditional deflationist, like a redundancy theorist, will claim that saying "it is true that *p*" doesn't say anything significantly more than saying *p*. This is how the thought that there isn't anything really in common among the things that are true that makes them true gets off the ground. At first, it may look as if there must be a general principled explanation, an explanation in terms of some common property shared by all and only true propositions, for why we accept every instance of (T). The redundancy theorist argues, however, that the need for this explanation is illusory, since the claim that it is true that snow is white is, in some sense or other, telling us nothing more than that snow is white.

Whatever its merits in the case of (T), that answer is definitely implausible when we turn to (TN). We are not talking about *snow,* elliptically or otherwise, when we say that it is good to believe that snow is white! We are saying that one *ought* to have a certain *belief.* So, unlike the case of (T), there is no reason to think there is a semantic equivalence between the right- and left-hand sides of (any instance of) (TN). As such, we can't appeal to any such equivalence in explaining why we are disposed to accept every instance of that schema.

So we are left with our question: why do we accept the infinite list of little belief norms? Answering this question is crucial, because the nonminimalist has a ready and obvious answer. The reason we should accept that it is good to believe that snow is white just when snow is white, and good to believe that Socrates was a philosopher just when he was, is that it is good to have true beliefs. What makes it good to believe a proposition is that proposition's *being true.* But obviously the minimalist can't at this point adopt this simple and obvious explanation, because according to minimalism, there is no fact involving truth that doesn't derive from (T). So there is nothing about true beliefs themselves that could, on this view, rationally explain why we think it is good to have just that sort of belief. As a result, minimalists must either come up with some other explanation, or admit they can't explain every fact about truth.

Horwich has acknowledged the force of this demand in a number of places.[25] In his earliest writings on this topic, he argued that the minimalist could explain why we accept (B) solely by appealing to the pragmatic value of having true beliefs.[26] To put the point in minimalist terms, if we want to get to the hotel, and we believe that we will if we take the train, then it will be good if it really is the case that if we take the train then we'll get to the hotel. More

generally, for anything X that I might happen to want, I ought, rationally speaking, to make sure all of my beliefs of the form "If I do A, then I'll get X" are true. Further, since such beliefs always are the result of inferences from other beliefs about the world and how its contents behave, I have a solid pragmatic rationale for always seeking the truth of my beliefs. For I can never know what beliefs might be useful in the future for helping me get what I want. Thus what makes it good to accept *every* instance of (B) is that it is practically valuable, or at least potentially practically valuable, to do so.

This is fine as far as it goes, but it runs smack up against the point that truth has more than instrumental value. In more recent work, Horwich has noted this and argued that minimalism can account for this fact as well. Bernard Williams, interestingly, agrees.[27] The point is not difficult. According to Williams, accepting that truth is more than instrumentally good amounts to accepting:

(BI) It is more than instrumentally good to believe that p if and only if p.

But here again the minimalist faces the problem of explanation, and this time in spades, for now we are accepting an open-ended list of deep, noninstrumental norms. What accounts for our accepting infinite statements of this form? What makes it more than instrumentally good to believe that Socrates is a philosopher just when he is?

Again, the answer can't be in terms of some good-making property of beliefs. The minimalist must explain our acceptance of all the instances of (BI) by appealing to some other reason. We've already seen that this reason can't be, for the minimalist, that for each p, "p" and "it is good to believe that p" simply mean the same thing. Rather, the minimalist is likely to respond that the individual belief norms of (BI) are *explanatorily basic* in precisely the same sense the instances of (T) are basic. That is, we accept them in "the absence of any supporting argument" and "we don't arrive at them, or seek to justify our acceptance of them, on the basis of anything more obvious or more immediately known."[28] If so, then the minimalist may argue the he *can* explain the value of truth as follows: We can deduce (TN) from (a) the equivalence schema (T), and (b) for each p, the explanatorily basic fact that it is good to believe that p if and only if p. Since facts of this form do not involve truth, it follows that (TN) poses no problem for minimalism.

I have two replies. First, to say that instances of (BI) are basic is to say that we don't need to justify our acceptance of them. But we have encountered in this book many philosophers who precisely believe that we do need to justify

our acceptance of them. These philosophers don't think it is obvious that we should think that for any *p*, it is more than instrumentally good to believe that *p* if and only *p*. These skeptical views are *coherent*, even if they are not correct. We needed arguments to dispose of them. But it would be hard to see how we would have needed these arguments if instances of (BI) were just explanatorily basic. For similar reasons, it is certainly reasonable to ask *why* we should think that it is more than instrumentally good to believe that roses are red if and only if roses are red. It is not a question that necessarily seems to answer itself. The tempting answer surely is that it is (more than instrumentally) good to believe this precisely for the same reason it is more than instrumentally good to believe that snow is white if and only if snow is white: because it is good to believe what is true.

My second point is that by claiming that instances of (BI) are explanatorily fundamental the minimalist is committed to holding an implausible form of *particularism* about cognitive norms. Particularism is the view that there are no general rules, even *prima facie* rules, for determining what is good or bad in particular cases. Rather, particular normative judgments are explanatorily basic: they are not justified by any more basic normative rules. The most familiar form of particularism is moral particularism. Thus, the traditional moral theorist, for example, will justify a particular judgment (you should repay this specific debt) on the basis of a principle (you should, other things being equal, repay your debts). The moral particularist, on the other hand, takes each situation as different and even unique, and denies that an appeal to principles will help us justify our decisions about what to do. The fact that you've repaid one debt today involves no appeal to any general rule that would justify repaying a different debt tomorrow.

My point is that if we say that instances of (BI) are basic in the sense that we don't need to justify them, then we are adopting an analogous form of *cognitive* particularism. Again, consider the analogy with promising. The moral particularist may agree that it is good to keep that promise, and that one, and so on. What she disagrees with is that we need to justify all this promise-keeping with a general norm of the form *if x amounts to keeping your promise then x is good*. Similarly, the minimalist suggests that it is good to believe that snow is white if and only if snow is white, and good to believe that grass is green if and only if grass is green, but denies that we need to justify this by appealing to the cognitive norm that *it is good to believe what is true*.

Particularism can be tempting. But it is classically very difficult to maintain, for at least two reasons.[29] First, it is difficult for the particularist to ex-

plain how we learn from our experience. As Hare notes, "to learn to do anything is never to learn to do an individual act; it is always to learn to do acts of a certain kind in a certain kind of situation; and this is to learn a principle. . . ."[30] For example, a child learns to say "thank you" after receiving something, just when he grasps that the next time someone gives him something, he *should* say "thank you." Learning takes place in particular situations, but it is *learning* just when it involves the adoption of general rules. This in turn uncovers the second point: that normative reasoning always implicitly involves general rules. This is because in making normative judgments, we are required to make similar judgments in similar circumstances. Consider again the moral case. Suppose I advise two friends to keep their promises, even though they are different promises made to different people. If questioned, it would be odd if I didn't try appealing to a general principle that *explained why* I treated the cases alike. And it would be very odd if I instead insisted that there was nothing alike between the cases, and that it was just a basic fact that in each situation, the promise should be kept. Similarly, it would be just as odd if I told one friend to keep her promise and the other not to do so but refused to *explain why* the cases were different. Either way, it would be as if I had opted out of the normative point of view. It is part of normative reasoning to treat like cases like, and in so doing, we implicitly appeal to principles that pick out the common features of the situations in question. And it is hard to see why the same point won't hold in the case of belief. If I am justified in thinking it is more than instrumentally good to believe that snow is white just when snow is white and so on for every other instance of (BI), then it seems reasonable, just on the basis of these uncontroversial facts about normative reasoning, that this is because there is something in common among all these instances: in each case, it is good to believe what is true.

Nonminimalists can adopt cognitive particularism as well, of course.[31] But if the above reasoning is right, minimalists are committed to it. And that seems a serious problem for minimalism. For even if we allow that the jury is still out on whether cognitive particularism is correct, this means that minimalism is tied to it in a way that other views are not.

So far, I've considered how the minimalist might simply refuse, in effect, to give an explanation for why we accept instances of (BI). One more alternative deserves attention. Perhaps he could give a pragmatic or instrumental explanation. At one point, Horwich seems to suggest this: "Commitment to truth, alongside kindness, courage and so on, does seem to be a moral virtue. But this concession does not undermine [minimalism] because our acknowledgement

of that virtue is surely grounded in the utility of truth. After all, an important discovery is not useful merely to the person who makes it, but to all the rest of us to whom it is communicated. Thus it is beneficial to each member of a community that the other members pursue the truth. And this explains why children are inculcated with the moral norm, and hence why we all endorse it."[32]

Minimalists aren't the only ones who might feel the pull of this sort of account of truth's more than instrumental value. Chase Wrenn has argued that reductive naturalists like Stich could adopt the same position, as might Rorty.[33] For the response that Horwich's passage suggests is completely consistent with the idea that truth has no deep value at all, yet nonetheless *it pays to think that it does*. As Wrenn points out, wishful thinking can lead to greater success than one could otherwise obtain. Much like the naive amateur mountain climber, whose false belief that the summit is attainable helps him get farther up the slope than he might have otherwise been able to, believing falsely that truth is deeply good may help us to obtain other ends, like better scientific theories and more honest societies.

I certainly have no quarrel with the idea that there is a pragmatic payoff to believing that truth is deeply good. But put that aside. Even if one of the reasons we believe that truth has deep value is that it is useful to do so, this can't be the whole story.

The basic structure of the view we are considering is that the sole reason that we believe that x is more than instrumentally good is it is useful to do so. This is an inherently unstable, even self-undermining position. It reminds one of Pascal's "argument" for believing in God, according to which it is useful to believe that there is a God even if there is no such thing. Famously, this reasoning itself could never produce sincere belief. One either submits oneself to brainwashing or ends up just pretending.[34] Then there is rule utilitarianism, which endorses, on strictly utilitarian grounds, rules or dispositions to engage in actions that would ordinarily not be chosen by a utilitarian. Like Pascal's view, rule utilitarianism seems impossible to put in to practice without engaging in pretence or brainwashing. For when faced with a decision about whether to follow some rule and do something that would result in negative utility, the reflective rule utilitarian has only considerations of utility to fall back on. She is back to just weighing the consequences for acting this way or not. Therefore, if she is to follow her own advice and carry on like a good soldier, she must somehow forget her original utilitarianism. Or finally, imagine someone who believes that romantic love is an illusion, a "social construct"

without any deep merit whatsoever. Nonetheless, he might insist that it can still be useful for the social system to encourage a belief in romantic love, and even that he will be happier if he has this belief. But of course this sort of reasoning is just ridiculously at odds with being able to be a sincere lover. Either he forgets it or he won't ever love at all. When it comes to love, social constructivism is definitely, as it is sometimes put, one thought too many.

So one thing you might say is that the situation is similar in the present debate over the value of truth. The position that the only reason for believing that truth is more than instrumentally valuable is that it is useful to do so becomes a sort of pretense. And like most pretenses, this one is bound to erode under reflection.

While I think the "one thought too many" point is worth making, there is a much simpler point to make against the minimalist here. The real problem isn't that the minimalist has "one thought too many" about the value of truth. The real problem is that the mere fact (if it is a fact) that it is useful to believe that truth is deeply good doesn't explain *why it is deeply good, or even how it can be deeply good.* And that, surely, is the question at issue. All the noise about what is useful to believe simply evades the main question, namely, given that the minimalist doesn't think there is a substantive property of truth, how can she explain why it is deeply good to have the beliefs we call "true"? For if, strictly speaking, truth has no nature, then it can't be its nature to be a property that is good for beliefs to have. Our frustration with the minimalist here is similar to the frustration one can have with Pascal's argument, which has everything to do with why we should believe that God exists and nothing to do with the question that really interests us—whether or not God *does* exist. Similarly, we wish the minimalist to come right out and say what she thinks—that is, either admit that truth is not good, or agree that true beliefs really are good. Should the minimalist choose the latter, however, our reflections above indicate that she is left without an answer to why we should accept the infinite list of belief norms. And this means she hasn't explained all the facts about truth.

It would be too hasty to say that this proves that minimalism—or deflationism in general—is mistaken. The right lesson to draw is subtler, if just as interesting. What the above considerations show is that if minimalism is to be maintained, it must cast its lot with the revisionists. For a key assumption of the above argument—one that Horwich himself wishes to grant—is that truth is, to at least some extent, more than instrumentally valuable. Again,

one might reject this claim, or even, as Stich and Rorty do, reject the idea that truth has any value at all. But if minimalists reject these assumptions, they must admit that they are no longer trying simply to capture all the things we normally want to say about truth. Rather, like Rorty and Stich, they must admit they are trying to convert us, to change our minds about truth and its value, to get us to cast down, once and for all, our false idols.

Part III Why Truth Matters

8 Truth and Happiness

A Personal Question

What do you care about? In asking this question, I am asking about what really matters to you. It is, I think you'll agree, a question worthy of reflection.

We care about something to the degree that it is *important* to us, when we are devoted to it, when our lives are to some extent directed by our concern for it. To care about something isn't simply to want it. I often want ice cream, but I don't really care about it; ice cream isn't all that important to me. Mere desires can be fleeting, momentary, where caring for something entails that we treat it as *end,* a goal by which we measure some of our actions and their success over a sustained period. When we deeply care about something, we care about it for its own sake.[1]

What we care about, and how much we care about it, depends on who we are. Some people's entire lives are ordered around a single commitment, such as their religious belief, that for them grounds or unifies all the others. On the other hand, many of us are less organized. What we most deeply care about, and how much we care for it, changes slowly over time. In most cases, what we deeply care about includes various specific things: our lovers, our children, our family, perhaps our ethnic identity, sexual preference and gender, an artistic or other sort of project, or our career. But most of us are also likely to care about various abstract principles and values, like personal and political freedom, God, equality, art, or the value of the environment.

Or truth. In the first two parts of this book, I've wrestled with various misunderstandings and bad theories and attempted to convince you that truth does matter to most of us. I've claimed that true beliefs are better than false beliefs. The most obvious reason they are better is that believing truly gets us other things we want. As I put it earlier, true beliefs keep us from getting run

over by buses. But I've also argued that most of us value truth as more than just a means to other ends. We *care* about having true beliefs. Truth isn't the only thing we care about, or even what we care about most deeply, but we do care about it.

I now want to turn to the question of what makes truth *worthy* of caring about. Not everything someone cares about—even cares about for its own sake—is worth caring about. But even if we are confident that what we care about is worth caring about, it is important to ask why. For answering that question can teach us something. Asking why truth is worth caring about will tell us what makes truth good; it will help us understand why truth matters.

As I've said numerous times, that it is good for our beliefs to be true doesn't mean that every last truth, no matter how trivial, is worth caring about all things considered. Indeed, it is a safe bet that the answer to some questions (e.g., how many threads there are in my shirt) will never be worth caring about. In such cases, whatever value the truth has is overridden by the consequences of pursuing it. Yet a skeptic might point out that these commonsense facts just seem to indicate that in many real life cases, it *is* the practical consequences of true belief that matter, not the truth of the belief itself. If so, then even if truth has some value on its own, it seems that when it *is* worth caring about all things considered, what makes it so is never anything more than its ability to get us other things we want. So even if we do value truth for its own sake, that is irrelevant to our everyday concerns as human beings.

I take this point very seriously. Unless we can show that it is, at least sometimes, important to care about truth for its own sake in our ordinary lives, we won't have really shown that truth matters. With this in mind, my strategy will be to move inward out. I'll start in this chapter with the most personal reason we should care about truth: caring about truth is deeply connected to happiness. This is because our lives go better when they are lived authentically and with integrity. And authenticity and integrity, are both, in different ways, connected to truth. In the next chapter, I'll turn to a reason for caring about truth that has to do with not only your own happiness but with the happiness of others. And in the last chapter, I'll argue we should care about truth because it has political value as well.

Know Thyself

In Tim O'Brien's groundbreaking and hallucinogenic novel of Vietnam, *Going after Cacciato,* the protagonist Paul Berlin remembers his path into the war:

By the end of his second year at Centerville he was back where he started. A feeling of vague restlessness. He remembered talking to the school counselor. "Drop out?" the man had said, a short little guy without humor. "Don't you know there is a war on?" And the truth was that Paul Berlin did not know. Oh he knew, but not in any personal sense. . . . So in the end he dropped out. It wasn't really a decision; just the opposite: an inability to decide. Drifting, letting himself drift, he spent the summer of 1967 working with his father in Fort Dodge, building two fine houses on the outskirts of town, long hot days, a good tan, a sleepwalking feeling. And when he was drafted, it came as no great shock. Even then the war wasn't real.[2]

Berlin's ambivalence toward the war, his lack of personal direction, is initially a reflection of his youth. As the novel develops, however, it reflects his deeper, and partly moral, confusion about his participation in the war. And it strikingly contrasts with what he imagines to be the noble purposefulness of the deserter Cacciato, who Berlin dreams simply walks away from the fighting in order to fulfill his lifelong ambition to see Paris. Berlin fantasizes about Cacciato's subsequent adventures because Cacciato not only escapes the war; he represents to Berlin someone who knows what matters to him. Cacciato knows what he *cares about.* Berlin, on the other hand, is adrift. He doesn't know what he wants.

What we can know—or not know—about ourselves runs the gamut. We can know what we believe, what we want, what we perceive, and what we feel. In saying that we "know" such things, I use that word to indicate only true belief. When we talk about self-knowledge, "knowing" is more synonymous with "being aware." In wanting to be self-aware, what we want is to have the truth about ourselves.

Self-knowledge in this sense is obviously important. For example, it helps to know what you believe about the candidates of an election before going over to vote, and it helps to know what you want to order before signaling the waiter. In these sorts of cases, knowing what you want and believe is useful as means to other ends. But there is another sort of self-knowledge, indeed, the sort of self-knowledge we are ordinarily most concerned to have, which we value for more than its consequences. This is knowledge of what matters to us, what we care about. It is because of this sort of self-knowledge that the Greek dictum "Know yourself" resonates so powerfully with us, and why the question "Who am I?" is not just the product of teenage angst, or a call for pointless navel-gazing. As most people know, it is a question that can reappear throughout one's life. Self-knowledge is important to us, precisely because we often lack it, and lacking it, we fear that we may be sleepwalking our way through life.

People sometimes don't know what they care about for different reasons. One reason is a general lack of self-reflection. I might care about something very deeply, but not realize that I do because I've never paused to think about it. As a result, I might find myself moved to tears, or anger or worry over some event without knowing why.[3] The causes of this lack of self-reflection may be my own: I may be lazy or undisciplined. But much of the time, the reasons people don't self-reflect on what matters to them have more to do with the external circumstances in which they find themselves, circumstances that may include poverty, hunger, lack of education, or a culture that, in various insidious ways, actively discourages reflection.

Another reason that I might not know what I care about is by engaging in what Sartre called "bad faith," that is, by literally deceiving myself about what matters to me.[4] Sometimes we don't want to admit that we care about something we don't wish to care about. We may love someone but out of cowardice, or fear, or anger refuse to admit it, even to ourselves. More commonly, perhaps, bad faith moves in the opposite direction. In Camus's *The Fall,* for example, the protagonist Jean-Baptiste confesses that he had merely played the *role* of a lawyer interested in fighting for justice, pretending to himself that he was someone who "took life seriously," when in fact, he was neither.[5] He did not care about helping people; he cared, he eventually realized, only about how people judged him. Jean-Baptiste's situation is of course not unique. Many people do not identify with the public roles they play, but hide this fact from themselves—perhaps like Camus's protagonist, by engaging in virtuoso acts of forgetfulness; perhaps by simply not paying attention. In such cases, we don't really care about what we think we care about, and we live our lives in bad faith.

Another reason I may not know what I care about, as Harry Frankfurt has pointed out, is that I am sometimes ambivalent about what I want.[6] My will is divided, my mind not made up. So a person may not know what she cares about because there is no stable truth about what matters to her. She flicks back and forth, first one direction, then another, and in so hesitating, is often lost. It is possibly this situation that Paul Berlin finds himself in the above passage of O'Brien's novel. As he says, his dropping out of college is not based on a decision; it was more "the inability to decide." It was not that he didn't really care about going to war, or staying in college, or neither; it was that he was ambivalent, torn in several directions, and therefore going in none. In such a situation, as O'Brien describes Berlin in the passage above, one can only be described as adrift.

It is important to see that in some cases not knowing what you care about may be perfectly understandable, even an inevitable response to a terrible situation. Later in O'Brien's novel, for example, Berlin is torn between different attitudes toward the war. The constant meaningless violence tears at him, yet he also feels bound to his fellow soldiers. He is not sure what is most important. But the cause of Berlin's lack of knowledge is not, strictly speaking, ambivalence of the sort just described. It is not the result of inner indecision so much as the overpowering and contradictory pressures of outer circumstance. In the nightmare he finds himself in, Berlin's lack of knowledge about whether fighting the war matters to him enough to keep doing it is a reasonable response to what is happening to him. Nonetheless, it also contributes to his feeling of being lost, of unhappiness, and it is what encourages him to dream about following Cacciato. Of course, just as the complexity of one's outer life can block self-understanding, so can the complexity of one's inner life. In Berlin's case, it seems his capacity for imagination and self-reflection is partly responsible for this. In contrast, the simpleminded Cacciato does not seem to think so much; his sense of purpose (at least as Berlin imagines it) is a result of Cacciato's own innocence.

When it is possible, it is useful to know what most matters to you, what you care about. Knowing what you want helps you to figure out how to get it. But knowledge of what you care about is more than useful. It is a constitutive part of some of the most important aspects of our psychic lives. In particular, it is essential for a certain network of attitudes we need to have toward ourselves.

Intuitively, what I most deeply care about helps to constitute my identity. I don't mean my *numerical* identity—what makes me one and the same person over time. Rather, the nexus of my various commitments and projects determines my identity in the sense of determining the *kind* of person I am. They form what Susan Wolf has called my deep or real self.[7] These are the things that I most care about, that I am most (perhaps figuratively, possibly literally) willing to fight for. They give my life meaning. Without them, I would find myself at a loss, "no longer the same person." By determining what actions, choices, and possibilities I most identify with, they determine who I am.

When I know who I am, I have what I'll call *a sense of self*. By this term I don't mean knowing *everything* about myself. No one has that much knowledge about himself, and as the psychologist Martin Seligman and others might remind us, that is probably a good thing.[8] Rather, I mean by "having a sense of self" that I am aware of the truth about what matters to me, what I stand for.

A sense of self comes in degrees. A person with a strong sense of self is very aware of what she cares about; she almost always knows, in other words, what really matters to her, while obviously a person with a weaker sense of self has less knowledge of this sort. In either case, however, it is having certain true beliefs that is essential. Knowing what you care about is constitutive of having a sense of self.

Having a sense of self is good in itself. But it is also an essential part of other goods, like self-respect. Self-respect isn't, as it is sometimes suggested, simply a matter of liking yourself, or being self-satisfied, but a complex self-reflective attitude. It includes, as John Rawls notes, "a person's sense of his own value," a belief that his life is worth living.[9] In other words, to respect ourselves, we need to have at least a minimal sense of who we are—a sense of self. Otherwise, we wouldn't know whom we were respecting. This is not to say that having a sense of self is sufficient for self-respect. We respect our selves insofar as we believe that our actions have actually flowed out of our character, our deep self. When they do not is when we come to revile ourselves, to see ourselves, like Jean-Baptiste, as betraying who we really are. When we lose self-respect in this way, Rawls notes, "nothing may seem worth doing, or if some things have value for us, we lack the will to strive for them. All desire and activity becomes empty and vain, and we sink into apathy and cynicism."[10] Consequently, self-respect seems to be what Rawls calls a "primary good," or basic component of human happiness. We don't need a famous philosopher to tell us this, of course. Respecting yourself is the first step to respecting others and being respected by them. Life without it becomes miserable and empty.

Having a sense of self is also part of another self-reflective attitude. The particular attitude I have in mind can and does go under many names. I'll call it *authenticity.* Roughly speaking, one is authentic in this sense when one is true to oneself.[11]

What does it mean to be true to your self? We can get a handle on this idea indirectly by reflecting on an influential analysis of freedom pioneered by Frankfurt, Wolf, Watson, and others.[12] According to this view, having freedom of will involves having the will you want to have. Think of it this way: some of a person's desires are "first-order" desires, like the desire to smoke. Other desires are desires about what desires one would like to act on, such as the desire not to desire another cigarette. *Acting freely,* this analysis suggests, means that your actions are those that are in accord with those desires you most desire to be effective. Thus the person who wishes to stop smoking acts

freely, on this account, when what he does is the result of his desire not to smoke as opposed to his desire to have another cigarette. The unwilling smoker identifies with his higher-order desire not to smoke, and so he wants that desire to guide his conduct. When it does, he is acting of his own free will on this account; when it doesn't—when, in other words, his first-order desire to smoke again wins out—he is not.

As an account of free action, this position is intriguing, but ultimately lacking. Whether an action is ultimately free depends on more than just whether it is the result of a desire I desire to have. Part of the question, surely, concerns whether or not your actions—and your desires—were causally *determined* by past events and the implacable laws of nature. Nonetheless, even if the account is not successful as an analysis of free action, it can, I think, help us to understand authenticity.

Intuitively, to live an *authentic* life, you must *identify* with those desires that effectively guide your action. You identify with a desire when it reflects the kind of person you wish to be, what you care about.[13] You identify with not smoking when you begin to realize that kicking the habit matters to you, or at the very least, is required by what does matter to you, such as not worrying your loved ones. I am then true to myself, when I identify with my effective desires. When I do, I can then be, as Frankfurt might say, "wholehearted" in my commitment to my actions.

Now consider someone like Paul Berlin who does not know what he cares about. It follows that he does not know which of his first-order desires he identifies with. He may, in various senses of the words, still be "free" and "responsible" for his actions. After all, it was he, Paul Berlin, who left college. But there is a sense in which Berlin is not being true to himself by being ambivalent about his being drafted. In the novel, it is Cacciato who symbolizes an authentic life, precisely because although he is a simple soul, he knows what he wants, what matters to him.

Like the case of the person who can't kick his addiction to nicotine, a lack of authenticity is linked to a lack of self-control. And it is this connection that illustrates the importance of authenticity for happiness. In Berlin's case there is no unequivocal answer to what is important to him, and therefore he does not know what he cares about. And by not knowing what he cares about, he does not know what he wishes to will, and thus cannot know which of his initial desires (the desire to attend college, the desire to be tested by war, and so on) he desires to have. Consequently, he does not identify with anything,

and to that extent his subsequent actions are what I'm calling inauthentic. As the metaphor of being adrift suggests, he is no longer in any real sense the proverbial captain of his own inner ship.

What this shows is that not only does life go better when you care about something, you also need to know that you do. Suppose Paul Berlin was not in fact ambivalent about the war but simply unaware, perhaps because of youth and an incapacity for self-reflection, of what he really felt about it. Intuitively, he still wouldn't be able to discern which of his first-order desires he identifies with. And on that basis alone, he must—to some extent—lack control over himself.

Not knowing what you care about is like not knowing at which stop you should get off a train. You realize that one of the stops is where you are going, the one that is important you. But since you don't know which one that is, every stop becomes equally important or unimportant. Each is greeted with the same mixture of apprehension and dread. Unless you can figure out which stop is yours, you can only remain on the train or simply pick one of the stops and get off. In neither of these latter cases, however, are you in any plausible sense in much control of the situation. The same is true in life. If you don't know what you care about, you must either choose something and act *as if* you care about it, or simply remain adrift in indecision. In neither case are you in control, and in neither case can your actions intuitively be said to be authentic expressions of what matters to you.

In sum, authenticity, being true to yourself, requires having the will you want to have—identifying with the desires that guide your action. What you identify with is determined by what you care about. Thus if you don't know what you care about, if you lack a sense of self, in other words, you don't know which of your first-order desires you identify with. If you don't know which of your possibly conflicting desires you identify with, you cannot be acting authentically. Consequently, knowing what matters to you is partly constitutive of authenticity.

In making these remarks, I don't mean to suggest that authenticity in the sense I've used that word here does not come in degrees. It clearly does: one can be more or less true to oneself. Nor am I suggesting that there aren't necessary conditions for authenticity other than self-knowledge. My point is much simpler: that without some knowledge of what matters to you, you are like the person on the train. You don't know where you are going.

Let's tie the threads of our discussion so far together. So far I've argued that:

1. Self-respect and authenticity require a sense of self.

2. Because it is required for self-respect and authenticity, which are part of happiness, having a sense of self is an important part of happiness.

3. Having a sense of self means having true beliefs about what you care about.

4. Therefore, having some true beliefs—about what you care about—is also part of happiness, other things being equal.

If we grant, reasonably enough, that whatever is part of happiness is worth caring about for its own sake, from these premises we can deduce that the truth about what you care about is itself worth caring about for its own sake. There are some true beliefs worth caring about not because of what they lead to but because of what they are a part of, namely: a happy and flourishing life. Call this the *argument from self-knowledge*.

Let's look more carefully at the structure of this argument. A key point concerns what makes something worth caring about for its own sake. We can justify our care for something in different ways. One way we might justify it is by simply appealing to what it is, by saying that it is "good in itself" or "intrinsically" good. I've already mentioned that in my view, having a sense of self is good in this way. But while certain things seem intuitively good in themselves, it is notoriously difficult to *theoretically* justify our caring about something in this way, because we are appealing to nothing other than the nature of the thing itself, not its consequences or its relations to other things. This does not mean that nothing is worthy of caring about for this reason. But it does mean that appeals to intrinsic value are conversation-stoppers. They are where our spade is turned, as Wittgenstein puts it. This is somewhat analogous to the situation we can find ourselves in with regard to our beliefs about how objects look to us. After all, it is difficult to give a theoretical argument for why something *looks red* to us. It either looks red, or it doesn't—one doesn't mount a defense of this claim. The belief that something looks red is justified simply by the fact (if it is a fact) that the object in question *looks red*. Similarly, if we say that something is worthy of caring about just because it is intrinsically good, we are implying that this is a basic belief, one that we think justified, but which can't be justified by appeal to other beliefs or norms that don't already presuppose it.

A more helpful way of justifying our interest in something for its own sake is by showing that it is an essential *part* of something that is good, for example, by showing that it is an essential part of a good life. By a good life, I

mean a flourishing life—a "happy" life, in one meaning of that term. In this minimal sense, living a good life is a basic aim shared by each of us. Being happy is good—"in itself"—and other things can be worthy of deeply caring about because they are necessary parts of it. *Being a part of something good is crucially different from being a means to it.* A means to an end is *ipso facto* different from the end itself. A necessary part of something, on the other hand, helps make the whole of which it is a part the thing that it is. Change or destroy that part and you change or destroy the whole. Thus being good because you are part of something good (like happiness) is different from being good as a means to it. Of course, some things are good in both ways. Love, for example. One reason love is worth caring about is entirely instrumental—loving can lead to being loved, although sadly this is not always the case. But a deeper and better reason that love is worthy of pursuit is that loving and being loved are parts of a fulfilled and happy life. In other words, a life with some love in it is necessarily better than one without.

Something like love is what philosophers call a constitutive good. And being constitutively good, like being an intrinsic good, makes something worth caring about for its own sake, as opposed to caring about it for what it leads to. You care about it in these cases for what it is or what it is an essential part of, not for its effects.

The argument from self-knowledge shows that the truth of some beliefs is also constitutively good, and therefore worth caring about for its own sake. Knowing what you care about is a constitutive part of a whole set of self-reflective attitudes. Having these self-reflective attitudes is worth caring about, partly because of what they are in themselves, and partly because they in turn are elements in the greater good of having a fulfilled and happy life.

I should stress that while having a sense of self is an important part of happiness, it is far from being the only part. A strong sense of self doesn't guarantee happiness. I'll have more to say about happiness and flourishing at the end of this chapter; for now, I want to talk about the importance of caring about truth.

Caring about Truth

So far, I've claimed that having self-knowledge is a part of happiness. This gives us a reason, and an important one, for caring about the truth of some sorts of beliefs for their own sake. But I also think that the very act of caring

about truth has an importance all its own. And as we'll see, this will give us a reason to care about truth in general or *as such.*

So what does it mean to care about truth? Recall that to really care about something is to treat it as an end, as something that matters. This goes for truth too. To care about truth, then, is to care about it for its own sake. The first thing to notice is that caring about truth is different from simply believing the truth. One can form true beliefs without necessarily giving a damn. You can form true beliefs just by opening your eyes. But caring about the truth is an activity that engages the will. Very small children have beliefs, including many true beliefs, but they may be incapable (yet) of caring about truth. And there are people who know various truths—maybe know quite a bit—but for whom the truth itself is unimportant. Perhaps they are simply lazy but extremely lucky when it comes to forming beliefs. Or perhaps what matters to them is not so much determining whether what they believe is true, but whether their beliefs are successful at getting them other things they want, or making themselves feel good, or drawing acclaim, and so on. On the other hand, one can care about having true beliefs even if one doesn't have very many. Indeed life often works out that way. I can be carefully attentive to the evidence, open-minded, impartial, and so on and still end up being wrong as wrong can be. This is a frequent phenomenon in science. Socrates and Einstein cared about truth, but they weren't always right about everything, even in their fields. And someone who is deceived by an evil Cartesian demon, to cite an extreme example, is wrong about almost everything, but she may still care deeply about truth.

One doesn't count as caring about truth in this way just because one says so. Repeating to myself "I really care for truth" doesn't have anything more to do with it than playing "she loves me/she loves me not" has anything to do with whether she loves me. To care about the truth entails that one is *disposed to act* in certain ways. More exactly, just as one cares about the good to the extent that one has a virtuous moral character, so one cares about truth to the extent one has a virtuous intellectual character. By this, I don't mean that one has to be an *intellectual* in order to care about truth! I mean that to the extent that one cares about truth, one manifests particular character traits that are oriented toward the truth. It involves being willing to hear both sides of the story, being open-minded and tolerant of others' opinions, being careful and sensitive to detail, being curious, and paying attention to the evidence. And it also involves being willing to question assumptions, giving and asking for

reasons, being impartial, and being intellectually courageous—that is, not believing simply what is convenient to believe—politically or otherwise.[14]

Like all human characteristics, intellectual virtues are matters of degree. I can be more or less open-minded, or curious or careful. I can also manifest some of these virtues to a greater extent than others. One might be open to the truth, for example, without necessarily striving very hard to reach it, like a night watchman who will call the police if he sees someone from within his guardhouse but won't bother patrolling the area or checking to see if the doors are locked. Likewise, one might work hard to find what is true about some matter, following very rigorous procedures, consulting the best scientific evidence and so on, but remain intolerant of others' viewpoints on the matter. This might amount to being careful while remaining pigheaded.

But while being intellectually virtuous is a matter of degree, one does not count as having a virtue if one exhibits the appropriate behavior only selectively. In this respect, intellectual virtues are like moral virtues: if you tell the truth only when it pays to do so, you aren't really honest. Similarly, you aren't open-minded if you listen to others' opinions only when you have to. Intellectual virtues are in this sense completely general. When one is intellectually virtuous, one is disposed, other things being equal, to act in that way across the board. As much as is possible, one strives to be as open-minded about politics as one is about stamp collecting.

It is often a messy question whether one is being intellectually virtuous, just as it can be rather difficult to tell whether one is being morally virtuous. But that is to be expected. Life is hard. The important point is that to the extent that you care about truth, you exemplify these traits. Note that the reverse doesn't always hold. You can be intellectually virtuous in certain ways without caring about truth. As Heather Battaly has pointed out, one can be sensitive to detail, for example, without treating truth as an end.[15] Being sensitive to detail tends to produce true beliefs, but you might not care about that—you might care only about what those true beliefs themselves can get you. Thus an accountant might be sensitive to detail but care only about the fact that it gets him more business.

Nonetheless, there are some intellectual virtues that one can't have unless one *does* care about truth. Caring about truth is a necessary condition for having these virtues. One example of such a virtue, a virtue I think is closely connected to happiness, is intellectual integrity.

Integrity

How many times has this happened to you: you are sitting on a bus, or talking to your in-laws, or chatting at a party, and someone says something racist, or homophobic, or just plain mean. There is a momentary pause. You know that what was said was wrong and hurtful, and you want to say something about it, something that politely but firmly indicates that you thought the remark inappropriate. But you don't, and the moment passes. Later, thinking back on it, you think of all the things you might have said. You feel bad. You feel you've let yourself down.

Context matters, of course. In such situations, tact is often called for, and you must pick your battles. Nonetheless, we don't always stand up for what we think is right, even when we could. When that happens, we lack what we might call intellectual integrity.

Intellectual integrity is an aspect or part of integrity proper.[16] It requires being willing to stand up for your best judgment of the truth, by being willing to act in accordance with that judgment when the need arises. Like other intellectual virtues, intellectual integrity is a character trait. This means that you can have intellectual integrity even if you are never called on to stand up for what you believe, and even if you are prevented from standing up for what you believe. What matters is that you are *willing* to do so, that you are disposed, other things being equal, to try.

You don't lack intellectual integrity simply because you've done something wrong. Nor is it the same as not having self-control. And one can even do something morally permissible and lack intellectual integrity, a point underlined by the recent revelations of William Bennett's gross gambling debts. What amused people about the revelations of Bennett's gambling was not that it was wrong or indicated a weak will, but that the self-appointed virtue-czar, so salubrious in his praise of temperance and restraint, seemed unwilling to practice what he preached. He didn't stand by his own estimation of what was best.

Intellectual integrity requires caring for the truth for its own sake. This reveals itself in several important ways in our ordinary life. First, people who run around loudly defending whatever view they happen to land on, whether or not they've bothered to examine whether it is true, lack intellectual integrity. Willingness to stand for anything amounts to standing for nothing.

Second, a person with intellectual integrity is someone who is willing to *pursue* the truth. This means they are willing, as much as possible, to figure things out for themselves, to form their own opinion, to not just go along with the crowd or whatever happens to be fashionable or expedient. Consider, for example, a tobacco company executive who claims he is concerned about the safety of cigarette smoke. In forming his opinion that smoking does not cause cancer, he might consult several scientific studies. But intuitively, if he consults only those studies conducted by scientists on the company payroll, and ignores all the evidence amassed by those who are not, he lacks intellectual integrity—precisely because he has not bothered to really pursue the truth about the matter. If he is honest with himself, he cannot say that he is standing for his own best judgment on the matter, that is, for the judgment most likely to be true. He has not really bothered to determine what that judgment is. He is rather standing for what is most expedient for him to believe given his position.

Third, a person of intellectual integrity stands for what she thinks is true *precisely because she thinks it is true*. Martin Luther King, Jr., implicitly makes this point in his "Letter from a Birmingham Jail." In the letter, King responds to some leading clergymen who, while claiming that they agreed with the substance of King's views on race, derided King's protest movement against segregation in Alabama as "unwise and untimely." During his impassioned reply, King writes:

I have heard numerous southern religious leaders admonish their worshipers to comply with a desegregation decision because it is the law, but I have longed to hear white ministers declare: "Follow this decree because integration is morally right and because the Negro is your brother." In the midst of blatant injustices inflicted upon the Negro, I have watched white churchmen stand on the sideline and mouth pious irrelevancies and sanctimonious trivialities. . . . Where were their voices when the lips of Governor Barnett dripped with words of interposition and nullification? Where were they when Governor Walleye gave a clarion call for defiance and hatred? Where were their voices of support when bruised and weary Negro men and women decided to rise from the dark dungeons of complacency to the bright hills of creative protest?[17]

King believed his "moderate" critics were lacking integrity because while they *said* they wanted integration, they would encourage it only insofar as it was already legal. When the chips were down—when the law and what they said they believed were inconsistent—they went with the law. But as King reminds them elsewhere in the letter, legality is not morality. Just because something is legal is not any reason to think it is the right thing to do, and just

because something is illegal doesn't mean it is wrong. What distresses King is that if the white preachers really thought that African-Americans have civil rights, they should say just that. Further, they should support the peaceful protest of any laws that were inconsistent with such rights. But rather than standing up for what they said they believed was *true,* they stood up instead for what was legal.

Fourth, intellectual integrity also requires being *open* to the truth just because it is the truth. To be open to the truth is to be willing to admit that you are wrong. A good example of this is the actions of Governor Ryan, former Republican governor of Illinois. When elected to office, Ryan was a staunch defender of the death penalty. But in January 2000, after it was revealed that since 1977, thirteen people convicted of the death penalty were subsequently exonerated (while twelve others were executed), Ryan placed a controversial moratorium on executions in the state.[18] He would not, he said, approve any more executions until a thorough examination of the state's procedures for state executions was implemented and the process found to be neither arbitrary nor capricious. Some criticized Ryan's actions as lacking intellectual integrity because he had changed his mind. But to say this is to betray a lack of understanding of what intellectual integrity is. *Intellectual integrity is not simply a matter of being consistent.* Gritting your teeth and holding to what you've said in the past in the face of new evidence is not intellectual integrity, but stupidity. Thus, far from lacking in integrity, Ryan's actions, on this matter at least, were a paradigmatic instance of it, precisely because he was open to his view on the matter being mistaken, and he was willing to pursue the question until he felt confident that he had formed the best judgment possible about that matter.

Persons with intellectual integrity, it is worth emphasizing, don't care about truth selectively, whenever it suits them. Indeed, that's part of the point: to have intellectual integrity is to be willing to stand for one's own best judgment on *any* matter of importance—not just when it is convenient to do so. And since, as far as we know, almost any matter could be important at some point or other, to have integrity means caring about the truth in general. To have it, one must be open to having true beliefs *in general,* and pursuing the truth *in general,* on those questions that come before you, whatever those may be.

Caring about truth for its own sake, that is, being willing to both pursue it and be open to it, is therefore a necessary condition for intellectual integrity. I have not claimed that it is sufficient. A careful, open-minded reasoner is not necessarily a courageous one. Intellectual integrity requires not only that one

know what it is one thinks is right, it requires the intellectual courage to pursue what one believes in the face of opposition, a willingness to hold one's views even if they are unpopular, or against "common sense." It may, in some cases, require a willingness to sacrifice one's own advancement, or pleasure, or safety for what one believes in. When that happens, it can be no mean feat to maintain intellectual integrity.

Intellectual integrity should not be confused with authenticity. As I've been using the word, to live authentically is to identify with one's effective desires. But one might stand for what one thinks is right without necessarily identifying with it. It is possible to say to oneself "this is the right thing to do, and I will therefore do it, but I don't identify with it." Suppose a father who has always said it is wrong to discriminate against gays is faced with his son's own homosexuality. Confronted with the facts, he finds himself wishing that his son were not homosexual. He might nonetheless realize that this desire, despite being deep-seated and something he identifies with, is irrational, and therefore embrace his son as he is. If he does, he has intellectual integrity. He has stood up for what he thinks is true—even though, in this case, what he believes is true is not something he cares for. But his intellectual integrity does not mean that he is being authentic, for he is no longer identifying with his effective desire.

Conversely, one can lack intellectual integrity while remaining authentic. There is, after all, such a thing as an authentic bastard. Take someone who cares more deeply about power than anything else in the world. We can imagine such a person—sadly, it is not too hard—being willing to let nothing stand in his way in his pursuit of his goal. He may be willing, for example, to portray himself as just and kind to the poor, while all the time stealing from them, or removing their rights, or all sorts of terrible things. Further, let us imagine that he simply does not think about whether his pursuit of power at all costs is the right thing to do—a true moral principle. Whenever questions of that sort come up, he just ignores them. Nonetheless, he identifies with his goal. He finds himself unable to care about anything else. Such a person intuitively lacks intellectual integrity. This is not because he lacks principles. He has a principle: pursue power at all costs. What he lacks is a commitment to the truth. He does what he does out of expedience. Thus, he is not willing to stand up for what he thinks is true, because he doesn't care what is true. Yet he *is* authentic—he identifies with his effective desires.

Authenticity and intellectual integrity, despite their differences, are related. First, they are both connected to truth. Authenticity requires knowing the truth about what you care about. Intellectual integrity, on the other hand, does not require knowing any particular type of truth. It requires, rather, caring about the truth in general. Second, intellectual integrity and authenticity are both aspects of integrity proper. Some writers use "integrity" full stop to stand for what I've called "authenticity."[19] Others use it to refer to intellectual integrity.[20] The former stress that a person of integrity has integrated commitments and desires; their actions are in accord with what they care about. The latter stress that integrity requires standing for something. But as the above examples show, integrity full stop is best seen as requiring both authenticity and intellectual integrity. The father's self is not integrated; he stands up for what is true but is not wholehearted about it. The power-seeker is wholehearted but doesn't care about what is true. Neither has integrity. In this sense, integrity as a whole is best seen as a "higher-order" or "master" virtue—a way of being that incorporates both emotional integration, intellectual integrity, and their various components.

Are intellectual integrity and integrity as a whole part of happiness? One reason for thinking so is that they are both tightly bound to self-respect. Other things being equal, one will be happier if one respects oneself, and it is hard to respect oneself when one lacks integrity, intellectual or otherwise. Think back on the situation I described at the beginning of this section, where one fails to stand up for what is right. One does not respect oneself for this, as I put it: you feel afterward that you've left yourself down. On the other hand, we admire those who, like Socrates, or Gandhi, or King, or Governor Ryan, do stand up for what they believe is the truth. We think they are better for it, even as we know their lives can be rougher in other respects for doing so.

Yet you might object that these same examples show that intellectual integrity—and therefore caring about truth—can make you miserable. Indeed, like caring about love, caring about truth is an inherently risky business. It can get you ostracized, excommunicated, called before the inquisition, and killed. It can lead to questioning the very bases of one's worldview, leaving you bereft of what to think or do. But that doesn't show that intellectual integrity is not part of a flourishing and rich life. It just shows that there is more to happiness than having only intellectual integrity. Self-respect isn't enough, and therefore neither is intellectual integrity. As we'll see shortly, happiness

is—to make the understatement of the year—a complex matter. It is composed of many things.

We are now in a position to draw together the various threads of the argument I've been making. So far I've argued that

Caring about the truth as such is a constitutive good because it is essential to intellectual integrity, and therefore, to integrity proper.

This gives us a reason to care about truth *as such, or in general.* To care about truth as such, as opposed to caring about the truth of some specific belief, is to care about believing what is true and only what is true no matter what the question at hand.[21]

Our argument that we should care about truth as such illustrates an important fact: something can be worth caring about because the very *act of caring about that thing* may be good in its own right. There are things that are important to us because their being important to us is important to us. In other words:

1. If intellectual integrity is a constitutive good, then so is caring about the truth as such.

2. Intellectual integrity is a constitutive good.

3. Therefore, caring about the truth as such is a constitutive good.

4. If caring about the truth as such is a constitutive good, then truth as such is worth caring about for its own sake.

5. Therefore, truth as such is worth caring about for its own sake.

Above, I argued that having some particular true beliefs—beliefs about what you care about—is partly constitutive of living well. While significant, that conclusion fell short of a completely general justification of caring about true belief for its own sake—or caring about truth as such. The present argument, what we might call the *argument from integrity,* gives us exactly that. What makes having true beliefs worth caring about for their own sake—as such—is that caring about truth as such is itself part of the weave of the flourishing life, the life lived well. In the next section, I explore further what that means.

Happiness

I've claimed that having certain true beliefs and caring about truth are important parts of happiness. But happiness is a personal matter. So how can I claim that you should care about truth if you want to be happy? Aren't I just

imposing my own views on something that is really up to each individual? To answer this question, we need to think further—not about happiness itself really, but about how to think about happiness.

"Happiness" is a slippery word. I don't mean by it a fleeting and momentary state of mind. Like the Greeks, I use it to refer to something far more complex, a feature of a life as a whole. By a happy life, I mean a good or flourishing life, a life lived well. I've argued that caring about truth and having certain true beliefs are necessary for happiness. I now want to say a bit more about what that is, and how I think of it.

Nowadays, we tend to think that living a flourishing life is one thing and being moral is another. Indeed we think that the two can actually be at odds with one another. By and large, the ancient Greeks, and Aristotle in particular, did not see it this way. For Aristotle, the "good" in "the good life" captured things that we would sort in the "morally good" box—such as acting responsibly toward others, being trustworthy and kind, *and* things we would sort in the "nonmorally (or personally) good" box, such as having friends, being healthy, and being wise. For him, flourishing required many things—it was a complex whole with many parts. Figuring out how to be a better person means figuring out what sort of life one should lead in order to be happy. Aristotle and many other ancient Greek philosophers also believed in the *unity* of the virtues. That is, they believed that you couldn't be courageous unless you were also generous, and kind, and honest. This also conflicts with our contemporary ways of thinking—we tend to think that being virtuous in one way doesn't necessarily mean you'll be virtuous in every other way.[22]

My own view on these matters is not quite Aristotle's but is not far away either. Unlike Aristotle, I think one can flourish in some ways but not in others. (That does not mean that there is no connection between the virtues, however. Someone who is cruel will be unable to be a true friend or lover, for example.) But like the Greeks, I think that some things that are important for flourishing—like integrity, self-respect, love, or friendship—are not easily sorted into either the "morally good" box or the "personally good" box. Earlier I said that roughly speaking, a belief's being true is cognitively, not morally, good, because that which is morally good is something that is fit for praise or blame. On that basis, I noted that the pursuit of truth might have both moral and cognitive value. This was, in the context of our previous discussion, a useful distinction to make. But on closer inspection, it is more difficult to separate out the moral values from the nonmoral values. For one

thing, our contemporary intuitions generally sort those goods that are primarily self-regarding (like having self-esteem) as nonmoral, while those that are other-regarding (like being charitable) are thought to be moral. This makes things more complicated. For many of the things that are good, like integrity and self-respect, are self-regarding, but are also worthy of praise. Furthermore, many of the things that are good are so because they are parts of the good or flourishing life. Caring about truth is like this. But is the "good life" morally good or nonmorally good? Both? Neither? At the end of the day, I don't think how we label the value of the good life matters all that much. Similarly for how we label the value of truth. What does matter is that many of the reasons we have for believing that truth is good, however labeled, trace back to the relationship between truth and living a flourishing life. Consequently, at the deep level, any distinction between the "moral" and "nonmoral" value of truth becomes less useful, even arbitrary. The distinction that matters is between goods that are deeply normative and those that are not; otherwise, goods are goods are goods.[23]

The goodness of a life is a matter of degree. In asking about what makes a life a good life, we ask about what makes a life better. Therefore, to say that something is partly constitutive of happiness or the good life is to say that your life would go better with it than without it. Further, the various ways in which one's life can go better or worse need not always travel together, as our discussion of authenticity and intellectual integrity illustrated. Accordingly, whether a life is a good life is not a black and white matter—it may be better in some respects and yet worse in others.

So what makes life go better? Many people believe that what makes life good is getting what you want.[24] After all, it is generally good to get what you want. Furthermore, this answer grounds flourishing nicely in human psychology—in what we actually desire; it is practical, down to earth, direct, and no-nonsense. It is also wrong.

A popular version of the "go get what you want" view has it that what we all really want is pleasure. According to hedonism, as it is called, your life goes better just to the extent that it increases in pleasure. If it feels good—do it. Hedonism is liberating for people who have been denied basic pleasures (whether the pleasure of sex or the pleasure of listening to music), but at the end of the day, there is more to life than pleasure. Other things being equal, I wouldn't trade my present life, with all its ups and downs, for a life lived permanently within a pleasure machine (although I wouldn't mind trying it out

for a few days). Neither would I wish to live in the fool's paradise, where people just pretend to like and respect me. These examples, and others like them, show that we value something more than experience—even just pleasurable experience. We want certain realities behind those experiences, and thus we want certain propositions to be true.

Don't get me wrong—I am all for pleasure. No finger-wagging Victorian sensibilities here. Experiencing pleasure and avoiding pain are undoubtedly and obviously very good things. Most of the people on this planet experience far too little pleasure and far too much pain in their daily lives. Their lives would go much better if they experienced less pain and more physical pleasure—if, for example, they had adequate housing and enough food to eat. Indeed, if one is in great pain, then relief from that pain will be the greatest good you can pursue at that time. So feeling good is extremely important; it is just not the only important thing. Hence, a pleasurable life isn't *necessarily* a good life just because it is pleasurable.

Now those who believe that what makes life good is getting what you want needn't disagree. Nothing stops them from simply saying that we want more than pleasure. But even when it is expanded to include more than pleasure, the idea that flourishing consists in getting everything you want is not promising. Some things that I want, as I indicated above, may not be worth wanting. People often want things that, intuitively, are not the sort of things that would make their lives better. Some of us want things (cigarettes, relationships with people who abuse them, and so on) that make our lives worse.

Other things I want, while perhaps worth wanting, don't seem to have any impact on the quality of my life. To borrow an example from Derek Parfit, I might meet a young artist on a train who, during the course of our short conversation, I come to respect and admire. I may desire that she succeed in her goal of becoming a successful artist. But even if that desire is met, it seems odd to say that *my* life is better for it, unless I come to have some further connection to her.[25]

If all that matters for living well is getting what I want, then the best way to live well would be to adopt desires that are easily satisfied. Reducing one's desires can indeed be helpful. We all probably have more desires than we could satisfy and perhaps more desires than we should satisfy. I sometimes desire a new and fancier car; but it is not clear that I need that car, and it is certainly unclear that satisfying that desire will in any way make my life go better, even if it wouldn't make it go worse, either. And many people spend their lives

wishing for things that, realistically, they can't have. This makes them miserable. They would be better off without such desires. Yet while this is true, it is hardly the case that life would *always* be better when one has simpler and easily satisfied desires. For some of the things that are, intuitively, the most important to desire—for instance, lasting friendship or being a successful parent—are not desires that are easily satisfied. Further, sometimes a life goes well because it is engaged in long-term, incredibly difficult projects—such as the cure for cancer, or the search for world peace, or political justice for an oppressed minority. Such desires are incredibly difficult to satisfy; they might even be "fruitless." But lives are sometimes made much better for having them. Facing challenges—even impossible challenges—can give life meaning and value.

So getting what you want is not all that matters in life. There are some desires that matter more than others, and therefore we must appeal to some standard other than what we want in order to make sense of the good life.

This point brings us to objective theories of flourishing. The thought here is that there is some objective group of goods that make a life aimed at them and them alone better than any life that is not. Thus, on such theories, there is a difference between what we desire and what is in fact good—or what is worthy of desire, in other words. Some objective theories maintain that there is only one supreme good toward which we all should be aiming. Plato, for example, believed that the good life was the life of contemplating the abstract, perfect form of the "The Good"—that which all and only good things had in common that made them good. Not surprisingly, Plato therefore praised the philosophical life, the life of contemplation, as the best sort of life.

The idea that there is one and only one good life is not confined to dead Greek philosophers, of course. Many thinkers—both in Western and non-Western cultures—have insisted that it is the religious life that is the best sort of life. The best life is the life lived as God wishes it to be lived. And some of the "romantic" poets and philosophers argued that it is the artistic life that should get top billing. The best sort of life is one lived in pursuit of creative self-expression. But for many people in our culture, and I am one of them, the idea that there is one and only one way of living that is *the* best way for everyone to live is not compelling. Humans are too various in their needs, abilities, desires, and beliefs to make it plausible or even desirable that there is a single best way to live. Philosophical contemplation, for example, is good without a doubt, but that does not mean that a life directed at such contemplation as an ulti-

mate end is the only way to flourish. It is not very plausible that one and only one form of life is going to be the best form of life. It is much more likely that successful lives come in a variety of forms, because the circumstances humans find themselves come in a variety of forms. Context matters here as elsewhere. Plausibly, what makes for a better life for someone like myself (a white, college-educated Irish-American male living in the twenty-first century) will hardly be exactly the same as what makes life go better for an eighth-century Chinese farmer, or a twentieth-century Ethiopian grandmother.

We need, therefore, a different view of flourishing. We need a way of thinking of flourishing that allows for a degree of objectivity without collapsing into the position that there is only one best sort of life. The key to reaching such a conception is to understand flourishing as a fluid concept.

Fluid concepts are concepts that can be extended and enriched in new ways as circumstances demand. They come in different types. One sort of fluid concept is what Wittgenstein called a *family resemblance concept.*[26] The concept of a game was Wittgenstein's favorite example. Plausibly, there is no one characteristic or set of characteristics that *all and only* games share. Games come in a rich and seemingly never-ending variety of forms. Some use boards, but not all do; some involve competition between groups, but not all do; and of course not every competitive activity (like war) is a game. In learning the concept of a game, we don't memorize a list of the essential features that all and only games have, because there is no such list. Instead, we extrapolate from paradigmatic examples of games, extending our concept when necessary to cover new cases.

Another way for a concept to be fluid is for it to be open textured.[27] A concept is fluid in this sense when, starting from a shared, minimal core, it can be enriched in different and even incompatible ways as circumstances demand. Concepts of this sort are like sketches. Imagine we ask different artists to fill in a very minimal sketch of a landscape, to turn it from a sketch into a complete painting. Many of the resulting paintings will look quite different, since each artist may take lines in the sketch to suggest very different features of the landscape. Perhaps some might not count as developments of our sketch at all (e.g., one that simply painted over the sketch with one color), but others could easily be seen as equally good enrichments of the sketch. Suppose we asked which is the best filling-in of the sketch, or which is the *real* painting of the scene in the sketch. This is not a question we can answer absolutely. Both are, or neither is, depending on what you take the original sketch to be about.

And what the original sketch is about, although not completely up for grabs, will be to some degree indeterminate absent any appeal to a particular interpretation, or enrichment of the sketch.

Our common concept of happiness or flourishing is open textured in just this way. Unlike our concept of games, we believe that a happy life has some core—if thin and sketchy—characteristics. These minimal features are what anything we would count as a good life must have in common. More precisely: a life without these features would, other things being equal, be a worse life. But like the rough lines of our sketch, these characteristics are open to divergent development.

The fact that we think of happiness as having some minimal characteristics doesn't mean that we will all agree on what those are, although it would be surprising if most of us didn't agree on some. What it means *is that we are tolerant of there being more than one way to be happy, while at the same time agreeing that there are definite ways to be unhappy.* Thus, many of us will agree that happiness requires at a minimum a certain amount of physical and psychological health, freedom from continuous pain and the achievement of some pleasure, friendship, love, integrity, and self-respect. But we also think that there are many ways to go from here. There is a plurality of different but potentially equally good ways to be happy.

Most of what makes for my individual happiness is just that—individual. There may be some projects, for example, that will be good for me to pursue but not for you. As Paul Bloomfield has argued, the goodness of a life is in this respect like physical healthiness.[28] What is healthy for one person is not necessarily healthy for another. Healthiness is thus both relative and objective. If you have high cholesterol and I don't, then you should avoid fatty foods. They would be unhealthy for you—and this is an objective fact. Wishing it weren't so won't make it go away. In the same sense, pursuing a particular art may be objectively good for one person, while raising happy children may be what is good for another.

Even when we share the same idea of what makes for happiness, we may vary in how we weigh some goods in relation to others. The most obvious examples are probably cross-cultural, but they need not be. Perhaps because you suffered through difficult poverty in childhood, you weigh the avoidance of suffering more than the achievement of pleasure. This might cause you, for example, to value securing a stable form of income over pursuing a potentially more profitable but riskier career. Someone else might hold that

friendship is the most important aspect of his flourishing, while others might hold it as no more important than other basic goods.

To admit that our common, minimal concept of flourishing, of the good life, is fluid in these ways means not that anything goes, but simply that the rules we do have for deciding when a life goes better are not crystalline but open textured. The conditions for their future use are not determinate. Wittgenstein once asked what we would say if a chair started to appear and disappear, or grow, or move around on its own. Would we still call it a chair? That we don't know what to say doesn't mean that we don't know what a chair is—it is a device made for sitting—it only means that our concept of a chair is fluid, and might be used in the future in more than one way. So it is with flourishing and living well, both in general and in our own case. None of us knows what life has in store for us, and thus none of us knows how we may need to fill in our shared sketch in order to live a good life.

Plato once remarked, after cataloging various elements of happiness, that "Still there is something more that must be added, which is a necessary ingredient in every mixture. . . . Unless truth enter into the composition, nothing can be created or subsist."[29] He is more right than not. Caring about truth and believing the truth about what you care about are necessary parts of happiness by being necessary parts of integrity, authenticity, and self-respect. Implicitly, therefore, they are part of the minimal concept of happiness.

More Questions, More Answers

The preceding conclusions raise further questions, some of which I'll answer below. Not all of these issues can be dealt with here in any thorough way, but where possible, I will attempt to gesture at what more complete answers might look like.

Q: You have claimed that in a number of ways, believing certain truths and caring about truth as such are both necessary parts of human happiness. Does that mean that people not inclined to self-reflection, or incapable of it, are necessarily less happy than those that are? Similarly, couldn't someone who lacks intellectual integrity nonetheless be happy, or live a flourishing life by his own (perhaps corrupt) standards?

No, and yes. In thinking about these sorts of questions, two points need to be kept in mind. First, we need to remember that happiness is a matter of degree.

One is not either happy or not happy. One is more or less happy, or flourishing to a greater or lesser degree. Flourishing is also a complex whole that is made up of many parts. Therefore, just as someone could easily not be happy even if she has, say, a secure sense of self, so someone who lacks a good sense of self might flourish more than someone else who does not, *all things considered*. All the self-respect in the world won't do much good if you are starving. Conversely, living a life where one is loved, not hungry, with ample time for relaxation, and so on makes up for a lot. Likewise with authenticity, self-respect, and integrity.

What does follow from my arguments is that *other things being equal,* a person living a life that encompasses these self-reflective attitudes, and therefore a concern for truth, is necessarily better off for it. Take two people who live in identical circumstances of comfort, wealth, and so on, but where one knows what she cares about, respects herself, and has integrity, and the other not: the former will be flourishing more than the latter.

Q: You've said that a concern for truth is part of the minimal concept of happiness that we all, presumably, share to some degree. But you've argued that the minimal or thin concept of happiness can be expanded in various ways. So how do you know you aren't really just giving an analysis of one among many more robust concepts of flourishing, albeit one that is shared by many people in Western cultures?

When we evaluate what is necessary for a happy life, we do so not from some abstract God's-eye point of view but from—where else?—the standpoint of our own life. And my life, in virtue of the fact that I am living it, incorporates a particular way of filling in our shared minimal concept of happiness. But that goes for everyone, and it does not mean we can't reach general conclusions about what makes people happy. In discussing what is necessary for happiness, we are like painters who have filled in a common sketch in different ways. Once we have done so, it will be natural for us to disagree about what lines of our paintings belong to the original sketch. We may favor each aspect of our own painting as picking out what is essential. This does not mean that we can't ever agree, nor does it mean that anything goes. It simply reminds us of our proper attitude toward the truth—that we must stand by our best judgment, while admitting the possibility that we might be wrong.

I think that caring for truth, integrity, and so on are aspects of our minimal concept of happiness. I may be mistaken. If I am, and if, in particular, it turns out that some cultures do not think that integrity or knowing what you care

about is all that important, then I will revise that view. Note, however, that even if that should turn out to be the case, the arguments I've given for the goodness of truth still stand. For even in that case, caring for truth is a constitutive part of *our* happiness. And that, surely, is enough to make truth worthy of caring about for us.

Q: The argument from self-knowledge seems to presuppose that we each have something called a "self." But talk of selves, taken in a metaphysically serious way, summons up the specter of Cartesian dualism, souls, and the like.

The nature of the self is a question that bears on the nature of self-knowledge, but it is far too complex an issue for me to say much about here. But nothing in the arguments I've given commits me to Cartesian dualism, or to any view about whether the mind or self is physical or nonphysical.

Here's why. In talking about identity and related notions here, I've been talking not about numerical identity, or what makes you one and the same person over time, but about what makes you the kind of person you are. I've argued that one of the things that plausibly makes you the kind of person you are is the nexus of commitments, beliefs, principles, and so on that constitute what you care about. This nexus of commitments might be called your *self*, in a certain sense of that word. In my view, this complex set of attitudes, although undoubtedly psychological in nature, supervenes on underlying neural properties of the brain. But one might hold another view about what those psychological attitudes consist in and still believe in the self as I've described it. The self is a set of psychological attitudes; whether those attitudes are in turn physical or not is simply another question.

Q: Is the truth about your self discovered or created?

This again is a much larger question than I can answer here. What I can say is this. The way of understanding the self I've been talking about is happily compatible with an idea that a number of writers have recently converged on, namely that the self is "narrative" in nature. As Alasdair MacIntyre has put it, human beings are essentially storytelling animals, and the "unity of a human life is the unity of a narrative quest."[30] Living a life, on this view, involves telling a series of stories about your self to yourself and to others. We attempt to understand and reconcile our various actions, beliefs, commitments, and desires into a coherent temporal narrative that makes sense of it all. The self, on this view, is therefore partly constituted by one's sense of self. As Owen Flanagan puts it: "the self that answers questions about who a person is, what

that person aims at and cares about—is a complex *construct*. It is both expressed and created by the process of self-representation."[31]

On this basis, some writers have argued that the self is therefore a fiction—albeit a useful one. But this doesn't follow. To say that our self is partly a construct is not the same as saying it is a fiction. The fact that our sense of self contributes to the formation of our identity doesn't imply that it creates that identity out of whole cloth.[32] There are external constraints on the coherency of the narratives we weave about ourselves—our past history, our biology, our cultural circumstances, our emotions, and the views of others, who can point out to us when our sense of self is out of kilter with who we are. As I've emphasized above, we can make *mistakes* about what we care about, what we are committed to, what we really stand for. I may think that I've got a grip on who I am—that my self-narrative is coherent—but I can be wrong. And if I can make a mistake about who I am, then the truth about who I am is to that degree objective.

If this view of the self is on the right track, then the right answer to the question: "do we create or discover the truth about ourselves?" is probably "both." Our beliefs about ourselves, which constitute our sense of self, are capable of being true or false. But the truth of such beliefs is a prime example of a possibility that I spoke of earlier: that truth may sometimes take very different forms. Discovering the truth about oneself is not plausibly akin to discovering the truth about whether the cat is on the mat. What makes my belief that I care about my wife true cannot be that this belief corresponds to a mind-independent fact. This is because what I care about it is a matter of what I am committed to, what I identify with, and these are mind-dependent matters. Rather, if the narrative view of the self is correct, what makes that belief true is that it is a member of a coherent set of beliefs that I have about who I am. Since these beliefs don't exist without me, there is a clear sense in which I "create" them—by forming them as I move around in the world. But since I can't simply decide whether my self-narrative is coherent, it is just as right to say that I discover who I am, that I chart the shores of myself, those both far and near.

9 Sweet Lies

Liar, Liar

Lying, like breathing, comes naturally to human beings. We lie to hide our insecurities, to make others feel better, to make ourselves feel better, to distract attention from us, to make people like us, to protect the children, to extract ourselves from danger, to conceal our misdeeds, and for the sheer fun of it all. Lying is a true universal, practiced with skill the world over.

As befits something that we use in such a dizzy variety of ways, our attitudes toward lying run the gamut. On the one hand, we tend to think that lying is very bad indeed; lies are damn lies, and the liar "harms mankind generally," as Kant put it.[1] Yet we also romanticize the successful liar, the trickster like Odysseus or Loki, the charming con man who is able to win his way and fortune through deceit. Lying is bad, but like many bad things, it can also be sexy.

As these remarks indicate, lying is an extremely complex subject—whole books could be written about it, and they have been.[2] Here, I want to restrict my attention to just a few questions surrounding lying and its opposite, sincerity: what makes lies bad, and sincerity good, and what is the connection between truthfulness and the value of truth?

So far, I've concentrated on true and false belief. Lying to another person, however, is a public matter; language, not belief, is the liar's stage. Nonetheless, lying involves belief, because when lying, what you say is not what you believe.

Sometimes lying is defined in just this way—as saying one thing while believing another.[3] As it stands, however, this just won't do. In one sense, it is too strong—it would make lies of that which isn't. Actors on the stage, for example, speak what they believe to be false—the actor who announces, "It is I,

Horatio" knows very well that he is not Horatio, as does the audience. When acting, actors are not, except in a metaphorical sense, lying.

This first definition of lying may also tempt us to classify some lies as not lies at all. Consider, for example, the doctrine of the "mental reservation," spawned in the Middle Ages but still kicking around today. According to this idea, one does not lie in the sense defined above—by saying something you don't believe—just so long as you also "say" a crucial qualification to yourself that makes the whole thought true. For example, a man who insists he hasn't committed adultery doesn't lie on this view as long as he adds to himself "this week." Or take the doctrine of equivocation, according to which one does not lie if one uses words that are equivocal or ambiguous in meaning, even if you do so knowing that your audience will take your meaning to be different than the one you actually believe. Thus: did you sleep with him? No, she replies— truthfully on this account—if she didn't in fact literally *sleep* with the person in question. But I don't think many of us will take either of these views seriously; and those that have been victimized by either will be apt to regard them as sophistical.[4]

So lying isn't simply saying one thing and believing another. To lie, rather, is to assert something you believe to be false with the *intention of misleading or deceiving.* As Donald Davidson has noted, the deception involved in lying may vary.[5] I may wish to get you to believe what I say, or I may not. But at the very least, I aim to deceive in lying by aiming to both (a) present myself as believing what I do not believe; and (b) keep this intention hidden from my listeners. I deceive by portraying myself as sincere when I am not, and at the worst, I actually convince you to believe what is false in order to harm you. This is not what is going on in acting. There is no intention to deceive—when you go to a play, you know that the actors are actors. Similarly, if you intend to represent yourself as sincerely believing something you don't, then you lie—whether or not you cleverly equivocated or made a quick mental "reservation."

There is a long tradition in philosophy, represented most vividly by Immanuel Kant, which holds that lying is absolutely wrong. Kant held that it would be wrong to lie to a murderer if he came to your house and asked for the whereabouts of your friend hiding inside the house.[6] He believed that speaking falsehoods was always offensive to one's absolute moral duty, and that it was a deep betrayal of human dignity.

In Kant's opinion, then, lying was absolutely bad. Like many others, I don't share this view. As far as I can see, lying is always bad—but it is always *prima*

facie bad, that is, bad other things being equal, or bad considered by itself. Some lies are justified, such as lies to prevent grave harm. Indeed, this fact is what makes the subject so difficult. For once we admit—as surely we must—that lying isn't always wrong all things considered, the hard questions are why it is ever wrong, and how to tell a "good" lie from a bad one.

The second of these questions is really the issue of when a lie is *justifiable.* As Sissela Bok emphasized in *Lying,* a good way to test whether a lie is justifiable is to consider whether it would pass a publicity test.[7] Lies are by nature secrets, but a justified lie is one that—probably—would pass muster were it exposed to the light of day and subjected to the examination of reasonable people. This of course includes the people deceived by the lie. As in other cases of moral decision making, you must project yourself into the place of the other and ask yourself how you would feel about it if you wore his shoes. In this case, that means asking whether you would like to be lied to in this way.

Bok's suggestion is certainly to be commended. Most lies, in either the public or private sphere, won't pass the publicity test. Others will. Paradigmatic examples are lies we tell that we know in advance we will later reveal to the deceived. Lying about Santa Claus to a child is a good example. Another is a government that uses deception for reasons of national security during wartime but willingly reveals those deceptions when the war ends. The willingness to reveal the deception once the need for it has passed indicates confidence that the lie will pass the publicity test.

Yet we also need to be careful. In the moral realm, there are no foolproof tests. What "reasonable" people will understand as justifiable is a highly contextual matter. Standards of reasonableness change, as do the people who are considered capable of reason. So it is conceivable that some lies will pass the publicity test and still be wrong and that others will not pass but actually be right. This is not in itself a cause for alarm. Nor should it make us abandon the publicity test. It is just a reminder that in the moral realm, our need for rules of justification never completely escapes the need for individual judgment in applying those rules.

The publicity test is just that—a test for whether a lie is wrong. Flunking the test isn't what makes the lie wrong; it is merely an indication that it is. So while Bok's publicity test for when a lie is justifiable has definite merits, it doesn't answer our other question—what makes lying wrong.

The most obvious reason lying is wrong is that it tends to harm other people. This may be the intended result in some cases—you might lie to prevent me

from avoiding some danger, or to send me into danger, or to simply make me feel bad. But even when the liar is not motivated out of malice, his lie may well bring harm. Indeed, it is a sad fact that a liar often gets caught unawares by the harm that he has caused—"I didn't think it would hurt," he thinks; but that is the problem, that he misjudged the potential harm of his own lie.[8]

The simple point that much of the harm of lying comes from its consequences can also help us see why some lies may not be wrong. Some lies, in some situations, are frequently judged—with justification—to be harmless. We often call these white lies. The phrases "You look fine" or "I'm good, how are you?" are often used in this way, as are many cases of embellishment, fish stories, and small lies told for comic effect. And as I've already noted, some lies, such as lying to the murderers at the door, may be good to tell because they would clearly prevent great harm.

Now as I just pointed out, it is often quite difficult to determine what the consequences of any given lie might be. And obviously, what may be a white lie in one situation may not be in another. So even if we are focusing only on consequences we may still feel there is a general reason to refrain from lying. For we depend on others to give us accurate information about our environment, and almost any piece of information, even one that is not relevant now, may be needed later. Thus when you deceive me about what is true, I may end up relying on that bad information at some other time—even if this was not your intent. Lies frequently breed lies, so the potential harmful consequences multiply as well. As a result, even if some lies may be justifiable, there is good reason, in general, to refrain from lying.

Concentrating on the consequences of lying tells us quite a bit, then. But might not there still be something about lying in general that is wrong, independent of the individual consequences of a given specific lie? This is worth thinking about. A reason to refrain from lying in general needn't be a reason for thinking that every lie must be wrong, all things considered. Rather, it may be a reason why—independently of the consequences of any particular lie—lying is, other things being equal, wrong.

One traditional argument against lying in general is that lying somehow corrupts or undermines the very practice of communication.[9] A very short version of the argument goes like this. Communication requires sincere assertion. So if one asserts what one doesn't believe, one damages communicative practice itself.

As it stands, this is not a very compelling argument. For one thing, it assumes the wrong notion of what lying is—namely, merely asserting something you don't believe. But the big problem with the argument is that it is not clear why, even if we grant the premises, we should accept the conclusion. As Bernard Williams has pointed out, even granting that we understand what it means to damage communicative practice, it is pretty clear that lying doesn't do it.[10] As I've already noted, people lie all the time. It is practically a national sport. And yet the practice of assertion and communication is ticking along just fine, thank you.

Nonetheless, there is a thought worth saving in the general neighborhood of the above argument. That thought is that much of cooperative human activity depends on the assumption that people speak the truth to each other. Many of the things we do require us to work together toward a common goal— whether it is building a house, planning a school's curriculum, parenting, or a thousand other things. To reach our goals, we need to share information, and that means telling each other what we know. Otherwise, things don't get done. Even when I am not engaging in literally cooperative activity, I am constantly dependent on what other people say is true—I trust the passing stranger for directions, I trust my lawyer's advice about the law, I trust my doctor's medical opinion. Every day, I trust that others will—by and large—tell me the truth. If I don't, I won't get where I need to go, or be able to avoid harm effectively, or plan appropriately. And the same goes for you. So while it is true that lying happens frequently and copiously, an expectation of truthfulness is the background against which this generally happens. Much of time, we don't even notice this, because as the examples above indicate, exchanging information or relying on the information of others is just part of the background of life. Of course, if we aren't stupid, we'll be on the lookout for situations where people have reasons to lie. But that's just the point—we don't expect people to lie without reason. A society where the reverse is true—that is, where lying is the default and truth telling (although perhaps common) is the exception—wouldn't last very long. Sharing information would be a terrible struggle (I would have to give reasons why someone should tell me the truth, for example; but of course, they would assume I'd be lying about those reasons). Cooperative activity would be limited or nonexistent.

These considerations point to two things—first, truthfulness is indeed a central aspect of human life. Accordingly—and this is the second point—one

reason lying is wrong is that *if everybody lied all the time,* things would be very bad indeed.

But although important, these points still don't amount to much of an argument against lying. And they certainly don't show that lying is always *prima facie* wrong. For the fact is that we don't all lie all the time. And even people who lie frequently and with malice do so not because they think that people in general should lie more. Far from it: the malicious liar *wants* other people to both tell the truth and trust that others tell the truth. Lying works because truthfulness is the default position, and the good liar takes advantage of just that fact.

This last bit brings to the surface a key point. Lying, as I just pointed out, is a violation of a certain expectation—the expectation that, absent reasons to the contrary, people are sincere in their assertions. The fact that truthfulness is the default position means that even the most cynical of us trust each other not to lie much of the time. Background trust of this sort, as we've seen, is essential to a shared human community. The unjustified lie violates that trust. And crucially, by violating that trust, the liar manipulates us.

For this reason, lying is a very basic exercise of power.[11] We must rely on others' knowledge to get around in the world, to accomplish our goals. By lying, the liar increases her own power and decreases ours. She hides what she truly believes and thus knows something we don't. As a result, our responses are shaped by the liar without our knowledge. We take the liar to be sincerely reporting what she believes to be true, and by believing her, we—to a greater or lesser degree, depending on the lie—relinquish some freedom. To at least some extent, we become subject to another's will. The liar prevents us from responding to the facts directly, or, perhaps more accurately, manipulates us by thinking things stand in ways they do not. In this sense, then, Kant was right to emphasize that the liar treats the deceived not as ends but as means—a means to his own increased power. And this is why we feel there is something wrong about lying even when some particular lie—all things considered— may do more good than harm. To lie to someone is fundamentally to not respect them as a human being.

An important upshot of this point is that the power that comes with lying is parasitic on the power of the truth. Plainly put, lying is bad partly because believing the truth is good. If it weren't, we wouldn't care about whether you told it or not. As it stands, of course, even when we sincerely express our beliefs, we don't necessarily speak the truth. Our beliefs might be false. But we do further each other's ability to pursue the truth by indicating what *we* be-

lieve is true, and allowing others to agree or disagree with it. By listening to you, I may not come to learn the truth, but I do come to learn what you believe is the truth, and this can be an important check on my own beliefs, since I may not have experienced what you have, and I may not have access to evidence to which you have access. Consequently, by lying I can, indirectly, gain a degree of control over your access to the truth. It is the value of truth, once again, that is in the driver's seat.

Sincerity

I now want to turn from lying to its more elusive opposite—sincerity. Sincerity is a virtue even more commonly associated with truth than authenticity and integrity, so it bears looking into. I want to focus on two questions—first, what makes sincerity good; and how is it connected, exactly, to caring for the truth?

Being sincere, or truthful, doesn't simply mean saying what you believe. Politicians frequently evade pointed questions by simply repeating certain vague phrases that can easily be interpreted to mean things that are true. By doing so, they "technically" speak the truth, while they hope to mislead a listener into thinking they've responded to the point of the question. On the contrary, to be sincere—a straight shooter, so to speak—is to be disposed to say what you believe, with the intention not to mislead. Understood in this way, sincerity is a useful disposition for the members of a society to have. As I've already indicated, we need to be able to speak the truth to each other much of the time if we are going to work together. To work together, we need to share information, and in doing that, it helps to be sincere. So sincerity has clear instrumental value. But mightn't it be valuable in some other way? Might it not be worth caring about for its own sake?

In his recent book on this subject, Bernard Williams says that it is. He argues that sincerity is worth caring about for its own sake because it is good in itself or intrinsically good. Williams rightly sees that just invoking the words "intrinsically good" isn't sufficient if what we are looking for is an *explanation* of sincerity's value, however. We need to understand what this means if it is to do any work. Hence, Williams offers a criterion for something's being intrinsically good. The account fails, but its failure is instructive.

According to Williams, it is a sufficient condition for something's having intrinsic value that "first, it is necessary (or nearly necessary) for basic human purposes and needs that humans should treat it as an intrinsic good; and

second, that they can coherently treat it as an intrinsic good."[12] In other words: something is intrinsically good only if we must *believe* that it is in order to get certain things we need to survive. So on this definition, truthfulness is intrinsically good only if we need to believe that it is. And of course, it seems likely that we do. As he points out, it seems likely that sincerity couldn't have the social utility it does unless we did view it as good in itself. If we instead followed Mark Twain's quip that "honesty is good, as long as it pays," we might find ourselves examining each request for information, no matter how minor, for whether it would benefit us to respond with the truth. And we would certainly not be truthful when it was uncomfortable or dangerous to do so. But then, of course, the social goods that come from the mutual and free sharing of information would to that extent diminish. If we thought sincerity was only instrumentally good, in other words, we'd probably end up telling the truth less of the time.

Williams seems to me right on this score. Habitually treating truthfulness as worthy of caring about for its own sake helps us to be more truthful, even in situations in which it might not pay for the individual to do so. I just don't see what any of this has to do with showing that truth is intrinsically good. It only shows that it is instrumentally good to *believe* that it is.

Williams, unsurprisingly, seems sensitive to this charge. This is why he adds his second clause: our belief in something's intrinsic value must be coherent—it must hang together with our other beliefs about what is good, and it must not erode under reflection. Coherence with our other moral beliefs is important, without a doubt. But I confess I don't see how our belief in sincerity's intrinsic value won't erode under reflection in just the way Williams fears. If what justifies our belief that something is good in itself is the fact that having that belief pays in helping us get certain things we need, *then once we realize this fact,* it seems likely that we'll no longer think of that something as really good in itself. We'll think of it as good because we have it—at least for now—in order to get something else we need. If we could just get those things in other ways, we could give up that belief. We might not be able to do so with great ease now, of course, but it is possible in the future. Our belief in the intrinsic value of truthfulness would seem to erode on reflection anyway, if Williams's account is right.

So Williams is mistaken about why sincerity is worth caring about for its own sake. Yet there is something right here, too. We can get a better grip on what that is by looking closer at the connection between truthfulness and truth.

Just as the wrongness of lying ultimately depends (at least in part) on the goodness of believing the truth, so too must the goodness of sincerity, however it is construed. In Williams's view, this order is strangely reversed. The value of truth, he says, insofar as he thinks it makes sense to talk of such a thing, is explained by the value of the virtues of truth: what he calls accuracy and truthfulness, or the "human concerns with the truth."[13] If what we *mean* by accuracy is "believing truly," or expressing one's true beliefs, then this is fine. Beliefs are good just when they have the property of truth, and thus, by concentrating on why it is good to believe truly, we can understand the value of that property. On the other hand, if we mean by the virtue of accuracy being disposed to be reliable in one's belief-formation, then Williams's approach is backward. Someone is a reliable believer just when they are likely to form true beliefs. But we cannot explain the value of that without first explaining the value of having true beliefs. Being a reliable believer is good because believing truly is good, and not vice versa—for the simple and obvious reason that a "reliable believer" *just is* someone who is likely to believe what is true.

A similar point holds in the case of sincerity. Here too, part of the connection between sincerity and truth is instrumental. Being truthful is good because, for example, it helps us exchange information—and that gets us (we hope) closer to the truth. We prize sincerity in people in large part because we think that in the long run and over the long haul, if people are sincere, all of us will end up believing more truths than falsehoods. But this isn't the whole story. The value of sincerity also depends on the value of truth in a stronger sense. If true belief weren't valuable at all, then sincerity wouldn't even be a virtue.

While sincerity is no proof against error—it is just the disposition to say what you *think* is true without wanting to mislead—it is still a relationship that tends toward the truth. Specifically, if you are sincere, you care about the truth. And you care about it as such. Other things being equal, a sincere person says what she thinks is true, on any particular subject that arises, *because she thinks it is true.* In sum, sincerity is good because true beliefs are good, but sincerity requires caring about the truth as such for its own sake. As with intellectual integrity, caring about truth is a necessary part of being sincere. Someone who couldn't care less about the truth may end up telling the truth about this or that when it suits him, but he won't be a sincere person. He'll just be honest when it pays.

But let's be careful. Even if one needs to care about truth in order to be sincere, it doesn't work the other way around. Insincerity doesn't necessarily

mean that one does not care about truth. The most obvious form of insincerity is lying. But liars—even frequent ones—are very much aware of the power of truth and truthfulness, and that is very much part of the reason that they lie. Hence, although there is clearly a sense in which I don't care about the truth when I violate your trust, it is crucial to see that this is not completely right. One reason for this is that some liars may actually be, bizarrely enough, motivated out of a concern for getting the truth out. Thus the zealous missionary might tell some lies (e.g., about how his own religion is connected to native beliefs) if he believes that in so doing, "the greater truth" of his religion will meet with a warmer reception from the natives. The missionary may well care about the truth—indeed he may exemplify to some extent or other the various intellectual virtues. But even in less dramatic cases, liars are usually very concerned with the truth—they are concerned to hide it. Liars generally recognize that hiding the truth that they believe something other than what they say can be a source of power. Of course, to the extent that this power is their sole motivation, they are to that extent less *motivated* by the truth as an end, and to that extent caring less about truth than they could or should. But this needn't be the case. One may lie and still care about the truth.

There is another way of being insincere that is more readily a sign of not caring about the truth, however. Liars are different from what both Harry Frankfurt and Akeel Bilgrami call "bullshitters."[14] To bullshit is not necessarily to lie. It is to be careless with the truth. The bullshitter is different from both the liar and the sincere person in that he intends neither to say what he believes (even if he does) nor to hide what he believes (even if he does). He is just not interested in the ways things are—in the truth. He is interested in other things—power, prestige, being titillating or convincing.

Storytelling is not the same as bullshitting. Someone who tells a good story, even a tall tale or "the one that got away story" is not necessarily bullshitting (although he might be). Indeed in some cultures and subcultures, storytelling is a prized and expected way of communication. This is certainly part of my own ethnic experience as an Irish-American. In my extended family, in certain situations, one is expected to embellish and exaggerate, and everyone involved knows this. Spinning a yarn about one's difficulties in getting to Thanksgiving is part of the fun. The crucial differences are that (a) the storyteller and her listeners know that they are being told an embellished or exaggerated form of the truth, and (b) the storyteller is often motivated by communicating some important piece of information—albeit in a colorful way.

Let us return, then, to why we care about sincerity. Williams started out on the right track. We do value sincerity more than instrumentally, and we should. And like Williams, I don't find saying that sincerity is simply "good in itself" is all that helpful as an explanation. The key is to remember that we can justify our caring for something for its own sake in more than one way. Some things are worth caring about because they are parts of larger wholes that are good. And it seems natural to understand sincerity in this way.

Lying, I've argued, is bad not only because of its consequences but because it shows a fundamental lack of respect for the victims of the lie. The underlying assumption here—one that we get from Kant—is that respecting persons is a basic and fundamental good.[15] Furthermore, it seems plausible that respecting other persons and respecting yourself are two sides of the same coin. They come together. If you don't respect yourself, you will have a hard time respecting others, and if you truly respect yourself, then you will be at the very least more inclined to respect others. So even if respect for others is not an intrinsic good, exemplifying this virtue is arguably part of flourishing.

One way or the other, it seems very plausible that respecting others is more than instrumentally good. Yet insincerity not only shows a lack of respect for persons; arguably, being sincere shows the opposite. One treats other humans with dignity when telling them the truth. You do not usurp their power—you don't get in between them and the facts, as it were. Therefore, being sincere—in the dispositional sense—is not simply a means toward respecting others, it is an essential component of that respect and hence itself a constitutive good. If it is a *prima facie* constitutive good, then it is worthy of caring about for its own sake.

What's more, we are now in possession of another reason to care about truth as such, or in general. Call this the *argument from sincerity:*

1. If sincerity is a constitutive good, then so is caring about truth as such.
2. Sincerity is a constitutive good.[16]
3. Therefore, caring about truth as such is a constitutive good.
4. If caring about truth is good, then truth as such is worth caring about.
5. Therefore, truth as such is worth caring about.

Like the arguments from integrity and self-knowledge, the argument from sincerity helps to explain why we think truth is good. It reminds us of an important fact: if we value sincerity, then we had also better care about truth.

10 Truth and Liberal Democracy

We Are Not Lying

In early 2002, the Pentagon announced that it was going to start lying—officially. As widely reported in the media at the time, the short-lived but cheerily named Office of Strategic Influence was charged with spreading so-called black propaganda, or false stories, in only the foreign press. Outrage among media advocates and the Congress was high. Given the globalization of the media, skeptics rightly pointed out that even if the office refrained from directly placing false stories in U.S. newspapers, it would be exceedingly difficult to prevent some of these stories from cropping up there eventually. Perhaps not surprisingly, the Office of Strategic Influence was quickly closed.[1]

As news, the revelation of official deceit would have been less than shocking, except for the paradoxical fact of the very public announcement of its existence. This gave the subsequent press briefings on the topic by Donald Rumsfeld and others a darkly comic air ("We were planning on lying but we swear we aren't doing so now"). One couldn't help getting the sense that it would be the closest we'd ever get to a real-life reenactment of the old Liar paradox—or what to make of someone who announces that honestly speaking, he is a liar.

In any event, and despite the hubbub caused by the Office of Strategic Influence, few people are ever surprised to learn that our government—or any government—would engage in outright deception of its citizens. This is partly because we all know that even the most democratic government must sometimes keep secrets from its citizens, and that sometimes means lying; and, it is partly because of the well-documented post-Watergate, post-Iran-Contra, post–Monica Lewinsky, and post-Iraq cynicism about government. Such cynicism is understandable and good in some ways, bad in others. But our lack of

surprise about official deceit is also due to cynicism about truth itself of the kind I've been discussing in this book. This attitude is very bad news for those like myself who still think that liberalism is our best hope for a pluralist, egalitarian society. The less we think that truth matters, the more a rational response to the increasing imperialism of our own government becomes lost in the rhetorical fog. Give up on caring about truth, and you give up, as an old civil rights slogan has it, speaking truth to power.

I've so far concentrated on personal reasons, broadly conceived, for caring about truth. Caring about truth, I've argued, is just part of a good life. But there is another reason to care about truth. Truth matters politically. Concern for truth is a constitutive part of liberal democracy.

The relationship between truth and democracy is a big topic, and I won't try to cover every aspect of it, or even most of it. I will be concerned, in particular, with two sets of issues. The first is practical and includes, most obviously, the question of why it is almost always wrong for a democratically elected government to lie to its citizens. The second is more general: to what extent must a liberal democratic government value truth?

My two questions are related. You can't explain why it is bad to lie without first explaining why it is good to tell the truth, and you can't explain that unless you know why believing the truth is a good thing. It seems likely that the same order of explanation will hold at the political level. We can only answer why it is good for a government to be truthful by first explaining why it is important in general that a modern liberal government must value the pursuit of true beliefs. Therefore, we first need to ask about the relationship between believing the truth and democracy.

The Social Value of Truth

I want to begin by returning to a basic question: what is the point of having an idea of truth in the first place? I argued earlier that the most obvious reason we need an idea of truth is that we need a way of distinguishing good opinions from bad. This is not to say that "true" and "false" are the only concepts we use for this purpose. We can and do evaluate beliefs for their correctness in other ways: as justified or unjustified, as reasonable or unreasonable, as based on evidence or not, and so on. But as I've argued throughout this book, these latter sorts of evaluation are always linked to truth. We think it is good to have some evidence for our views *because* we think that beliefs that are based on ev-

idence are more likely to be true. We criticize people who engage in wishful thinking *because* wishful thinking leads to believing falsehoods.

So the point of having an idea of truth is to sort correct judgments from incorrect ones. This is a simple point, but as we've seen, like a lot of simple points, it often gets lost in the jumble of theory. And it has some interesting consequences. The most important consequence for present purposes is that the normative function of truth has a clear social dimension.

One of the things humans like to do when they are together is disagree with each other. Yet, as I've noted before, the possibility of disagreement over opinions requires there to be a difference between getting it right and getting it wrong. In asserting an opinion, I assert what I believe is correct. When you disagree, you disagree about whose opinion is correct. So if there is no such thing as being right, wrong, or even in-between, then we can't really disagree in opinion. We may of course still differ in all sorts of ways—in our hopes and fears and desires. But we aren't disagreeing over who is right and who isn't. When there is no question of being correct or incorrect, there is nothing to disagree about.

Now imagine Orwellia, in which everyone—and I mean everyone—believes that what makes an opinion correct is whether those in power hold it. Disagreements in Orwellia are settled by consulting the Authorities, since Orwellians believe whatever the Authorities say, because they believe that everything the Authorities say is correct. So if the Authorities say that blacks are inferior to whites, or love is hate, or war is peace, then the Orwellians sincerely believe this is so.

Orwellian society lacks something, to say the least. In particular, it seems to be lacking a vital point of information about truth.

Do they lack the *concept* of truth? Probably not. This might be reasonable to think if the Orwellians believed, *as a matter of definition,* that "whatever the Authorities say is correct, and whatever is correct is what the Authorities say." If they did, they could not even grasp the *thought* that the Authorities were mistaken. Such a thought would be empty to them. If so, then we might think they lack the concept of truth—for they seem to think, contra our first truism, that believing—by the Authorities—really makes it so. But the line between what is true by definition and what isn't is famously murky (to philosophers anyway). And furthermore, it is not clear that the Orwellians would have to believe in the Authorities' omniscience as a matter of definition—they might simply be brainwashed into thinking it is just a hard fact about the Authorities.

In any event, whether or not the Orwellians lack the very idea of truth, they definitely misunderstand what truth is. And—here's the point—their misunderstanding undermines the very point of even having the concept. Social criticism involves expressing disagreement with those in power—saying that their views on some matter are mistaken. But a member of Orwellia doesn't believe that the Authorities can be mistaken. To believe that, they would have to think that what the Authorities say is incorrect. But their understanding of what correctness is rules this out. So criticism—disagreement with those in power—is, practically speaking, impossible.

This story reveals what we might call the social value of having a concept of truth. Having that concept opens up a certain possibility: it allows us to think that something might be correct even if those in power disagree. Without this idea, we wouldn't be able to distinguish between what those in power say is the case and what is the case. We would lack the very idea of speaking truth to power.

Recently there has been a bit of a revival of interest in Orwell, and especially in his book *1984,* to which I just obviously alluded.[2] This is partly because of a concern over "doublespeak" from the government. But it is important to keep in mind that the most terrifying aspect of the Ministry of Truth isn't its ability to get people to believe lies, it is its success at getting them to give up on the idea of truth altogether. When, at the end of the novel, the sinister representative of Big Brother O'Brien tortures the hapless Winston into believing that two and two make five, his point, as he makes brutally clear, is that Winston must "relearn" that whatever the party says is the truth is the truth. O'Brien doesn't really care about Winston's views on addition. What he cares about is getting rid of Winston's idea of truth—for good reason, for O'Brien is well aware of the point I've just been making. Eliminate the very idea of right and wrong independent of what the government says and you eliminate not just dissent—you eliminate the very possibility of dissent.

Truth and Rights

Having a concept of truth allows us to distinguish between what is correct and what isn't. Consequently, the concept of truth takes on social importance: it allows us to distinguish between what is the case and what those in power believe to be the case. The social importance of truth in this sense is entirely general—it applies to any society. But now I want to move to a more

specific question. How does this point help us understand the importance or value of truth in a civil democratic society like our own?

It is a platitude that a democratic government should treat each of its citizens with equal respect. According to the recent traditions of political theory, there are two fundamentally different ways to interpret this platitude.[3] On the first theory, treating people with respect means treating them as they ought to be treated given a particular understanding of how people should go about living their lives. Equal respect requires a vision of the good life, and treating people with respect, therefore, means treating them as they should be treated given that vision. To have a conception of the good life is to have a conception of what matters—what it is you should pursue, and how you ideally wish to live your life. On this first sort of theory, you can't treat people respectfully until you know what the good for people really is. Once you know that, you can treat them with respect when you treat them as they should be treated. As a consequence, advocates of this first theory sometimes think it is the job of the government to encourage people, as much as possible, to follow that vision of the good life, which, perhaps unbeknownst to them, is the sort of life they all should be trying to lead.

According to the second story, on the other hand, a government should allow, to the extent to which it is possible, people to pursue different conceptions of the good life. Some of us value contemplation and reading more, others see a good life as involving religion and religious activities, while others see it as involving just lots of beer and pizza. This second theory holds that the government should remain, as much as possible, broadly neutral on the question of how best to live your life.

According to this second theory, identifying one's freedom to pursue one's own vision of the good life is a fundamental right. Protection of this right requires, in turn, the identification and protection by law of more specific rights—rights to freedom of speech and religion, freedom of assembly, sexual preference, and so on. Rights like this, on this second theory, protect our more basic right to pursue our own vision of the good life.

This second theory is of course traditional liberalism, and were I to choose between the two theories as I've so far presented them, it would be the one I would defend. But as a number of commentators have pointed out, the ordinary way of advocating the view makes a mistake when it portrays liberalism as offering a political theory that is neutral between different conceptions of the good life.[4] This is not quite true. The idea that a government should, to the

greatest extent possible, remain neutral concerning different conceptions of
the good life itself embodies a particular conception of the good life. The vi-
sion the advocate of a liberal democracy is offering is that *life goes better if one
lives in a society where the government restrains itself, as much as possible, from ad-
vocating one conception of what makes life go better than another.* Unlike some, I
don't find this to be a devastating problem for liberalism. To distinguish liber-
alism from the first sort of theory of equal respect, one needn't say that liber-
alism has no consequences for what is good in life. In this respect, the ordinary
way of distinguishing the two theories is something of a false dichotomy. But
that doesn't mean that there is no difference between them. There is a dif-
ference, and the difference, at least in part, stems from the vision of what is
valuable in life. For my part, I find liberalism in this sense to be a perfectly rea-
sonable view of the good, and I am willing to defend it from those who think
life would be better in a society where everyone had to be Christian, or Mus-
lim, or atheist—or liberal.

But let us put to one side whether liberalism is the *right* political theory, or
even how to understand it in detail. The question I am interested in here is
not whether liberalism is true, but whether the concern for equal respect in
the liberal sense requires a concern for objective truth.

Conservative critics like Robert Bork and Allan Bloom have long insisted
that not only does liberalism not require an objective notion of truth, it is in-
consistent with it.[5] Surprisingly, many liberals themselves seem to agree. As
Richard Rorty once argued, "It is central to the idea of a liberal society that . . .
open-mindedness should not be fostered because as Scripture teaches Truth
is great and will prevail, nor because, as Milton suggests, Truth will always
win in a free and open encounter. It should be fostered for its own sake. *A lib-
eral society is one which is content to call 'true' whatever the upshot of such en-
counters turns out to be.*"[6]

The argument lurking behind the scenes here is, apparently, quite seduc-
tive. While it is unclear whether Rorty himself would ever have endorsed it, I
think many people clearly do. It goes like this: liberalism involves equal re-
spect for different conceptions of how to live. The ultimate way of showing
respect is to say that every view of the good life is equally true. Therefore,
truth can't be understood as independent of people's beliefs. Truth—to use
Barry Allen's ringing phrase—is just whatever passes for truth in one's shared
community.

This is bad news. From the liberal perspective, its most tragic flaw would be that it is self-defeating as a political position. As I noted, the liberal must herself acknowledge that, in advocating liberalism, she is advocating one view among others of the good life. But if it is part of the liberal's view that every view of the good life must be seen as equally true as her own (or potentially so, should it end up passing for truth in the national conversation), then it is unclear why she is advocating liberalism at all. If her opponents' views—those say, of the fundamentalist Right—are equally true as the liberal's own, then what motivation does she have for opposing them? It cannot be that she thinks she has the correct view of how to run a democratic society. No doubt there are several motivations possible besides a desire for the truth. But one worries that the most obvious motivation that remains is to assert *power*—the very attitude I've always believed liberalism was meant to combat. In any event, I'll think you'll recognize this view—call it *relativistic liberalism*—as a fairly common one. As a result of its influence, it is not surprising that defenses of liberal causes have become so mealymouthed and weak in recent years. It is hard to stand up and fight for a position that by definition takes itself to be no better than any other on offer.

We defenders of liberal democracy need to reject this view. Far from eschewing truth, liberalism requires that truth is a value. In particular, I'll argue, one cannot care about equal respect unless one also cares about truth in the minimally objective sense I've defended in this book.

The liberal conception of equal respect requires, as I noted above, a system of rights.[7] Such rights justifiably protect the citizens' freedom to pursue their own life as they see fit. Broadly speaking, rights can be either fundamental or not. Fundamental rights differ from other rights by being, as Ronald Dworkin has put it, matters of principle and not of policy.[8] A right is granted as a matter of social policy when a protection or advantage is accorded to a person in order to advance some desirable social goal. An example of this nonfundamental sort of right is the right for a police officer to carry a concealed weapon. A fundamental right, on the other hand, is not a matter of policy; it is instead what Nozick has called a "side-constraint" on policy formation.[9] Unlike rights justified by policy, which are justified because they are means to a worthwhile social goal, fundamental rights are justified either because they are directly necessary out of basic respect due to human persons, or because they are constitutive of any political system that accords basic respect to persons. In either

case, the justification for fundamental rights is seen as enormously strong, perhaps even absolute; thus the tag "inalienable." As Dworkin puts it, rights of this sort trump other political concerns. You can't lose them just because the majority no longer wishes to respect them. You can't lose your right to free speech, for example, just because the majority suddenly becomes convinced that criticizing the government is unpatriotic. The whole point of having a fundamental or, as it is often put, "human right," is that it can't justifiably be taken away just because a government suddenly decides it would be convenient to do so.

These comments on fundamental human rights are, by and large, uncontroversial. They simply mark out the minimum of what we mean by talking about such rights. Nonetheless, they have an important consequence. It follows from the conception of a right just sketched that a necessary condition for there being fundamental rights is that there is a distinction between what the government—and by implication in the case of a democracy, what the majority—believes is so and what is so. If whatever the majority believes were true, for example, then if they thought there was no right to free speech then it would be true that there was no right to free speech. Accordingly, it would make no sense to talk about rights at all, because there wouldn't be any sense to saying that you have a right to free speech independently of what the majority might think.

Consequently, a necessary condition for people to *believe* that they have such rights is that they believe that there is a difference between what the majority believes and what is the case. That is, it must be possible for me to have the following thought: that even though everyone else thinks that, say, same-sex marriages are bad, I don't think they are. But I couldn't have that thought unless I am able to entertain the idea that believing doesn't make things so, that there is something that my thoughts can respond to other than the views of my fellow citizens.

In sum, what I've just argued for is this. The liberal ideal is that one's society should respect, as far as possible, different conceptions of the good life. This requires the idea of rights. But the very idea of having a right requires the distinction between what our peers let us get away with and what is true. Therefore, it is not that the liberal must identify truth with what passes for truth in free and open debate, but rather the exact opposite: the liberal must believe that what passes for truth may nonetheless not be true. Our very concept of a right presupposes the concept of truth.

A classic defense of liberalism argues that respect for different ways of pursuing the good life helps us get to the truth.[10] This is the point of J. S. Mill's famous argument that only in the free marketplace of ideas is reaching the truth possible. The idea, essentially, is that by letting a thousand flowers bloom, we have a better chance of discovering those worth preserving; that is, we have a better chance of discovering better ways to live our lives. There is a lot of sense to this idea—although in my view, there is more sense to it if we don't take the "marketplace" metaphor too seriously. Rather than defend that idea here, however, what I want to point out is that the arguments we've been discussing turn Mill's point on its head. On the Millian view, the reason liberalism is good is that truth is good. This is precisely the position we saw Rorty criticize above: the core liberal values of tolerance, open-mindedness, and so on, on his view, are not good because they lead to the truth, because the truth itself just is the beliefs we end up having at the end of conversation governed by those liberal values. In contrast, I've argued that this must be mistaken precisely because the very existence of liberal values—the very possibility of equal respect in the liberal sense—rests on an objective notion of truth.

Let's pause and review where we are. So far, I've argued that (1) liberalism requires rights; (2) the concept of a right presupposes the concept of objective truth; therefore (3) liberalism presupposes a concept of objective truth. This is, in effect, a conceptual argument: you can't be a liberal without believing in rights, and you can't believe in rights without believing in objective truth. So far, so good, I'd say, but it is crucial to see that an additional inference is also warranted: namely, that *concern* for equal respect and other liberal values among the citizens of a democratic government requires a *concern* for truth. Thus, while it may be, as Mill and others have argued, that liberal values are worth caring about because they help us achieve the truth, it is also the case that *if we care about liberal values, we better care about truth.*

Those who would resist this conclusion have three likely objections they might push. They can argue, first, that liberalism doesn't require fundamental rights at all; second, that even if it does, liberalism doesn't require inalienable fundamental rights; and third, that even if liberalism does require inalienable fundamental rights, such rights don't presuppose an objective notion of truth.

I will not waste much time on the first objection. The idea of liberalism, as a political theory, has long been associated with the idea of fundamental rights. Rights are integral to all sorts of liberal views—from the classical libertarianism of Nozick to the welfare liberalism of Rawls.

More interesting is the second objection. The idea that certain rights, such as the right to religion, free speech, or privacy are "inalienable" or absolute is a matter of grave controversy. But it is one on which we need not take a stand here. For the conclusion that the very idea of a right presupposes an objective notion of truth follows whether human rights are seen as absolute or not.

Before addressing this objection proper, however, let me clear up another objection that may be confused with it. I have above defined rights in a typically Kantian way, in terms of respect due to persons as persons. Some may therefore believe that avoiding this interpretation of rights and adopting a utilitarian conception could avoid the conclusion of my argument. On the utilitarian conception, rights are seen as rules that any just government must respect. The utilitarian can even regard such rules as being inviolable in a certain sense: that is, it can be maintained that as a contingent fact, violating them will always result in a greater net loss of utility in the long run. The justification of such rules therefore rests not on appeals to human dignity but on the rules' being means to achieving the greatest amount of happiness. This need not be a subjective matter. Indeed, on the traditional utilitarian view, whether or not having a right to free speech is a fundamental right (because it increases utility) is entirely independent of whether the majority of those in power believe that establishing that right would increase utility. Whether or not an action or rule increases utility is not a matter of convention, but (hypothetically at least) an objective matter. Thus even a utilitarian view of rights presupposes that just because the majority (or those in the White House, or whoever) thinks that something is or isn't a right doesn't establish that it is.

Returning to the second objection, it is easy to see that our conclusion is consistent with the idea that no rights are absolute. We might hold, for example, that some rights, even fundamental human rights, could be justifiably violated, if there is what is often called a "compelling" state interest. Fine, just so long as the wishes or interests of the majority—or those in power—are not considered compelling reasons. Even if the majority began hating a particular ethnic group and would materially benefit from stealing their property, this would not be a compelling reason for violating their fundamental human rights. More exactly: *that the justification for a right may be defeasible does not entail that whether that justification is overridden or not in a particular situation is up to the majority, or otherwise dependent on whether anyone thinks it is justifiably overridden in that situation.* The point, in other words, is that we can make mistakes about what counts as a compelling reason to infringe on a right. Just because we think a reason is compelling does not mean that it is.

The last objection I mentioned is the most direct: it aims at my claim that the very notion of rights presupposes a notion of objective truth.

This would be Rorty's way of responding: he would agree that a liberal society requires rights. But he would disagree that the notion of a right requires a notion of truth.

There are several elements of Rorty's overall philosophy that feed into this reply. Let me briefly disentangle them. Rorty agrees that we *can* use a concept of truth to point out the mistakes of those who have the power. He just doesn't think this means very much. Reminding ourselves that believing doesn't make it so is simply a way, he thinks, of reminding ourselves that "people in different circumstances—people facing future audiences—may not be able to justify the belief which we have triumphantly justified to all the audiences we have encountered."[11] In short, the idea that truth is objective is only a reminder that what someone may justify to one audience she may not be able to justify to another. And while it may be important to remind ourselves of this cautionary tale for obvious political reasons, we don't really need the idea of truth to tell it.

One might think that this reply is a result of Rorty's deflationism. Deflationism, as you might recall from our earlier discussion, is the view that (a) although the word "true" might serve some useful function in our language, (b) it doesn't pick out a real property that some of our beliefs have and others lack. But it isn't Rorty's deflationism that is in the driving seat here; it is his skepticism about the value of truth. In Rorty's view, talk of truth and falsity inevitably leads to bankrupt, foundationalist ways of thinking. Whatever legitimate work we do with a concept of truth, therefore, would be *better* done with a concept of justification. We will be far better off, Rorty thinks, if we stop worrying about whether our beliefs are true and just worry about whether we can justify them to as many audiences as possible. And of course what determines whether we can justify something to an audience has nothing to do with truth. Justification *is* "relative to an audience."[12] And since beliefs differ widely across communities, what will be justified to one audience may not be justified to others.

It is this last aspect of Rorty's view that makes his position distinctive. Many deflationists would reject Rorty's attempt to get us to give up caring about truth altogether. According to these philosophers, accepting deflationism does not require that one give up on the idea that truth is deeply valuable. As I argued earlier, I don't agree—on this matter, I think Rorty is correct. Deflationism does lead exactly where Rorty thinks it does—to nihilism about the value of

truth. But put that aside. For the real question here isn't whether my arguments concerning rights and truth are consistent with deflationism. As I pointed out, many deflationists would think they are. The real question is whether beliefs in fundamental rights are consistent with nihilism about the value of truth.

Rorty doesn't think so. Thus, it is not surprising that Rorty says that "to speak of human rights is to explain our actions by identifying ourselves with a community of like-minded persons—those who find it natural to act in a certain way."[13] Such talk, he says, is justified by its "social utility"—because in the long run, "inclusivist societies are better than exclusivist ones."[14]

I agree that inclusivist societies are better than exclusivist ones. But I think it is revealing that this is the most that Rorty thinks he can say on behalf of rights. The best he can say is that we and our like-minded friends find it useful to believe that there are such rights—we find it useful to believe that there are some freedoms that can't be taken away from us by any government or majority rule. Yet come tomorrow, our like-minded friends may no longer be so like-minded. They may come to think that it is more useful to believe that we should start restricting what books people read, or the ideas they think. If so, then they will be justified in the Rortian sense in abandoning talk about rights. Rorty would agree that this would be tragic, but that is all. It wouldn't be wrong except in the sense that he wouldn't agree with it. But this, I submit, is just not what we have in mind when we talk of rights. For the liberal, the idea of a right is the idea of something I can't lose no matter what any audience happens to think is justified.

Second, Rorty's view seems unstable in just the way we've seen that other pragmatic attempts to justify our concern for truth are unstable. It amounts to holding that even though it is not true that we have rights independently of any audience, it is best to believe that we do. The problem with this position is the problem that faces all such positions. Believing it is like trying to convince you of Pascal's argument for God. Pascal infamously argued that you were better off believing God existed whether or not He really did. So if you don't believe already, you should try to just brainwash yourself into religious faith. No such argument will ever generate sincere belief. One must engage in bad faith to make it work. Or recall my example of trying sincerely to love someone after you've already decided that love is a meaningless social construction. One might hold such a position but still think that he would be better off loving someone. But having the view that love is empty and point-

less is at odds with being a sincere lover. It is pretense, and cannot be maintained in the long run.

At this point in such conversations, Rorty likes to pull out his ace in the hole: although his view of society may sound rather grim, it is better than the alternative. As he might put it, the traditional liberal conception of rights makes sense only against a background of bad metaphysics. It ends up simply grounding out the bad old Platonic ideas that the Truth is One and Certain. It makes sense only if we believe that rights are God given, and it encourages the belief that only some of us (the priesthood, say, or the philosophers) can read the mind of God and tell us what rights really are. These are bad ideas, and so we had better just grow up and accept that there is no foundation for our beliefs in human rights or anything else. We had better just accept that "the notion of 'inalienable human rights' is no better and no worse a slogan than that of 'obedience to the will of God.' Either slogan, when invoked as an unmoved mover, is simply a way of saying that our spade is turned—that we have exhausted our argumentative resources."[15]

Rorty's point here actually reflects a worry that many folks have about rights. Appeals to fundamental human rights seem to require a metaphysical foundation out in the world to which talk about such rights can correspond. They seem to require human-independent *facts* about rights. But where are these facts, and how could we know about them? These questions seem patently unanswerable. Therefore, the thought goes, to talk of rights can only be the useful pragmatic fiction that Rorty believes it to be.

This common worry rests on a mistake. A belief in fundamental rights does not require that one believe in Natural, God-given Rights or other bizarre metaphysical entities. It requires only an objective notion of truth in the minimal sense of "objective" that I've been employing in this book. In this sense, a belief is true just when the world is as that belief portrays it as being. Just because a belief passes for true among our peers, or is even justified by the available evidence, does not make it true. Believing, as I've said repeatedly, doesn't make it so. Crucially, then, truth's objectivity does not mean that beliefs can be true only if they "correspond to mind-independent physical facts." The minimal objectivity of truth is compatible with beliefs being true in different ways. Truth, I argued in part II, depends or "supervenes" on lower-level properties of beliefs. These lower-level properties realize or accomplish the job of being true. But which properties realize that job may vary depending on the subject at hand. Consequently, when we say, "X is a fundamental human

right," there is no need to think that this must be made true by some mysterious *fact* out in the mind-independent physical world. In general, there is no reason that corresponding with a mind-independent fact is the only way a belief can be true.

But how else might one understand the truth of our claims about rights? To answer this question would be, in effect, to give a full ontology of rights. I cannot do that here. But something like the following suggestion, at the very least, seems to be on the right track. Intuitively, talk of rights is not like talk of things—it is not like talk of cars, or mountains, or cats. We don't think of rights as natural objects. Therefore, it seems reasonable that the existence of rights—and hence the truth of our beliefs in them—depends instead on how our beliefs about them would fit into a comprehensive and developed *political morality*. In other words, it seems more reasonable to think that the truth about rights supervenes not on a belief's *correspondence* with reality but on its *coherence*. In particular, it supervenes on whether some right would belong to a coherent system of beliefs about individual rights and the equitable distribution of resources.

Intuitively, for a political morality of this sort to be coherent, it must meet at least three conditions. First, a coherent political morality must be internally coherent. Inconsistent sets of beliefs, or beliefs that do not have relationships of strong mutual support, would not be true. Second, a coherent political morality must itself be coherent with the empirical and nonempirical truths about human actions and personhood. When we reason about rights we often appeal, in part, to what we believe are the empirical facts relevant to the situation. And sometimes our beliefs about these matters are wildly mistaken, as was the case when slave owners claimed that slaves lacked the intelligence to have rights. Thus no belief about rights can be true that is inconsistent with the rest of what is true about the world. Note that I do not say: coherent with just our other beliefs about the world. For a belief about rights to be justified, or responsibly held, it may indeed be sufficient for it to hang together with the rest of what we believe. But this is not sufficient for it to be true. To count as true, a belief about rights would also have to be coherent with the other truths—with the empirical facts, as we might put it. Crucially, of course, these other true propositions, including as they would propositions about the physical world, human beings and their biology, and so on, would be true in some other way. But again, the present point is not

that *all* beliefs are true when they would be part of a coherent set of beliefs, but only that beliefs about rights might have their truth realized in this way. Finally, whether or not a political morality is coherent in the above senses cannot itself be a matter of coherence. In particular, the proposition that a political morality is coherent is not true if it is, because it is coherent with that political morality. If it is true, it is because that political morality actually *is* coherent—it hangs together internally and with the empirical facts.

A coherent political morality in this sense is obviously an ideal. We hope that some of our beliefs about rights *would* be part of such a system, were there such a thing. And on the present suggestion, this is what makes these beliefs true right now. If they would be part of a coherent political morality, they are true; if not, they are false.

Coherence of this sort is an objective matter. Some beliefs about rights might be coherent without our ever entertaining them. Such beliefs would be true without our knowing about it. Further, mistakes could be made, because one can (sadly) be wrong about whether one's political views are or would be coherent. Indeed, because the coherence of a political morality depends not on what anyone believes but on its ideal coherence, even *global* error is possible. All the people could be wrong all the time. Consequently, the truth about rights would remain minimally objective.

Developing the suggestion further is a topic that lies outside the scope of this book.[16] My main point here is that a belief in rights needn't entail a belief in mysterious, mind-independent Natural Law. We needn't choose, as Rorty thinks we must, between Big Bad Platonic metaphysics on the one hand and Rortian pragmatism about rights on the other.

None of this is to deny that it is very difficult to defend the existence of human rights in a non-question-begging way. As Rorty suggests, it is possible that a belief in human rights is simply rationally basic in the sense that we can't justify it except by appeal to moral intuitions that already presuppose it. This means we must be open to there being other, equally rational ways of thinking about human freedom. But it doesn't mean that we must admit that every way of thinking is as good as any other, or give up the idea of truth. It doesn't mean that we must believe in only One Truth, or that there can be only one true story of the world. All it requires is the minimum objectivity that comes along with any account worth calling an account of "truth": namely, that a belief is true when things are as that belief says they are, and

not because, say, nine out of ten people recommend it. The crucial point is simply that believing doesn't make it so.

Isaiah Berlin ends a justly famous essay on liberty by quoting Joseph Schumpeter's remark that "to realize the relative validity of one's convictions and yet stand for them unflinchingly is what distinguishes a civilized man from a barbarian."[17] Rorty sees this as supporting the idea that liberalism starts from an acknowledgement that matters of truth are irrelevant to politics. I see it differently. What I take from Berlin's point is that we need to understand our views about what matters as being subject to revision. And that is a hallmark of participating in a liberal society. Part of living in such a society involves acknowledging one's own fallibility and the fallibility of one's entire group. This fact, far from undermining the notion of objective truth, presupposes it. For if what is true is just what your community believes—even justifiably believes, in Rorty's sense of that word—then any belief held by the community is automatically true. It can't be wrong, and hence the community is blessed with infallibility. But that is a dangerous idea. No one, and no government, is infallible. We can make mistakes, but this should not stop us from aiming at the truth; it simply reminds us that the very act of aiming at the truth requires admitting the possibility that you may never hit the target.

The Silence of Slavery

A concern for liberal democratic values, I've argued, requires that we are concerned with truth. I'll close with some brief comments on how this actually manifests itself politically.

Broadly speaking, this manifests itself in two ways. First, a liberal democratic concern for truth justifies the preservation of certain basic liberties; second, it justifies the demand that a democratic government be as *transparent* as possible—that is, that it provide adequate, and where possible, complete information about its actions to its citizens.

The link between the value of liberty and the value of truth can go in two directions. One direction runs from the value of truth to the value of a particular liberty. That is, one might attempt to justify the allocation of a particular civil liberty or liberties by arguing that it promotes true belief. This was Mill's strategy with free speech. As I noted earlier, according to Mill, free speech should be encouraged because the more ideas one has to choose from, the better chance there is to find those that are closer to the truth. This idea later

found itself into foundational jurisprudence in the United States as formulated by Oliver Wendell Holmes, Jr., in his influential dissent in *Abrams v. United States:* "the best test of truth is the power of the thought to get itself accepted in the competition of the market."[18] As Bernard Williams and others have pointed out, however, Holmes's and Mill's "marketplace" is best thought of as idealized. In *real* marketplaces, the best products *don't* always win out, as any consumer knows. Quality does not always rise to the top—good advertising, brand name, monopolies, and plain old luck have a lot to do with it. The same goes for ideas: sometimes it is just the person with the loudest voice, not the best opinion, who is heard. Nonetheless, there is something clearly right about Mill's thought. Even if freedom of speech doesn't always lead to the truth, limiting that freedom certainly cuts your chances. Moreover, although not all true ideas may end up being heard, or be given equal time in any given exchange, limiting what sort of ideas can be heard in advance of their entering into that exchange won't necessarily eliminate the false ones, either.

There is more to say about Mill's idea. But let's put it aside. For the relationship between liberty and truth that concerns me runs in the opposite direction: from liberty to truth. Traditional liberalism, as we've seen, asserts that to the greatest extent possible, a democratic government should allow for people to pursue their own vision of the good life. Thus, citizens of a democratic state should be allowed as much freedom as possible (that is, to the extent that this freedom does not harm others). One can't do this without adequate information. That is, one can't make decisions about how best to pursue one's goals in life without a certain amount of knowledge. Therefore, to the degree that one's access to knowledge, the type of knowledge one can access, and the way in which one can transmit knowledge is restricted, one's ability to pursue one's own goals freely is also restricted. A basic concern with liberty requires that we are also concerned with the way in which we access and distribute beliefs, and it encourages as much free access as possible to information.

The most obvious ways in which freedom of information is limited is directly: either via censorship, or when the government prevents citizens or the media from obtaining information about certain subjects. Sometimes these limitations are legitimate, sometimes not. But limits can also be imposed indirectly. The implementation of the ironically titled "Patriot Act" illustrates this fact. The Patriot Act was enacted in the wake of the September 11 terrorist attacks in order to give law enforcement officials "the appropriate tools required to intercept and obstruct terrorism." One of the things the act has

now made legal, for example, is the obtaining of business records from book-stores and libraries. That is, the judges of the Foreign Intelligence Surveil-lance Court (FISA) can now authorize the immediate release of a list of the books and magazines read by any patron of a library or bookstore—*without that patron's knowledge.*[19] Critics of this measure, such as the American Library Association, have decried it as a violation of privacy. But it might also be crit-icized as indirectly leading to a dampening of informational access. If one knows that what you read can lead to a secret governmental investigation of you and your interests, one might be less prone to pursue reading the sorts of books you believe (perhaps rightly, perhaps erroneously) would attract the attention of the FBI.

I now want to turn to the second main way that the value of truth manifests its importance politically. This is the issue of governmental transparency.

Let's start with the basic question: why should a democratic government, other things being equal, tell the truth to its citizens?

One of the best reasons is what Bernard Williams has called the "anti-tyranny argument." As Williams dryly puts it, "because of their peculiar pow-ers and opportunities," governments will be disposed to conceal both incompetent and illegitimate actions. Thus a government might wish to con-ceal that its members were using governmental powers to advance their own political or financial interests. The citizens of the state have good reason to wish to stop the government from engaging in such actions. But without true information from the government, or access to such information, they can-not do so. More generally, governmental transparency and freedom of infor-mation are the first defenses against tyranny. Without them, a government will be more prone to get away with doing what its citizens wouldn't ap-proved of in the light of day.

Curiously, while Williams agrees that this seems like a good point as far as it goes, he doesn't think it goes too far: "The trouble with these truisms about corruption and tyranny, and the reason for doubting whether they add up to an argument, is that just because everyone knows them, there is a question of who could possibly be listening to such an argument and in what circum-stances. Tyrants will not be impressed by the argument and their victims do not need to be impressed."[20]

This claim is unconvincing, to say the least. Even if every *Oxford don* knows these "truisms," not everyone in Tupelo, Mississippi, or even Greenwich, Connecticut, has heard the news. This is not to say that the question of who

might be open to such an argument isn't a good one. But in supplying only two possible choices, tyrants and their victims, Williams artificially limits the options. For although the anti-tyranny argument may not be important for everyone—no argument ever is—it *is* important for anyone worried about the integrity of liberal democracy. In particular, it is important for anyone who is looking for a rational platform on which to criticize a democratic government's lack of truthfulness on a particular issue. As Williams points out, such a rational platform won't be of interest to tyrants. And those already suffering under tyranny need more than rational platforms. But the anti-tyranny argument will be of interest to those whose government is *not yet tyrannical but is plausibly heading in that direction.* In short, the anti-tyranny argument is precisely the sort of argument that is of interest to concerned citizens of a liberal democracy like my own.

The anti-tyranny argument isn't the only useful argument one can make, either, for the importance of governmental transparency and honesty. A simpler reason is that in order to work, liberal democracies need their citizens to make informed decisions. And that means that the nation's citizens, in particular those citizens that are elected to act as political representatives for the rest of us, need to be as truthful as possible about the whys, whats, wheres, and hows of the government. Without such public honesty, the individual citizen cannot, for example, make an accurate decision about which candidate best represents her interests. And to the extent that such decisions cannot be made, the democratic process is illusory and the "power of the people" becomes just a slogan.

Like the anti-tyranny argument, this point could be derided, I suppose, as a truism. And like many of our previous arguments, it is a truism, in a sense: unless the government strives to tell the truth, liberal democracies are no longer liberal or democratic. But not all truisms are merely words to be mouthed in empty ritual. In the political arena, it is all too easy to sacrifice abstract principle on the altar of expediency. These truisms, while acting as rational platforms on which to criticize our government, also act as reminders. They warn us of what we have to lose. In Michel Foucault's apt phrase, unless it would impose the silence of slavery, no government can afford to ignore its obligation to the truth.[21] If this is a truism, then it is a truism that we should shout from the rooftops.

Epilogue

The body of a dead samurai is discovered in a remote grove of cedars and bamboo. In the famous Japanese short story *Rashomon* by Ryunosuke Akutagawa, three stories are told of how it came to be there. All agree in certain details but differ about the most crucial fact: who killed the man. A highway robber claims he killed him in a duel; his wife claims she killed him herself; and the samurai—making a guest appearance of sorts from beyond the grave—claims that he committed suicide. But the interesting thing about this story is not the mystery itself; the interesting thing is that it ends without resolution. No omniscient narrator appears to tell us whose interpretation of the events—whose story—is the right one. The only access we have to what happened is through the conflicting perspectives. Consequently, the reader is left wondering not only about whodunit but whether there is any answer at all.

Philosophical questions are often like this. They do not admit of clear and simple answers. They have, as a result, an air of folly about them.

But so what? One of the themes of this book is that if it is folly to pursue truth, then it is a folly worthy of praise. And a consequence of my defense of the pursuit of truth is a defense of the value of philosophical inquiry. This is because many of the reasons that people become cynical about the value of philosophy are the same reasons they become cynical about the value of pursuing truth full stop. Philosophy aims at the truth about certain very general questions. Yet its methods, insofar as there are any, are constantly open to question. And the truth at which it aims—considering the sorts of questions at issue—is not apt to be easily understood, or particularly precise, or testable in the lab. Further, there may not be one and only one true answer to certain philosophical questions, even if there are definitely wrong ones. So if you believe that the only truth worth pursuing is that which is crystal clear, empirically verifiable, free from subjective bias, or practically useful, you are likely

to be very dissatisfied with philosophy. Philosophical answers to philosophical questions are generally none of these things. They are messy, contentious, and stubbornly resistant to scientific proof.

So are a lot of questions that matter in life. How should I live? What matters to me? These are some of the most important questions any human being can ask of herself. They are not clear; they don't always admit of simple solutions; our answers change and conflict. But that doesn't mean we should stop asking them. I have argued in this book that pursuing the truth still matters even when it is difficult to achieve, and even when the truth achieved is partly subjective and contextual. And I've tried to show that the reason we should care about truth isn't only because having true beliefs is a useful means to other ends. Truth is also worthy of caring about for its own sake. So in defending the idea that truth matters, as I have, I have also been standing up for the idea that philosophical reflection matters.

Philosophy helps us to explore the grounds of our form of life. By this, I mean, roughly, it can help us to discover those concepts and beliefs that—at least currently—act as the foundations of our worldview and our social practices. This can be as simple a matter as reminding ourselves of the importance of certain distinctions. The distinction between what is justified and what is true is an example. Making this distinction makes no immediate difference to what we do, but it does allow us to understand that there is a difference between what the majority or the King or the Pentagon believes and what is true. And understanding that difference is a prerequisite for social criticism, or as I've put it before, speaking truth to power. By reminding ourselves of the importance of this distinction, we remind ourselves of the rational foundations that make social criticism possible.

We can also misunderstand those foundations. Another theme of this book is that modern philosophical thinking about truth has, by and large, missed the point. Although a considerable amount of philosophical work on truth has been done during the last one hundred years, most of it has concentrated on the metaphysical and formal aspects of the concept. Such aspects are indeed extremely important. But by concentrating on them exclusively, philosophers have lost touch with the fact that truth is also a deeply normative property.

Many philosophers think asking "What is truth?" is like asking "What is gold?" Traditional philosophers see their mission as discovering the secret nature of truth—truth's atomic number, as it were. More deflationary-minded thinkers, noting the lack of successful attempts to find this nature, have

concluded that this is a mistake. For them, however, this means not that we should rethink what truth is, but that we should see that truth is not a theoretically important property. If the reasoning in this book has been on the right track, both of these approaches have missed a fundamental point. Wondering about truth is less like wondering about gold and more like asking about the nature of justice. It is a question that intertwines the descriptive and the normative, the metaphysical and the ethical. Asking why we care about it helps us to understand what it is.

In *The Republic,* Plato has Socrates confront Glaucon's view that we have reason to be just only insofar as it serves our interests. Justice, for Glaucon, is a bit like money: it is worth pursuing only when it gets you where you want to go. Glaucon's position on justice mirrors many people's view on truth. And in rejecting this view, we learn (I hope) something about what truth is, just as Plato rightly thought that in rejecting Glaucon's position, we learn something about justice. And one of the things we learn, obviously, is that truth is less like money than it is like love: it is objective in its existence, subjective in its appreciation, and able to exist in more than one form. But it can also be dangerous, difficult to find, and frustrating to live with.

The question, "What is truth?" is not going to go away. Mysteries are like that. And that is good. Hard questions remind us not to take ourselves too seriously. We are historical creatures; we are products of a culture, and our conclusions, after all, are only our conclusions. We are apt to be fools, to get things wrong even by our own lights. The key is to appreciate this fact— which I have argued is part and parcel with appreciating the possibility of objective truth—without slipping into cynicism. If we are bound to be fools, let us be fools with hope.

Notes

Introduction

1. In his State of the Union Address in January, 2003. Among other things, it was claimed that Iraq was attempting to purchase uranium from Niger.

2. See, for example, "A Shifting Spotlight on Uranium Sales" by David E. Sanger, *New York Times,* July 15, 2003. As early as April 25, 2003, ABC News was reporting that officials inside the government and advisors outside had told ABC's John Cochran that the administration emphasized the danger of Saddam's weapons to gain the legal justification for war from the United Nations and to stress the danger at home to the United States. "We were not lying," said one official. "But it was just a matter of emphasis."

3. In "Truth But No Consequences: Why Philosophy Doesn't Matter," *Critical Inquiry* 29: 389–417 (2003).

4. William Bennett, *Why We Fight: Moral Clarity and the War on Terrorism* (New York: Regnery Publishing, 2003), p. 56.

Chapter 1

1. See Thomas Kuhn, *The Structure of Scientific Revolutions,* third ed. (Chicago: University of Chicago Press, 1996), pp. 53–54; and James Conant, *The Overthrow of the Phlogiston Theory: The Chemical Revolution of 1775–1789* (Cambridge, Mass.: Harvard Case Histories in Experimental Science, 1950).

2. Voltaire's *Philosophical Dictionary,* ed. and tr. H. I. Woolf (New York: Alfred Knopf, 1929), p. 305.

3. Aristotle: *Metaphysics,* tr. W. D. Ross (Oxford: Oxford University Press, 1979), IV, 5, 1001b. See also W. P. Alston, *A Realist Conception of Truth* (Ithaca: Cornell University Press, 1996).

4. William James, *Pragmatism and the Meaning of Truth* (Cambridge, Mass.: Harvard University Press, 1975), p. 42.

5. The philosopher of science Tim Lewens pointed out to me that in the Russell world I won't be able to satisfy all my desires that are *past directed,* like my desire to go to the store we went to last week. To this I reply as follows: Consider my beliefs when I have no past-directed desires. At those moments the worlds are absolutely identical with regard to instrumental value, and I surely prefer to not live in the Russell world. Furthermore, even when considering times I do have past-directed desires, it is surely possible to *momentarily bracket* or isolate whatever few past-directed desires I have at some time and simply consider the two scenarios with regard to all my other desires. When I do so, I still clearly choose the actual world over the Russell world.

6. Good but only defeasible evidence, of course. It is possible to care for something without believing it is worth caring about.

7. The distinction between thick and thin values stems from Bernard Williams; see, e.g., his *Ethics and the Limits of Philosophy* (Cambridge, Mass.: Harvard University Press, 1985), p. 128. Williams, however, applies the distinction to concepts, as opposed to properties, as I do in the text. Adam Kovach claims that truth is a thick value *concept* in his "Truth as a Value Concept," in *Circularity, Definition, and Truth,* ed. A. Chapuis and A. Gupta (New Delhi: Indian Council of Philosophical Research, 2000) pp. 199–215. I entertain that idea myself in my "Truisms about Truth," in *Perspectives on the Philosophy of William P. Alston,* ed. H. Battaly and M. Lynch (Lanham, MD: Rowman and Littlefield, 2004).

Chapter 2

1. Chuang Tzu, from Chan, Wing-tsit, ed. and trans., *A Source Book in Chinese Philosophy* (Princeton, N.J.: Princeton University Press, 1963), p. 190.

2. Descartes's demon: see the First Meditation in *Meditations on First Philosophy,* trans. J. Cottingham (Cambridge: Cambridge University Press, 1986).

3. "Universality and Truth," in *Rorty and His Critics,* ed. R. Brandom (Cambridge: Blackwell, 2001), p. 2.

4. "Truth Rehabilitated," in *Rorty and His Critics,* p. 67.

5. Waldseemüller's map: the Library of Congress in Washington, D.C. owns a copy of the *Cosmographie Introductio.* For background on Waldseemüller and Vespucci, see *Letters from a New World: Amerigo Vespucci's Discovery of America,* ed. L. Formisano, trans. by D. Jacobson (New York: Marsilio, 1992).

6. Kant, *Critique of Pure Reason,* trans. N. K. Smith (London: Macmillan, 1929).

7. *Measure for Measure,* act 2, scene 2, lines 115–124.

8. Who believed in the looking glass view of the mind? George Berkeley seemed to think that John Locke did: see Berkeley, *Principles of Human Knowledge/Three Dialogues Between Hylas and Philonous,* ed. R. Woolhouse (New York: Penguin, 1988). But al-

though Locke sometimes seems to champion a mirroring or "copy" view of truth, he is best understood, in my view, as endorsing an early form of causal realism. See chapter 6 below.

9. The literature on certainty is immense, beginning with Descartes (see above). For an important and intriguing more recent discussion, see Peter Klein's *Certainty: A Refutation of Skepticism* (Minneapolis, Minn.: University of Minnesota Press, 1981).

Chapter 3

1. Stanley Fish, "Condemnation without Absolutes," *New York Times,* October 15, 2001. For conservative texts decrying relativism, see Robert Bork's *Slouching towards Gomorrah: Modern Liberalism and American Decline* (New York: Regan Books, 1996); and Allan Bloom, *The Closing of the American Mind* (New York: Simon and Schuster, 1987). The reference to papal encyclicals is to Pope John Paul II's *Fides et Ratio,* 1998, which can be found, among other places, on the Web site of the Catholic Information Network: http://www.cin.org/jp2/fides.html.

2. Jean-Francois Lyotard, *The Postmodern Condition: A Report on Knowledge,* trans. G. Bennington and B. Massumi (Minneapolis, Minn.: University of Minnesota Press, 1984), xxiv.

3. Stanley Fish, "Postmodern Warfare," *Harper's Magazine* 35, no. 1826 (July 2002): 33.

4. Relevant texts include *The Order of Things* (New York: Vintage, 1970); *The Birth of the Clinic,* trans. A. M. Sheridan Smith (New York: Pantheon Books, 1973); "Truth and Power" from *The Nature of Truth,* ed. M. P. Lynch (Cambridge, Mass.: The MIT Press, 2001), pp. 317–320, reprinted from *Power/Knowledge* (New York, Harvester Press, 1980), pp. 131–133; and *Foucault Live,* trans. J. Johnston and S. Lotringer (New York: Semiotext(e), 1989).

5. Morton's views are described in Louis Menand's *The Metaphysical Club* (New York: Ferrar, Straus, and Giroux, 2001), pp. 101ff. The original source is Morton's *Crania Americana; or A Comparative View of the Skulls of Various Aboriginal Nations of North and South America* (Philadelphia, Penn.: J. Dobson, 1839).

6. Attributed to Aggasiz in a letter from George Gliddon to Samuel Morton, January 9, 1848, *Samuel Morton Papers,* Historical Society of Pennsylvania; quoted in Louis Menand's *The Metaphysical Club,* 109.

7. Foucault, "Truth and Power," p. 320.

8. *Foucault Live,* p. 304.

9. For two interesting discussions of maps and representation that influenced the present account, see Philip Kitcher's *Science, Truth, and Democracy* (Oxford: Oxford University Press, 2001) and Chris Gauker's *Words without Meaning* (Cambridge, Mass.: The MIT Press, 2002).

10. Classic presentations of how conceptual choices affect the way we sort the world are W. V. O. Quine's *Ontological Relativity and Other Essays* (New York: Columbia University Press, 1969) and Hilary Putnam's *Reason, Truth, and History* (Cambridge: Cambridge University Press, 1981). Another influential presentation can be found in Ernest Sosa's "Putnam's Pragmatic Realism," *Journal of Philosophy* 90 (1993): 605–626. The ideas discussed here are drawn, with modifications, from my earlier book, *Truth in Context* (Cambridge, Mass.: The MIT Press, 1998).

11. Law is moderately objective in Leiter's terms when "*x* is a legal fact if and only if under ideal conditions lawyers and judges take it to be a legal fact," "Law and Objectivity" in *The Oxford Handbook of Jurisprudence and Philosophy of Law*, ed. J. Coleman and S. Shapiro (Oxford: Oxford University Press, 2002), p. 981. I make a somewhat related claim in "A Functionalist Theory of Truth," in *The Nature of Truth*. An overview of the literature on the subject is Dennis Patterson's *Law and Truth* (Oxford: Oxford University Press, 1996).

Chapter 4

1. As reported by Oppenheimer. See J. W. Kunetka *Oppenheimer: The Years of Risk* (Englewood Cliffs, N.J.: Prentice Hall, 1982), p. 71; see also P. Goodchild, *J. Robert Oppenheimer: Shatterer of Worlds* (Boston, Mass.: Houghton Mifflin, 1981), p. 162.

2. An excellent resource for information pertaining to the Nazi's pseudoscientific experiments is the United States Holocaust Memorial Museum; for a useful overview of the information the Museum contains, see "Nazi Medical Experiments," http://www.ushmm .org/wlc/en/. See also Nava Cohen, "Medical Experiments" in *The Encyclopedia of the Holocaust* (New York: Macmillan, 1990), pp. 957–966.

3. See James Jones, *Bad Blood: The Tuskegee Syphilis Experiment* (New York: Free Press, 1993), especially chapter 11.

4. The distinction between *prima facie* and absolute goodness allows us to circumvent, as I make clear below, a common misunderstanding about the value of truth that often appears on the philosophical literature. See Pascal Engel, "Is Truth a Norm?" in *Interpreting Davidson*, ed. P. Kotatko, P. Pagin, and G. Segal (Stanford, Calif.: CSLI Publications, 2001), pp. 37–50. Richard Kirkham also misses this point; see his discussion of Michael Dummett's analogy between aiming at truth and aiming at winning a game in his *Theories of Truth* (Cambridge, Mass.: The MIT Press, 1992), p. 102. He says, for example, that "[Dummett's analogy] is faulty: winning is not what one aims at when say, one's opponent is a small child suffering from undernourished self-esteem." Presumably, the point is that truth isn't something we always aim at in believing either. No doubt; but this no more an argument for thinking that truth is not a goal of belief than the fact that sometimes it is best not to keep a promise is an argument against the goodness of keeping promises. For an account similar to the present one, see Adam Kovach's excellent "Truth as a Value Concept" in *Circularity, Definition, and Truth*, ed. Chapuis

and Gupta, pp. 199–215. Kovach also sees the importance of the *"prima facie"* clause, but he attaches it to our obligations to pursue truth and avoid falsity, not the good of truth itself.

5. For an important discussion of conceptual difficulties involved in taking truth as a goal, see E. Sosa, "For the Love of Truth?" in *Virtue Epistemology: Essays on Epistemic Virtue and Responsibility,* ed. A. Fairweather and L. Zagzebski (New York: Oxford University Press, 2001). The phone book example is Sosa's.

6. Shelley E. Taylor and J. Brown, "Illusion and Well-being: A Social Psychological Perspective on Mental Health," *Psychological Bulletin* 103 (1988): 193–210. See also Taylor's *Positive Illusions: Creative Self-deception and the Healthy Mind* (New York: Basic Books, 1989). For some interesting and related comments on this work, see Owen Flanagan's *Varieties of Moral Personality* (Cambridge, Mass.: Harvard University Press, 1991), pp. 318–323.

7. Martin Seligman, *Learned Optimism* (New York: A. A. Knopf, 1991), pp. 110–111. Seligman also discusses the relation between depression and truth; he is careful, however, not to assert that there is a necessary relationship between being nondepressed and having a less accurate picture of the world. See p. 111.

8. See Kitcher's *Science, Truth, and Democracy* (Oxford: Oxford University Press, 2001), chapter 6. The view defended here is more similar to that defended in Susan Haack in her *Evidence and Inquiry* (Oxford: Oxford University Press, 1993), p. 199.

9. "Pragmatism: A New Name for Some Old Ways of Thinking," in *Pragmatism and the Meaning of Truth* (Cambridge, Mass.: Harvard University Press, 1975), p. 115.

10. See Kuhn's *The Structure of Scientific Revolutions,* third ed.

11. For more on understanding, see Linda Zagzebski, "Recovering Understanding" in *Knowledge, Truth, and Duty,* ed. M. Steup (Oxford: Oxford University Press, 2001), pp. 235–253. See also Catherine Elgin's *Considered Judgment* (Princeton, N.J.: Princeton University Press).

12. The example is David Papineau's, from his "Normativity and Judgement" *Proceedings of the Aristotelian Society,* supp. vol. 72 (1999): 17–44.

13. The fact that there is a reason to x does not mean we have to know there is a reason to x.

Chapter 5

1. James's story is from "Pragmatism: A New Name for Some Old Ways of Thinking," p. 27.

2. A good source for information about Peirce's private life, as well as his ideas, is Louis Menand's *The Metaphysical Club.*

3. "How to Make Our Ideas Clear" in *Pragmatism: A Contemporary Reader,* ed. R. Goodman (New York: Routledge, 1995), p. 44.

4. Ibid., p. 34.

5. Ibid., p. 106.

6. Ibid., p. 97.

7. Ibid., p. 103.

8. The admirable pluralism of James's account of truth is not always noticed, although it seems clear from the text. Two notable exceptions are A. J. Ayer's account of James's theory in his *Origins of Pragmatism* (San Francisco, Calif.: Freeman, Cooper, 1968), pp. 192ff; and Hilary Putnam's "James's Theory of Truth," in *The Cambridge Companion to William James,* ed. R. A. Putnam (Cambridge: Cambridge University Press, 1997).

9. James, "How to Make Our Ideas Clear," p. 42.

10. See John Stuart Mill, *Utilitarianism,* ed. R. Crisp (Oxford: Oxford University Press, 1987), chapter 2.

11. James, "How to Make Our Ideas Clear," p. 110.

12. Ibid., p. 98.

13. "The Meaning of Truth," in *Pragmatism and the Meaning of Truth,* p. 284; see also "Two English Critics," in *Pragmatism and the Meaning of Truth,* pp. 312ff.

14. "James's Theory of Truth," in *The Cambridge Companion to William James,* p. 182.

15. Coherence theories have a long and distinguished history. Their original source is the nineteenth-century philosopher G. W. F. Hegel, but they came into their own with the work of the British philosopher F. H. Bradley, in *Essays on Truth and Reality* (Oxford: Clarendon Press, 1914), and the American philosopher Brand Blanshard, *The Nature of Thought,* vol. 2 (New York: HarperCollins, 1939), pp. 260–279. A more contemporary version can be found in Linda Alcoff's *Real Knowing: New Versions of the Coherence Theory* (Ithaca, NY: Cornell University Press, 1996). For a clear presentation and criticism of the view, see Ralph Walker's "The Coherence Theory of Truth," in *The Nature of Truth,* ed. M. P. Lynch (Cambridge, Mass.: The MIT Press, 2001).

16. As I understand it, Ralph Walker makes a similar criticism in "The Coherence Theory of Truth," pp. 147–149.

17. "Is Truth a Goal of Inquiry? Donald Davidson vs. Crispin Wright" in *The Nature of Truth,* ed. Lynch, p. 260.

18. "Reply to Pascal Engel," *The Philosophy of Donald Davidson,* ed. L. Hahn (La Salle, Ill.: Open Court, 1991), p. 461.

19. Allan Gibbard first suggested to me the analogy between investment and justification in conversation.

20. This idea appears many times in Rorty's writings if in various guises; see, e.g., *Truth and Progress* (Cambridge: Cambridge University Press, 1998), p. 2; and "Is Truth A Goal of Inquiry," pp. 263–264.

21. On cautionary use of the word "true": see "Pragmatism, Davidson, and Truth," in Rorty's *Objectivity, Relativism, and Truth* (Cambridge: Cambridge University Press, 1991); see also "Is Truth a Goal of Inquiry," pp. 260–261.

22. "Is Truth a Goal of Inquiry," p. 276.

23. "Truthfulness," *Common Knowledge* 7, no. 2 (1998): 20. See also his provocative *Truth in Philosophy* (Cambridge, Mass.: Harvard University Press, 1993).

Chapter 6

1. Good sources on naturalism, at least with regard to the mind, are Jaegwon Kim, *Philosophy of Mind* (Boulder, Colo.: Westview Press, 1996); and Tom Polger, *Natural Minds* (Cambridge, Mass.: The MIT Press, 2004), chapter 1.

2. Wilson, *Consilience: The Unity of Knowledge* (New York: Vintage Press, 1998). Wilson himself calls reductionism "the primary and essential activity of science," ibid. p. 59.

3. Logical positivism was a diverse movement. For some examples of different sorts of positivist views, see R. Carnap, *The Logical Syntax of Language* (New York : Humanities, 1937); K. R. Popper, *The Logic of Scientific Discovery* (New York: Basic Books, 1959); and *Logical positivism,* ed. A. J. Ayer (Glencoe, Ill.: Free Press, 1959). As I indicate below, while most positivists held a verificationist theory of meaning, not all positivists held a verificationist theory of truth. Many, like A. J. Ayer in *Language, Truth, and Logic* (New York: Dover, 1952), endorsed a version of the deflationary theory of truth. I briefly discuss deflationary views in the next chapter.

4. "How to Make Our Ideas Clear," p. 45.

5. Ibid., p. 47.

6. The view was often combined with a type of coherence view of epistemology. See C. Hempel, "On the Logical Positivist's Theory of Truth," *Analysis* 2 (1935): 49–59. For a more contemporary version of verificationism about truth, see M. Dummett, *Truth and Other Enigmas* (Cambridge, Mass.: Harvard University Press, 1978).

7. See A. J. Ayer, *Language, Truth, and Logic,* Chapter 6.

8. Similar objections against verificationism can be found in my *Truth in Context* (Cambridge, Mass.: The MIT Press, 1998), and in Alston, *A Realist Conception of Truth*.

9. See Wittgenstein's *Tractatus Logico-Philosophicus,* with Russell's introduction, trans. D. F. Pears and B. F. McGuinness (New York: Humanities Press, 1961); see also chapter 12 of Russell's *The Problems of Philosophy* (Oxford: Oxford University Press, 1912), reprinted as "Truth and Falsehood" in *The Nature of Truth,* pp. 17–24.

10. See Michael Devitt, *Realism and Truth,* second ed. (Princeton, N.J.: Princeton University Press, 1997) for a similar explanation of causal realism. The first expression of the view, at least as it might be applied to the truth of sentences, is in Hartry Field's classic paper, "Tarski's Theory of Truth," reprinted in *The Nature of Truth,* ed. Lynch, pp. 365–397.

11. The roots of the causal theory of representation (or reference) can be found in Hilary Putnam's "The Meaning of 'Meaning'" in *Mind, Language, and Reality: Philosophical Papers,* vol. 2 (Cambridge: Cambridge University Press, 1975), and in lectures by Saul Kripke from the early 1970s, later published as *Naming and Necessity* (Cambridge, Mass.: Harvard University Press, 1980). Neither Putnam nor Kripke saw himself as giving a theory of the nature of reference or representation in terms of causality, but later philosophers have built on their insights and attempted to do so. See, e.g., Michael Devitt, *Designation* (New York: Columbia University Press, 1981) and *Realism and Truth,* Second ed. (Princeton, N.J.: Princeton University Press, 1997). See also Fred Dretske, *Knowledge and the Flow of Information* (Cambridge, Mass.: The MIT Press, 1981), Ruth Millikan, *Language, Thought, and Other Biological Categories* (Cambridge, Mass.: The MIT Press, 1984), and Jerry Fodor, *Psychosemantics* (Cambridge, Mass.: The MIT Press, 1987). Millikan's view is discussed briefly in note 18 below. All versions of the position are more complex in their details than I have room to discuss. It is important to keep in mind that in the present context, I am not concerned with the views *per se* but only with how they might be used to enhance the correspondence theory of truth.

12. For a useful overview of some the problems with naturalist theories of representation and reference, see B. Loewer, "A Guide to Naturalizing Semantics," in *A Companion to the Philosophy of Language,* ed. B. Hale and C. Wright (Oxford: Blackwell, 1997), pp. 108–127.

13. For some interesting and related remarks, see E. J. Lowe's *Introduction to the Philosophy of Mind* (Cambridge: Cambridge University Press, 2000).

14. This sort of position is defended to a greater or lesser degree by D. Stampe, "Towards a Theory of Linguistic Representation," *Midwest Studies in Philosophy* 2 (1977): 42–63, and R. Stalnaker, *Inquiry* (Cambridge, Mass.: The MIT Press, 1984). See also Fodor, "Psychosemantics, or Where Do Truth Conditions Come From?" in *Mind and Cognition,* ed. W. Lycan (Oxford: Blackwell, 1990), pp. 312–338.

15. There are other ways to respond to these objections, and I am only sketching the basic problems with the view here. On Fodor's asymmetric dependency view, e.g., see his *A Theory of Content and Other Essays* (Cambridge, Mass.: The MIT Press, 1990). See also Ruth Millikan's view in *Language, Thought, and Other Biological Categories.*

16. For an overview of the problems regarding mathematical truth, see Paul Benacerraf, "Mathematical Truth," *Journal of Philosophy* 70 (1973): 661–79. For a breathtakingly brilliant defense of the view that, strictly speaking, there are no truths about numbers, see Hartry Field, *Science without Numbers* (Princeton, N.J.: Princeton University Press, 1980).

17. *Principia Ethica* (New York: Cambridge University Press, 1903).

18. Some may protest that so-called teleological accounts of representation *can* account for the normativity of concepts like truth. On this sort of account, representation is understood as an evolutionary functional process like digestion or blood circulation. The simplest version of such a position is the view that beliefs represent certain objects in the world because it is their biological function to do so. On the face of it, however, this sort of account is wildly implausible. No one could seriously think that every single belief I have is individually the product of natural selection. Actual teleological accounts, therefore, brim over with complications meant to address this point. For example, the philosopher Ruth Millikan, who is perhaps the most well-known defender of the teleological account of representation, has argued that what is naturally selected are not individual beliefs but underlying cognitive mechanisms (see Millikan, *Language, Thought and Other Biological Categories* and also Papineau, *Reality and Representation* [Oxford: Basil Blackwell, 1987] for an importantly different account). These mechanisms are selected for, roughly speaking, because they produce mental states (like beliefs) that bear a certain mapping or correspondence relation to objects out in the world. Thus, certain types of beliefs map the objects they do because they are produced by cognitive mechanisms that have the biological function of producing beliefs of that type. The way in which this view could be seen to help explain the normative aspect of truth is as follows. Where there are functions there are malfunctions. Some hearts beat irregularly, and some beliefs misrepresent. And yet surely biological functions are natural phenomena if anything is. So if true beliefs are beliefs that, roughly speaking, are functioning as they should, then perhaps we can explain the normativity of truth.

In reply, I say first that insofar as any naturalist account succeeds in showing that truth is *both* physical and normative—I have no objection to it. But I remain doubtful whether any such account will succeed. Take the present teleological account. For one thing, it is not clear that the type of normativity involved in biological functions is the same sort of normativity had by a property like truth. The fact (if it is a fact) that human males may have some traits that were biologically designed for sexual promiscuity does not entail that I ought to be sexually promiscuous. Biological functions don't imply obligations or reasons. A second relevant point is that teleological accounts of truth still confront an issue of scope. Many of our beliefs are about matters that it is implausible to think that evolution programmed us to react to in any specific way. So even if the teleological account of representation can explain how beliefs about physical objects are true, it doesn't seem capable of explaining how our beliefs about morality, philosophy, history, art, or literature are true and false.

19. Stich's arguments can be found in his *The Fragmentation of Reason* (Cambridge, Mass.: The MIT Press, 1991), chapter 5.

20. See W. Alston's *A Realist Conception of Truth,* pp. 258–261 and A. Goldman's *Knowledge in a Social World* (Oxford: Oxford University Press, 1999), pp. 72–73.

21. Stich, *The Fragmentation of Reason,* p. 124.

22. This position is often described as "motivational internalism."

23. See Paul Bloomfield's *Moral Reality* (Oxford: Oxford University Press, 2001), p. 154; and Michael Stocker's "Desiring the Bad: An Essay on Moral Psychology," *Journal of Philosophy* 76 (1979): 738–753. Although I am inclined to be a motivational externalist about moral values as well, I don't see any reason to make a *carte blanche* judgment in favor of externalism. The relationship between value and motivation may change depending on the sort of value (and the sort of motivation) one has in mind.

24. Bloomfield, *Moral Reality,* p. 155.

25. The idea that objective values would have to have "to-be-pursuedness" built into them is one made famous by J. L. Mackie, *Inventing Right and Wrong* (London: Penguin Books, 1977).

26. "A Reply to My Critics" in *The Philosophy of G. E. Moore,* ed. P. A. Schilpp (Chicago, Ill.: Open Court, 1942), p. 588.

27. The notion of multiple realizability was first introduced into the philosophical literature by Hilary Putnam, in "The Nature of Mental States," in *The Nature of the Mind,* ed. D. Rosenthal (Oxford: Oxford University Press, 1991), pp. 197–203.

28. The suggestion, more technically put, is that truth is a second-order multiple realizable property: the property of having a property that plays the truth-role (or does the truth job). A more detailed presentation of this position can be found in my "Truth and Multiple Realizability," *Australasian Journal of Philosophy* 82 (2004), and "A Functionalist Theory of Truth" in *The Nature of Truth.* See also C. Wright's *Truth and Objectivity* (Cambridge, Mass.: Harvard University Press, 1992).

Chapter 7

1. Friedrich Nietzsche, *Beyond Good and Evil,* trans. W. Kaufmann (New York: Vintage, 1966), section 1.

2. Ibid.

3. Ibid., section 4.

4. *The Will to Power,* ed. and trans. W. Kaufmann and R. J. Hollingsdale (New York: Vintage Books, 1968), section 423; he makes a similar comment in *Beyond Good and Evil,* section 6.

5. Ibid., section 534.

6. Ibid., section 583 C.

7. Ibid., section 552.

8. For general commentary on Nietzsche's views on truth, see M. Clark, *Nietzsche on Truth and Philosophy* (Cambridge: Cambridge University Press, 1990) and S. Hales and R. Welshon, *Nietzsche's Perspectivism* (Urbana, Ill.: University of Illinois Press, 2000); for a pragmatist interpretation of Nietzsche, see A. Danto, *Nietzsche as a Philosopher* (New York: Macmillan, 1965).

9. Alessandra Tanesini's interpretation can be found in her "Nietzsche's Theory of Truth," *Australasian Journal of Philosophy* 73, no. 4 (1995): 548–559. See also the interpretation of Barry Allen in his *Truth in Philosophy* (Cambridge, Mass.: Harvard University Press, 1993), pp. 41ff.

10. *The Will to Power*, section 480.

11. Ibid., section 507.

12. Bernard Williams, *Truth and Truthfulness* (Princeton, N.J.: Princeton University Press, 2002), pp. 12ff; for another defense of the idea that Nietzsche thought true beliefs had some value, see Kaufman's *Nietzsche: Philosopher, Psychologist, Antichrist* (New York: Vintage Press, 1968), pp. 356–360.

13. "Is Truth a Goal of Inquiry," p. 260.

14. *Consequences of Pragmatism* (Minneapolis, Minn.: University of Minnesota Press, 1982), p. xiii.

15. The redundancy view is generally thought to stem from from F. P. Ramsey, "Facts and Propositions," *Proceedings of the Aristotelean Society,* supp. vol. 7 (1927): 153–170. For an early variant, see P. F. Strawson, "Truth," *Proceedings of the Aristotelian Society,* suppl. vol. 24 (1950): 129–156.

16. I am not claiming that Rorty would himself advocate the redundancy version of deflationism over some other, less radical version of the view. Rorty, I think, would hold that any version of deflationism entails that truth is not a value. With this, I agree.

17. See, e.g., so-called disquotational theories, which take sentences, rather than propositions, as truth-bearers. Like classic redundancy theorists, disquotationalists see ascriptions of "true" to particular sentences as superfluous. But unlike the redundancy theory, the disquotationalist, as in Horwich's view that I discuss below, sees "true" as also necessary as a device for generalization. Significantly, however, most deflationists see this as an entirely pragmatic point, and hold that what we can say about the world with the predicate "true" we can say, at least theoretically, without it. Although he is not explicit on this point, I take Rorty himself to be a disquotationalist. For statements of the disquotationalist view, see W. V. O. Quine's "Truth," 77–88 of his *The Pursuit of Truth* (Cambridge, Mass.: Harvard University Press, 1990); and M. Williams, "Do We Epistemologists Need a Theory of Truth?" *Philosophical Topics* 14 (1986): 223–242. Disquotationalists *qua* disquotationalists can be neutral on the topic of whether truth is a property.

18. This point stems from William Alston's more general views on ontological commitment; see his classic essay, "Ontological Commitments," *Philosophical Studies* 9 (1958): 8–17.

19. See, e.g., H. Field, *Truth and the Absence of Fact* (New York: Oxford University Press, 2001) and "A Prosentential Theory of Truth," *Philosophical Studies* 27 (1975): 73–125; R. Brandom, "Pragmatism, Phenomenalism, and Truth Talk," *Midwest Studies in Philosophy* 12, (1988): 75–94; J. C. Beall, *Truth and Falsity* (New York: Oxford University Press, 2004); and J. Woodbridge, *Truth as a Pretense* (forthcoming). A collection of classic statements of deflationism (including many of those just cited) can be found in *The Nature of Truth*, ed. M. P. Lynch.

20. See P. Horwich, *Truth* (Oxford: Basil Blackwell, 1990) and *Truth,* second ed. (Oxford: Oxford University Press, 1998).

21. Horwich, *Truth,* second ed., p. 143.

22. On Horwich's view, either properties are reducible substantive properties, or they are not. It is worth noting that on the view of truth I sketched in the previous chapter, the property of truth *can* have a significant, explanatory role in our theorizing without being reducible to some one underlying property. In my view, it is plausible to think of truth as supervening on a variety of underlying properties—and therefore having, in one sense, a variety of "natures." Intuitively, it is therefore still a very "substantive" property.

23. Horwich, *Truth,* second ed., p. 7.

24. The idea that deflationary theories of truth can't account for the idea that truth is normative was first raised by Michael Dummett in "Truth," *Proceedings of the Aristotelian Society* 59 (1959): 141–162; reprinted in *The Nature of Truth,* ed. Lynch, pp. 229–250. C. Wright argues differently for the same conclusion in *Truth and Objectivity,* pp. 12–32.

25. Horwich, *Truth,* second ed.; *Meaning* (Oxford: Oxford University Press, 1998), pp. 190–191; and "Norms of Truth and Meaning," in *What Is Truth?* ed. R. Schantz (Berlin: De Gruyter, 2001).

26. *Truth,* second ed., pp. 44–45; "Norms of Truth and Meaning," pp. 44–45.

27. *Truth and Truthfulness* (Princeton, N.J.: Princeton University Press, 1992), p. 65.

28. Horwich, *Meaning,* p. 104; and "A Defense of Minimalism," in *The Nature of Truth,* ed. Lynch, p. 560.

29. For detailed discussions of particularlism, see B. W. Hooker and M. Little, eds., *Moral Particularism* (Oxford: Oxford University Press, 2000).

30. R. M. Hare, *The Language of Morals* (Oxford: Clarendon Press, 1952), p. 60.

31. This would amount to the odd view that although (TN) is not true, it is still the case that for many particular beliefs, that belief is good to have if and only if it has the substantive property of being true.

32. "Norms of Truth and Meaning," p. 143; although it is not entirely clear in the text, it is likely that Horwich is here advocating a merely causal explanation for why we accept instances of (BI), rather than trying to *justify* our acceptance of them. As I noted above, his most likely response to my argument is that instances of (BI) are explanatorily fundamental.

33. Chase Wrenn's discussion of the value of truth can be found in his *Truth and the Normativity of Epistemology* (Ph.D. dissertation, Washington University, 2001).

34. This argument, I hasten to add, is not what was behind Pascal's own belief in God. As Bill Alston reminded me, Pascal himself thought this sort of reasoning was to be used as something of a last resort.

Chapter 8

1. My discussion of the concept of caring draws heavily on the writings of Harry Frankfurt, particularly on "The Importance of What We Care About" from the book by the same name (Cambridge: Cambridge University Press, 1988) and "On Caring" from his *Necessity, Volition, and Love* (Cambridge: Cambridge University Press, 1999). Related discussions that have been deeply influential on my thinking in this chapter are Owen Flanagan's *The Varieties of Moral Personality* (Cambridge, Mass.: Harvard University Press, 1991), especially pp. 65–85, and Bernard Williams, "Persons, Character, and Morality" in his *Moral Luck, Philosophical Papers, 1973–1980.* (Cambridge: Cambridge University Press, 1981).

2. Tim O'Brien, *Going after Cacciato* (New York: Delta Publishing, 1979), p. 202.

3. Of course, I may *find out* what I care about by suddenly having a strong reaction to something, as well.

4. See Sartre's "Bad Faith," in *Jean-Paul Sartre: Essays in Existentialism,* ed. W. Baskin (Newark: Carol Publishing, 1956), pp. 147–186.

5. Albert Camus, *The Fall* (New York: Knopf, 1956).

6. "The Faintest Passion" his presidential address to the American Philosophical Association, reprinted in his *Necessity, Volition, and Love.*

7. *Freedom within Reason* (Oxford: Oxford University Press, 1990).

8. See his *Learned Optimism* (New York: Knopf, 1991).

9. *A Theory of Justice* (Cambridge: Harvard University Press, 1971), p. 440. Rawls in fact holds that self-respect is the most important and basic primary good.

10. Ibid.

11. "Authenticity" is used in a variety of ways; compare discussions in Charles Taylor's *The Ethics of Authenticity* (Cambridge, Mass.: Harvard University Press, 1991). For some

interesting remarks on the existentialist origins of the idea, see M. Warnock's *Existentialism* (London: Oxford University Press, 1970).

12. See Frankfurt's seminal article, "Freedom of the Will and the Concept of a Person," in his *The Importance of What We Care About* (Cambridge: Cambridge University Press, 1988). See also Gary Watson, "Free Action and Free Will," *Mind* 94 (1987): 145–172; Susan Wolf, *Freedom within Reason.*

13. As Heather Battaly pointed out to me (in correspondence), one of war's more insidious psychological effects is not only that it can make you care less about human life, it can prevent you from knowing what you care about, by putting you in situations where you find yourself, like Paul Berlin, torn between different images of yourself.

14. There is a growing literature on the intellectual virtues. The present revival of interest is due to some seminal papers by Ernest Sosa, many of which are collected in his *Knowledge in Perspective* (New York: Cambridge University Press, 1991). My own account of the virtues is influenced by Sosa's work and especially by James Montmarquet, *Epistemic Virtue and Doxastic Responsibility* (Lanham, Maryland: Rowman and Littlefield, 1993). Other sources include John Greco, "Virtues and Vices in Virtue Epistemology," *Canadian Journal of Philosophy* 23 (1993): 413–432; also Linda Zagzebski, *Virtues of the Mind* (Cambridge: Cambridge University Press, 1996).

15. See Heather Dawn Battaly, *What Are the Virtues of Virtue Epistemology?* (Ph.D. dissertation, Syracuse University, 2000). The argument appears in chapter 5. See also her "Thin Concepts to the Rescue: Thinning the Concepts of Epistemic Justification and Intellectual Virtue," in *Virtue Epistemology,* ed. Fairweather and Zagzebski, pp. 98–116.

16. The account of intellectual integrity here is influenced by C. Calhoun's "Standing for Something," *Journal of Philosophy* 92 (1995): 235–260. Calhoun, however, would understand what I am calling intellectual integrity as integrity proper. See also Lynne McFall, "Integrity," *Ethics* 98 (1987): 5–20.

17. "Letter from a Birmingham Jail," reprinted in *Reason and Responsibility,* tenth ed., ed. J. Feinberg and R. Shafer-Landau (New York: Wadsworth), pp. 657–666.

18. Dirk Johnson, "Illinois, Citing Faulty Verdicts, Bars Executions," *New York Times,* February 1, 2000.

19. See, for example, B. Williams, "Integrity," in *Utilitarianism: For and Against,* ed. J. J. C. Smart and B. Williams (New York: Cambridge University Press), pp. 108–117. Compare E. Ashford, "Utilitarianism, Integrity and Partiality," *Journal of Philosophy* 97 (2000): 421–439. See also Flanagan, *The Varieties of Moral Personality* (Cambridge, Mass.: Harvard University Press, 1991), chapters 3 and 4.

20. C. Calhoun, "Standing for Something" *Journal of Philosophy* 92 (1995): 235–260.

21. See Ernest Sosa, "For the Love of Truth?" in *Virtue Epistemology,* ed. Fairweather and Zagzebski, p. 51.

22. A good source of information on ancient Greek conceptions of the good life is Julia Annas, *The Morality of Happiness* (Oxford: Oxford University Press, 1995). See also especially Aristotle, *The Nichomachean Ethics,* trans. D. Ross (Oxford: Oxford University Press, 1998).

23. This is not to deny that there is an important distinction between things that are good that we are responsible for and those that we are not.

24. The distinction discussed in what follows between so-called desire-fulfillment views of flourishing and objective theories is influenced by Derek Parfit's well-known discussion, "What Makes Life Go Best," in appendix I of *Reasons and Persons* (Oxford: Oxford University Press, 1986).

25. Parfit, *Reasons and Persons,* p. 494.

26. Wittgenstein's discussion of family resemblance concepts can be found in *The Philosophical Investigations,* third ed., trans. G. E. Anscombe (New York: Prentice Hall, 1999).

27. See my *Truth in Context,* chapter 3.

28. *Moral Reality* (Oxford: Oxford University Press, 2001).

29. *Philebus,* 64b; *The Dialogues of Plato,* vol. 3 tr. B. Jowett (Oxford: Clarendon Press, 1953), p. 626.

30. *After Virtue,* second ed. (Notre Dame, Ind.: University of Notre Dame Press, 1984), p. 219.

31. *Self Expressions* (Oxford: Oxford University Press, 1996), pp. 69–70.

32. Ibid., p. 73.

Chapter 9

1. "On a Supposed Right to Lie from Altruistic Motives," in *Critique of Practical Reason and Other Writings in Moral Philosophy,* tr. L. W. Beck (Chicago, Ill.: University of Chicago Press, 1949), p. 347.

2. For some examples, see Sissela Bok, *Lying: Moral Choice in Public and Private Life* (New York: Vintage, 1979); for a less philosophical and more historical account, see J. Campbell, *The Liar's Tale: A History of Falsehood* (New York: Norton, 2001).

3. For a discussion of various definitions of lying, see Sissela Bok, *Lying.*

4. Bernard Williams makes similar points to those made here in his *Truth and Truthfulness* (Princeton, N.J.: Princeton University Press, 2002), pp. 102–104; compare Peter Geach's interesting and quite different discussion in his *Truth and Hope* (Notre Dame, Ind.: University of Notre Dame Press, 2001), chapter 4.

5. "Deception and Division," in *The Multiple Self,* ed. J. Elster (Cambridge: Cambridge University Press) pp. 79–92. For criticism of Davidson, see David Simpson, "Lying, Liars, and Language," *Philosophy and Phenomenological Research,* 52, no. 3 (1992): 623–639.

6. "On a Supposed Right to Lie from Altruistic Motives," p. 348. See also Augustine, "Lying" and "Against Lying," in *Treatises on Various Subjects,* ed. R. J. Defarrari, Fathers of the Church (New York: Catholic University Press of America, 1952), vol. 16, 47–183.

7. Bok, *Lying.*

8. Kant himself makes this point in "On a Supposed Right to Lie from Altruistic Motives," p. 348.

9. See Augustine, "On Lying." Kant sometimes is taken to be offering this sort of argument; see his *Groundwork of the Metaphysics of Morals,* tr. H. J. Patton (New York: Harper Torchbooks, 1964), p. 71.

10. Williams, *Truth and Truthfulness,* p. 107.

11. Ibid., pp. 118–119.

12. Ibid., p. 92.

13. Ibid., p. 61.

14. See Harry Frankfurt, "On Bullshit," in his *The Importance of What We Care About* (New York: Cambridge University Press, 1988), pp. 117–134; Akeel Bilgrami, "Is Truth a Goal of Inquiry," pp. 260–261.

15. I refer here to the thought that we should treat people as ends in themselves. See *Groundwork of the Metaphysics of Morals,* pp. 96.

16. Again: a *prima facie* constitutive good.

Chapter 10

1. For background, see James Dao and Eric Schmitt, "Pentagon Readies Efforts to Sway Sentiment Abroad," *New York Times,* February 19, 2002. For an update on the Pentagon's efforts, see "Pentagon and Bogus News: All Is Denied" by Eric Schmitt, *New York Times,* December 5, 2003.

2. See, e.g., Christopher Hitchens, *Why Orwell Matters* (New York: Basic Books, 2002).

3. My way of putting this point is influenced heavily by Ronald Dworkin's "Liberalism," in his *A Matter of Principle* (Cambridge, Mass.: Harvard University Press, 1985), pp. 191ff; and Michael Sandel, *Liberalism and the Limits of Justice,* second ed. (Cambridge: Cambridge University Press, 1998).

4. See, e.g., Sandel, *Liberalism and the Limits of Justice,* pp. 185ff., and Simon Blackburn, *Ruling Passions* (Oxford: Oxford University Press, 1998), p. 274.

5. See Robert Bork, *Slouching towards Gomorrah,* and Allan Bloom, *The Closing of the American Mind.*

6. *Contingency, Irony, and Solidarity* (Cambridge: Cambridge University Press, 1989), p. 52.

7. The following discussion of rights is influenced by Ronald Dworkin, *Taking Rights Seriously* (Cambridge, Mass.: Harvard University Press, 1978), and Jeffrie Murphy's discussion in *The Philosophy of Law,* revised ed., ed. J. G. Murphy and J. L. Coleman (Boulder, Colo.: Westview Press, 1990), pp. 82–90.

8. Ronald Dworkin, *Taking Rights Seriously.*

9. Robert Nozick, *Anarchy, State, and Utopia* (New York: Basic Books, 1974), p. 30.

10. The classic utilitarian conception of rights can be found in Mill's *Utilitarianism,* ed. R. Crisp (Oxford: Oxford University Press), chapter 5.

11. "Universality and Truth," in *Rorty and His Critics,* ed. Brandom, p. 4.

12. R. Rorty, *Truth and Progress* (Cambridge: Cambridge University Press, 1998), p. 20.

13. "Ethics without Principles," in his *Philosophy and Social Hope* (New York: Penguin Books, 1999), p. 85.

14. Ibid., pp. 84–86.

15. Ibid., p. 83.

16. For some more comments about this sort of view, see my "How to Be a Relativist," in *Truth and Judgment,* ed. P. Nerhot (Dordrecht: Kluwer, forthcoming. See also Ralph Walker's "The Coherence Theory" in *The Nature of Truth* and Crispin Wright's "Truth in Ethics," *Ratio* 8 (1995): 210–226.

17. Isaiah Berlin, "Two Concepts of Liberty," in his *Four Essays on Liberty* (Oxford: Oxford University Press, 1969), p. 172.

18. Oliver Wendell Holmes, Jr., *Abrams v. United States,* 250 U.S. (1919), 630.

19. The USA Patriot Act (the Patriot Act), P.L. 107–56, 115 Stat. 272 (2001). For information on the American Libraries Association's official response to the Act, see http://www.ala.org.

20. *Truth and Truthfulness* (Princeton, N.J.: Princeton University Press, 2002), p. 108.

21. *Foucault Live: Interviews 1966–84,* p. 308.

Index